# A Garden Rhapsody

## Enchanted English Cottages and Floral Melodies

e·a·r
BOOKS

Copyright © 2005 by edel CLASSICS GmbH, Hamburg / Germany
Photographs copyright Andrew Lawson
Music copyright see music credits
All rights reserved. No part of the publication may be reproduced in any
manner whatsoever without permission in writing from the publisher.

ISBN 3-937406-31-X

Editorial Direction by Astrid Fischer / edel
Music compiled by Bernd Kussin / edel
Design by Leslie Strohmeyer
Foreword by Kristina Faust
Produced by optimal media production GmbH, Röbel / Germany
Printed and manufactured in Germany
EarBooks is a division of edel CLASSICS GmbH

For more information about EarBooks please visit **www.earbooks.net**

edel CLASSICS

MANUFACTURED BY
**optimal** MEDIA PRODUCTION

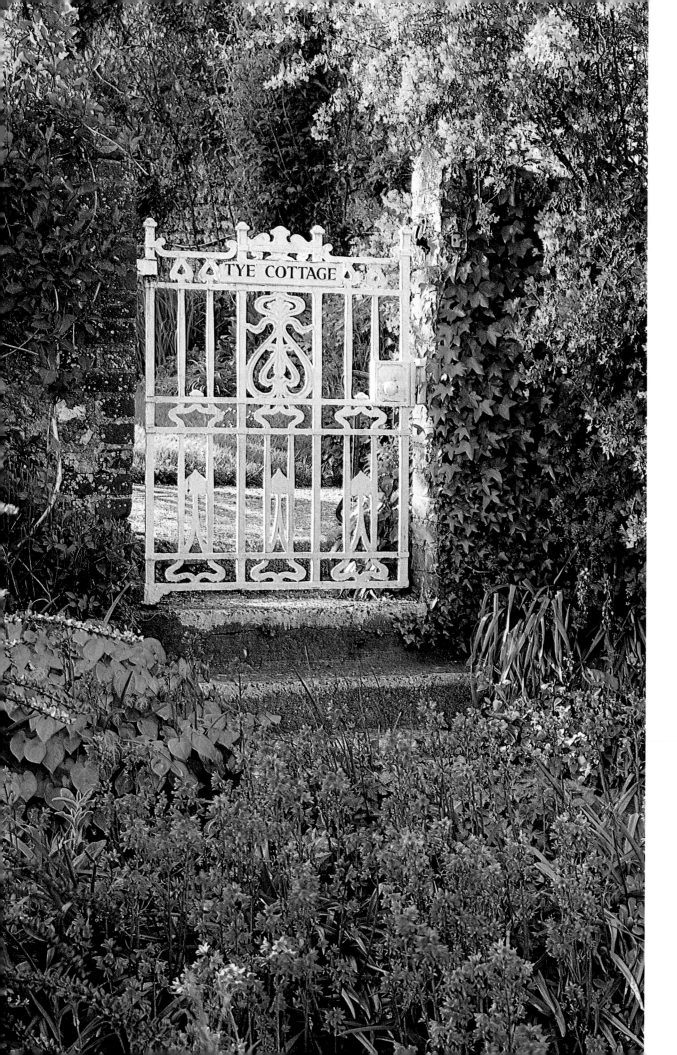

## Foreword

A visit to a cottage garden is a romantic expedition. Although house and garden fit perfectly into their surroundings, there is always room for a surprise. For example, a small opening in a hedge might frame an unexpected view of voluptuously blooming roses. All contrasts are fully intended and unite to form a harmonious aesthetic. Each unassuming parcel of land becomes a potential Garden of Eden – an appealing thought for garden lovers everywhere.

The rich gardening tradition in England has followed one goal with a passion: to out do nature's own compositions. Fabulous cottage gardens present a picture of impetuous ardour, which is actually the result of a well-laid, if decidedly relaxed, plan. English cottage gardens exhibit vitality, even unbridled joy, in a very cultivated manner.

What had begun in England in the Middle Ages as subsistence horticulture developed over time to become one of the most admired examples of idyllic landscaping. During the Renaissance, garden influences from the continent literally found fertile ground in England. Later, botanic souvenirs from abroad were added to domestic varieties and the mixture of the exotic and the familiar animated garden planners to the utmost in sophisticated arrangements. Ingenious, free compositions which use different forms and structures, always addressing spatial aspects, remain at the heart of the art form to the present day. Classic details, such as vases, statues, or small fountains accentuate the scenery.

The continuing popularity of English cottage gardens' atmosphere and charm have made them the standard for devotees of wild beauty around the world. Flawless landscaping on larger estates and in parks is beautiful to look at, but the natural beauty of cottage gardens is designed to be lived in.

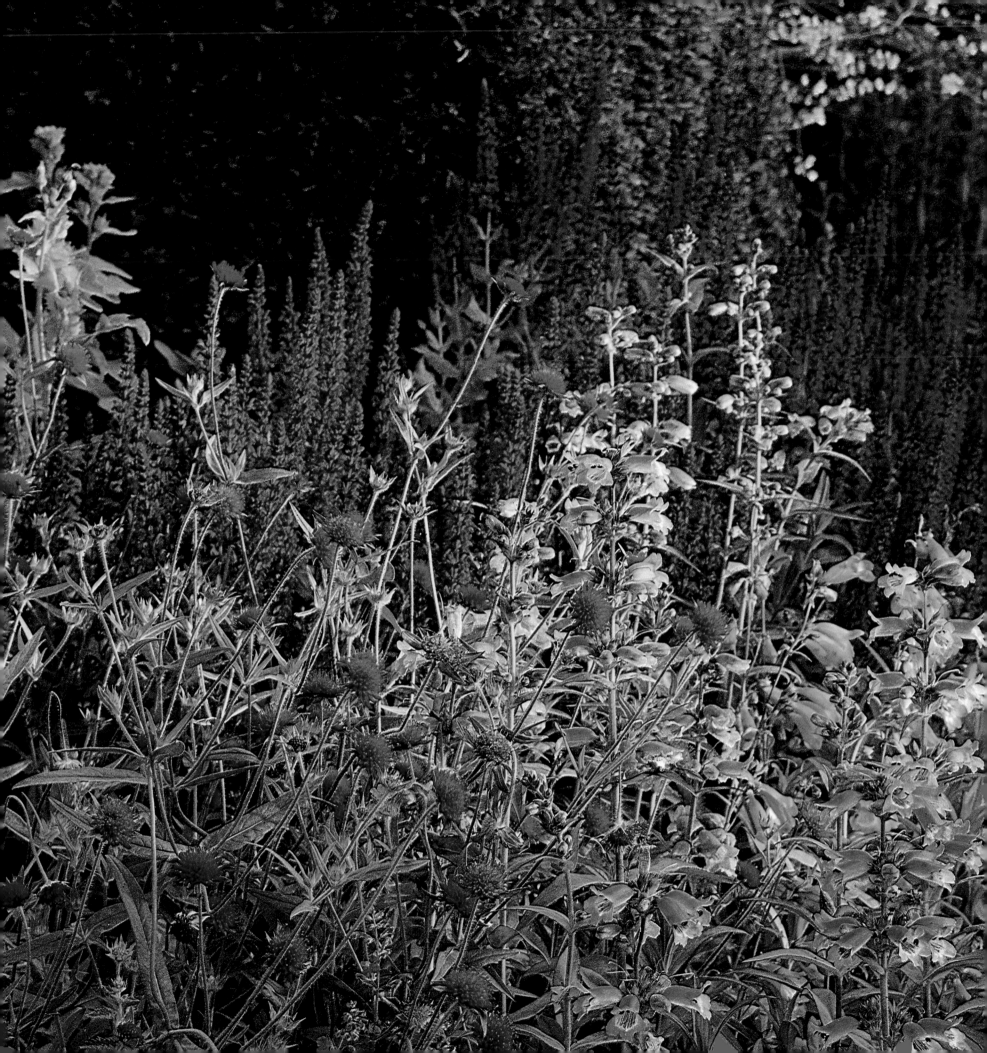

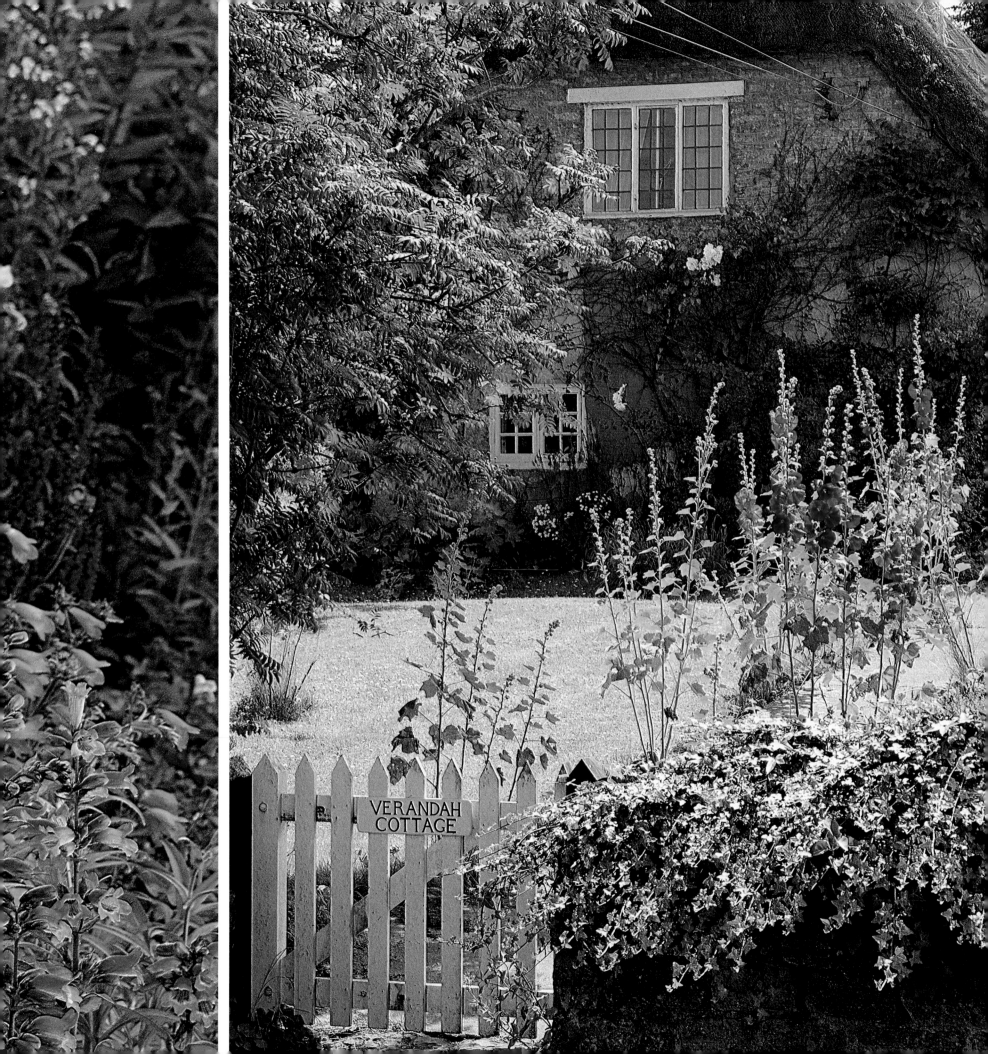

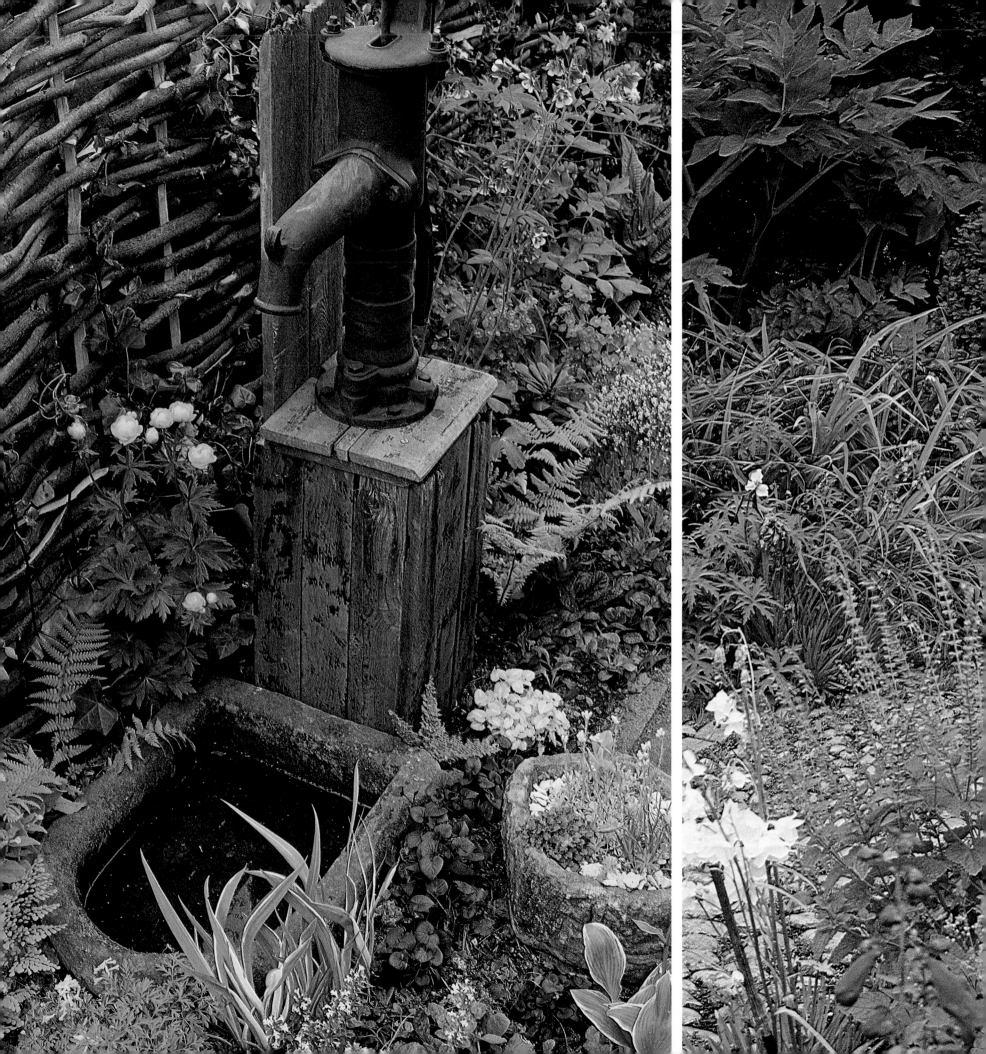

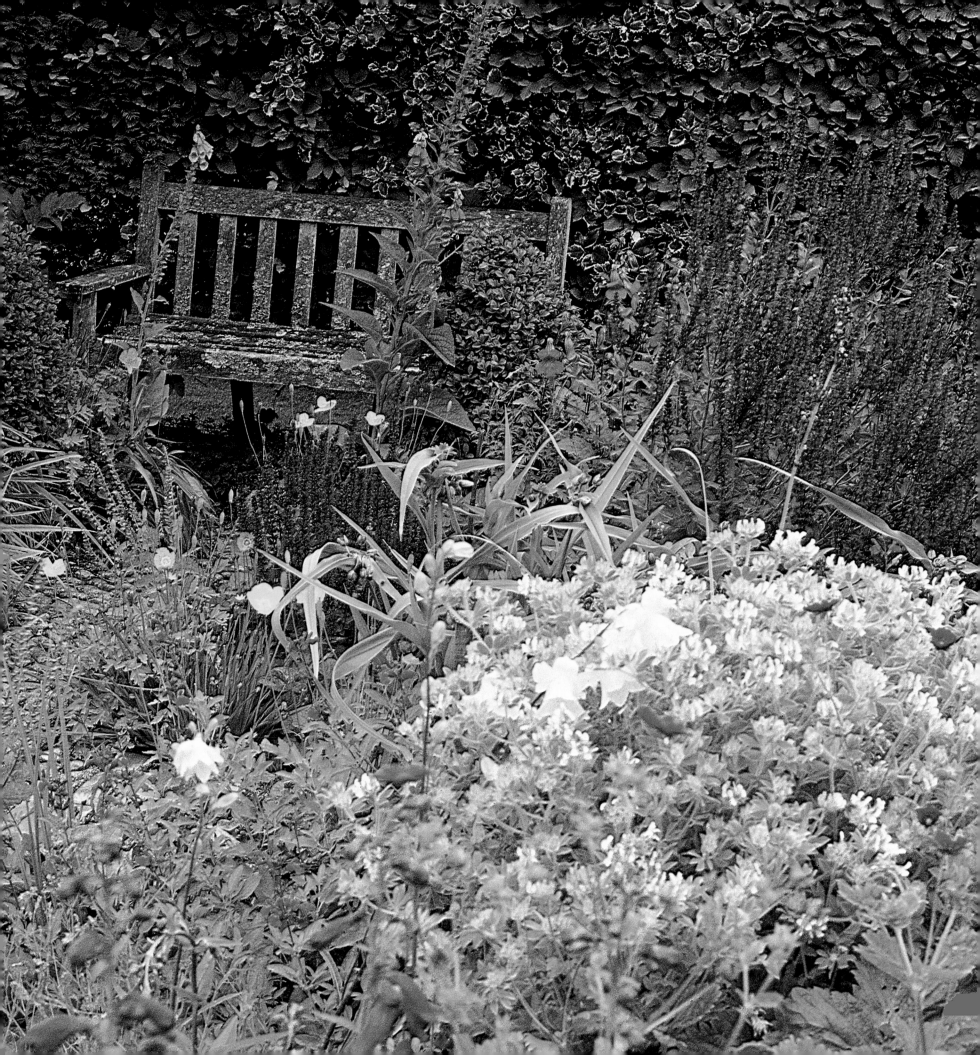

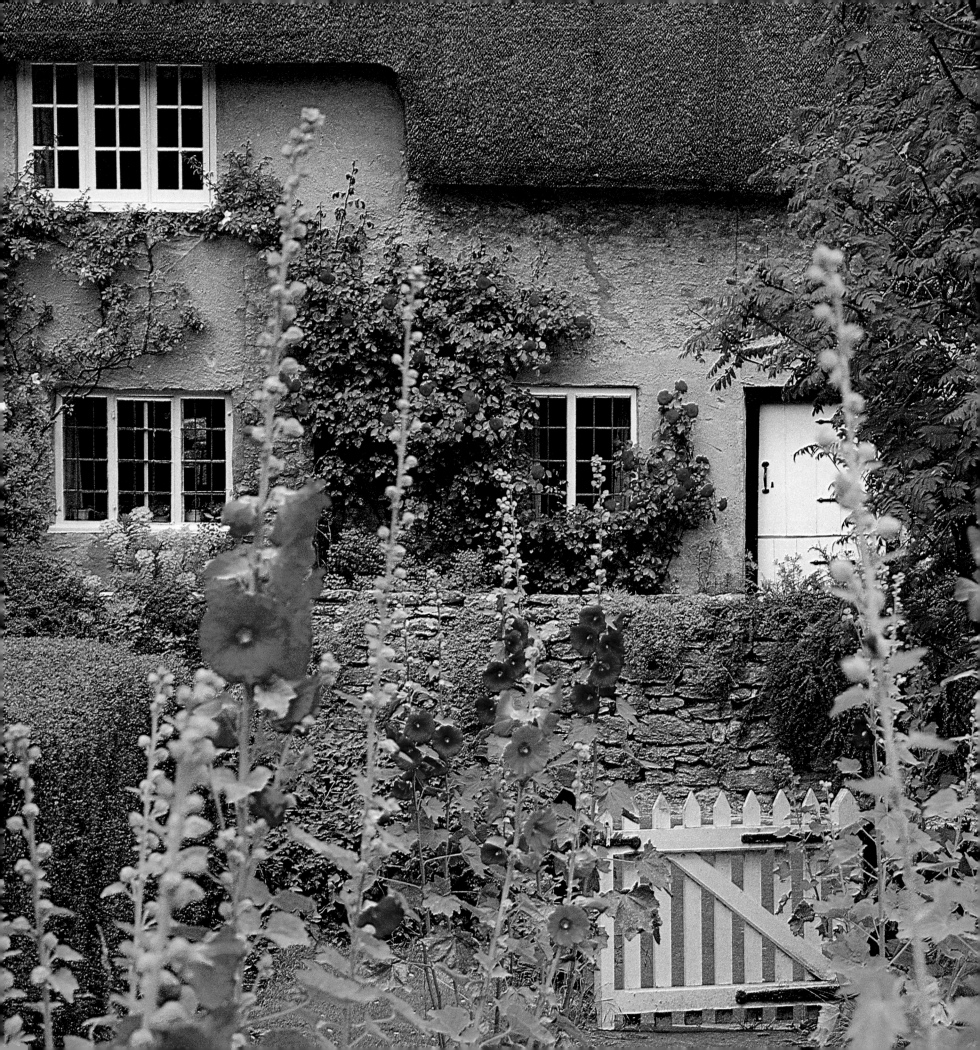

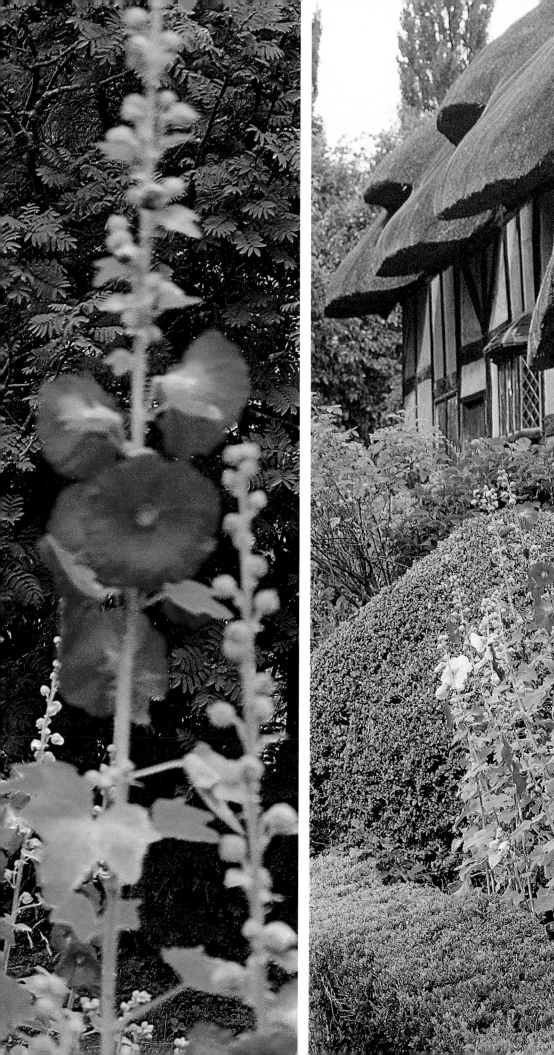
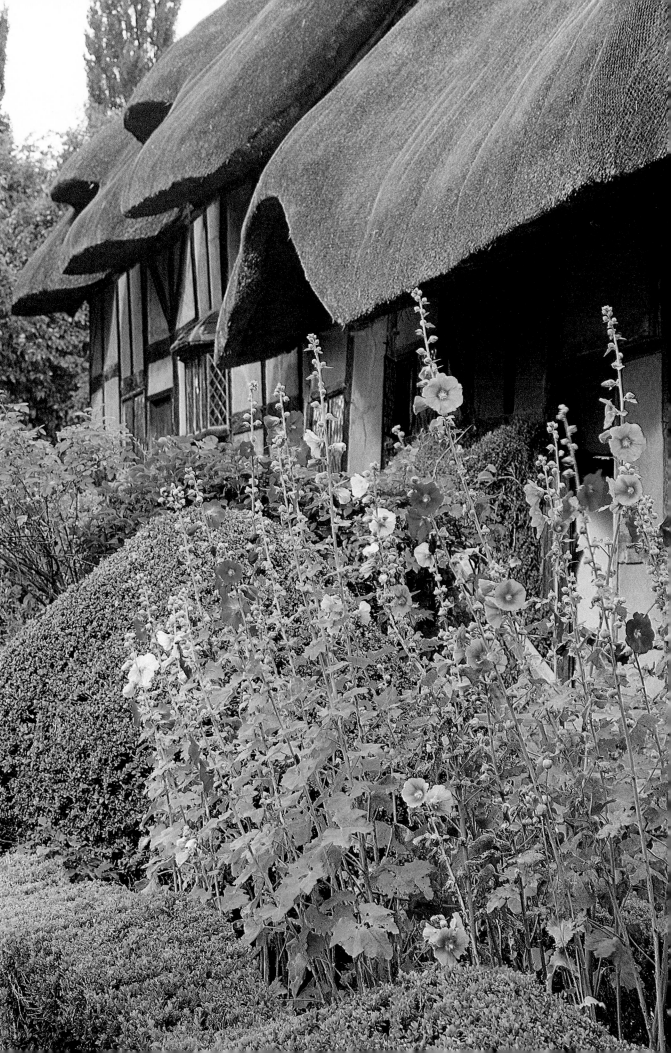

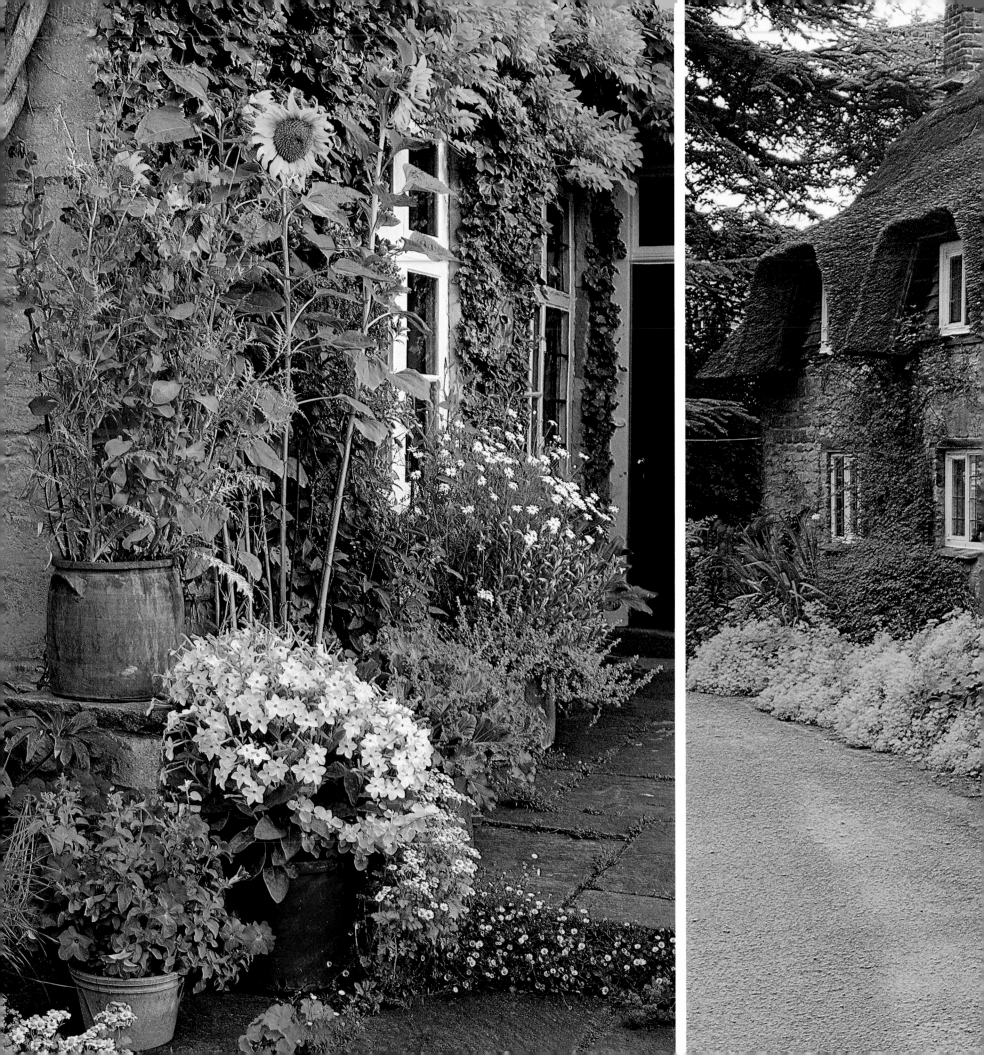

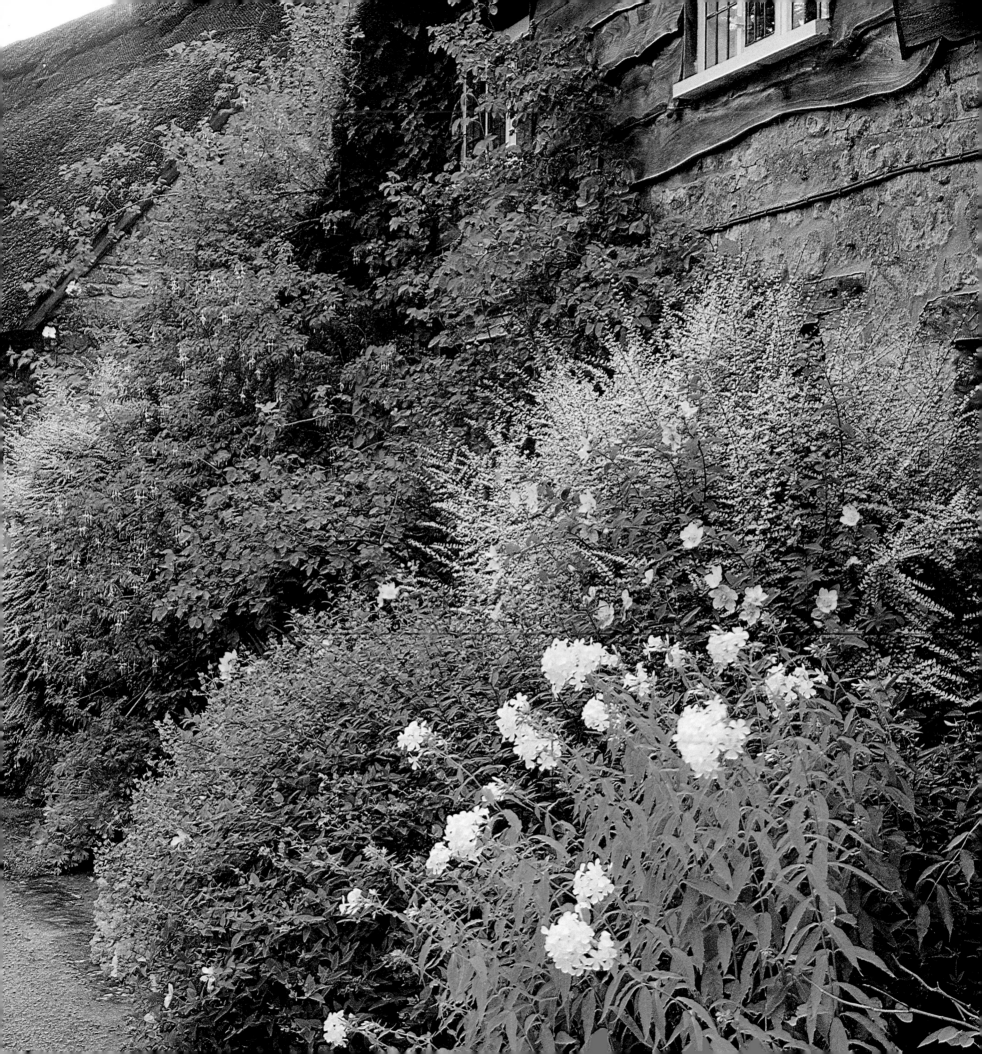

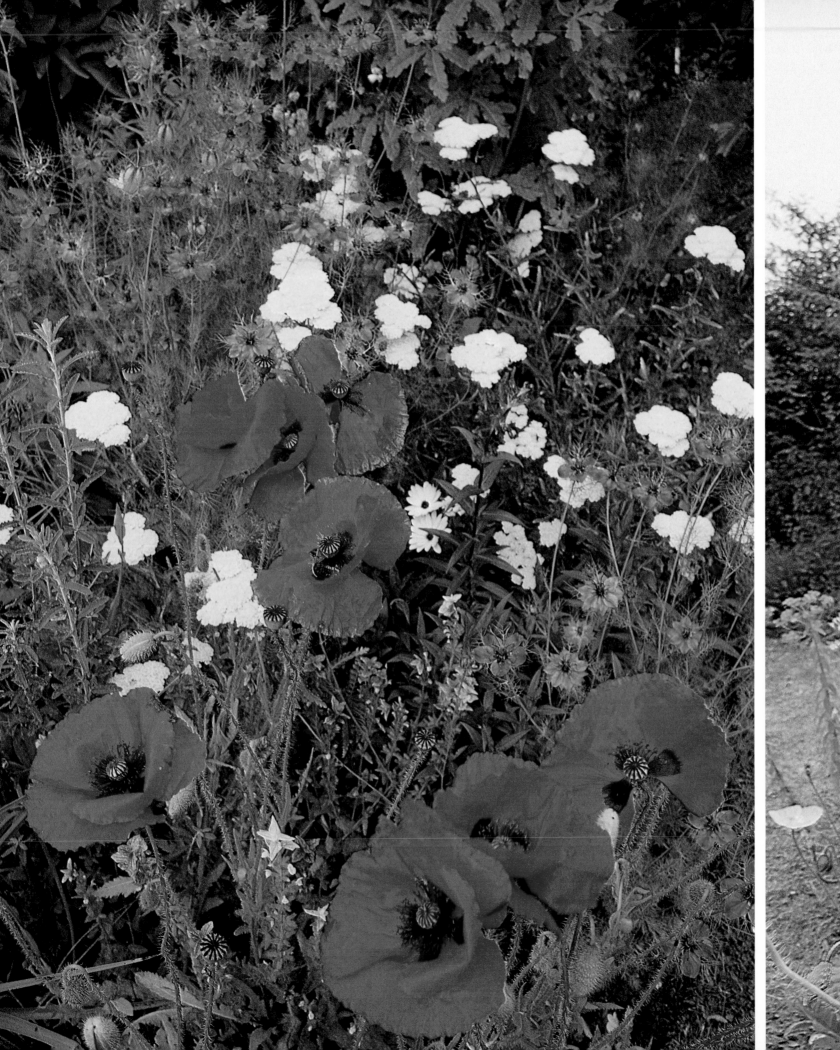

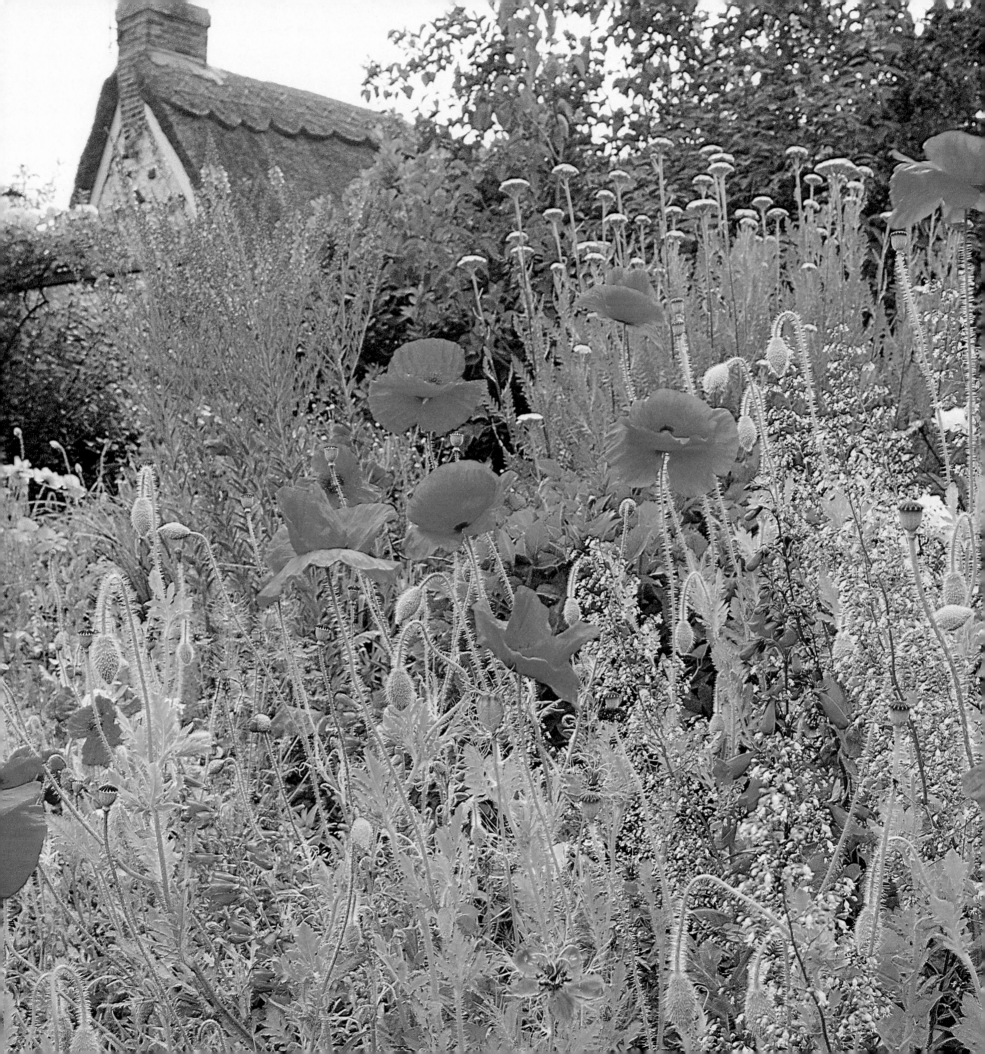

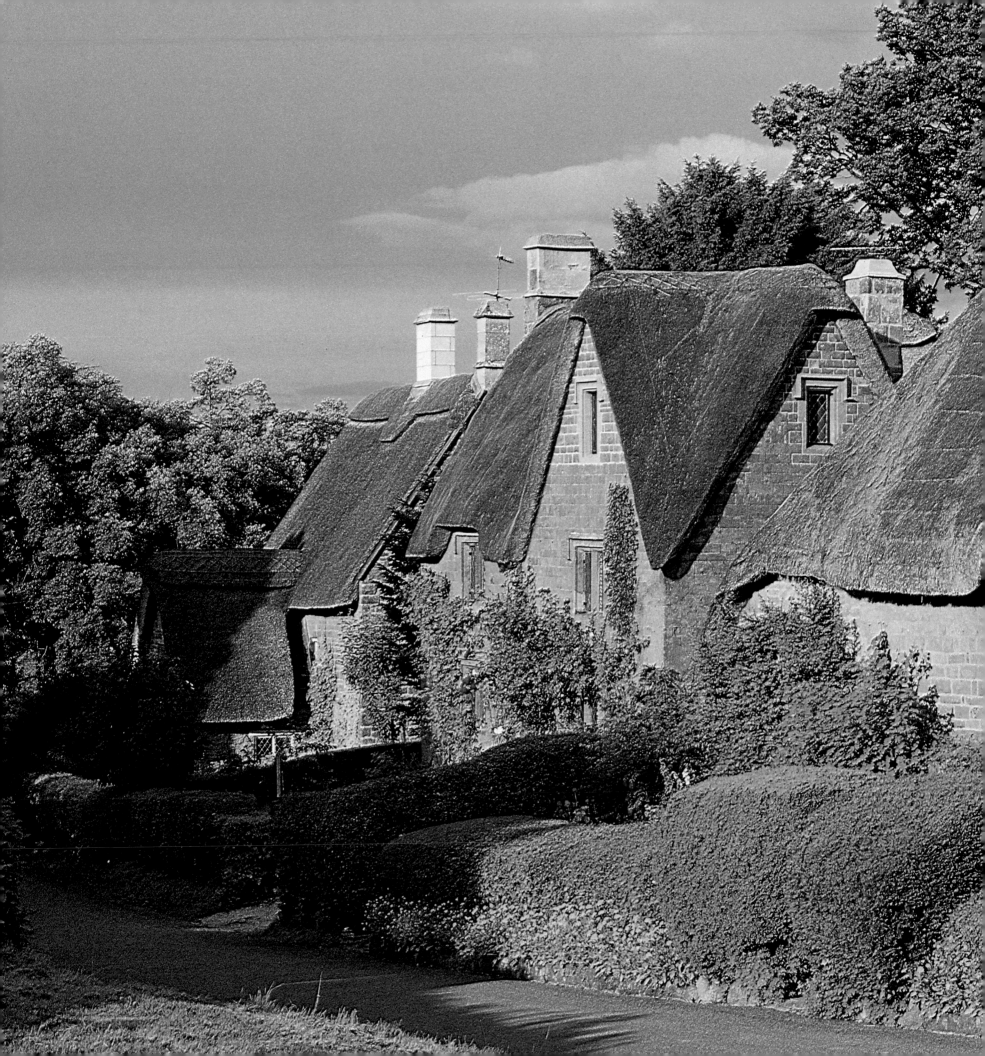

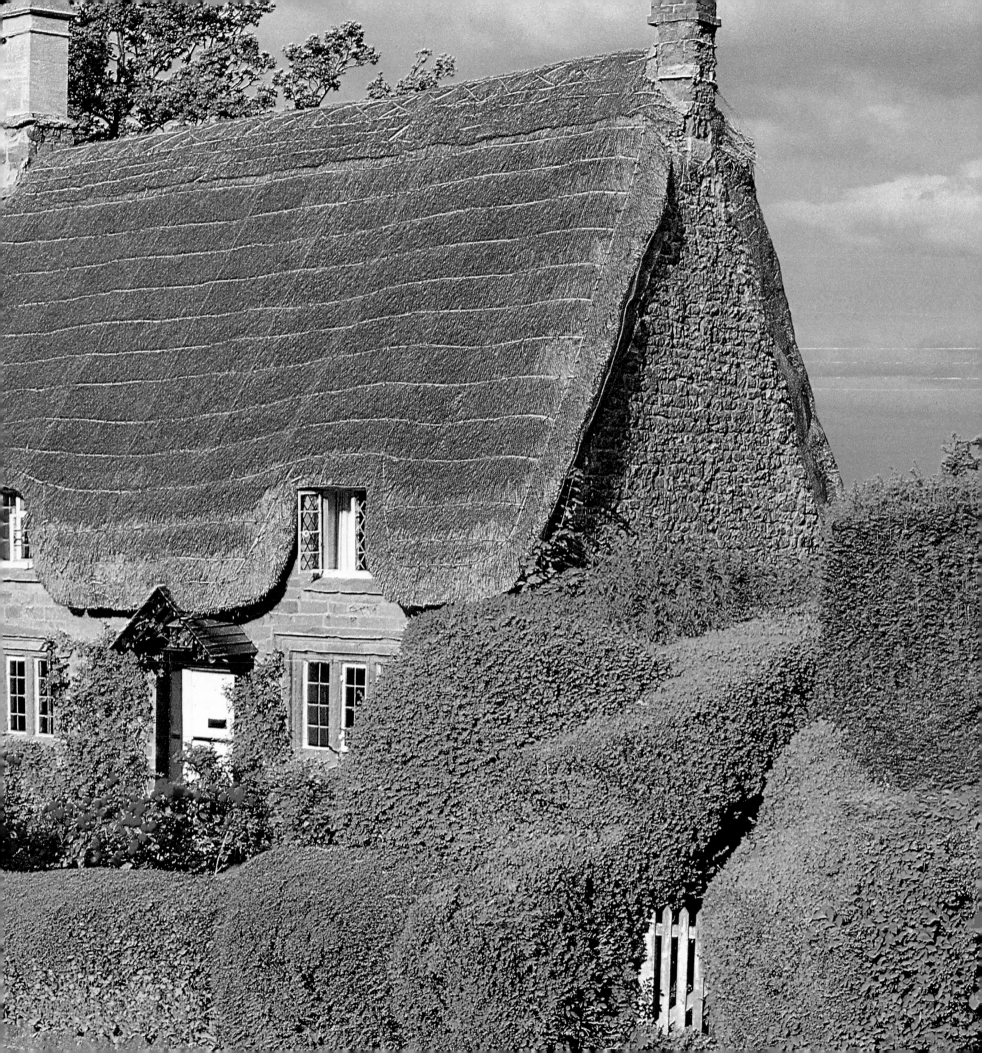

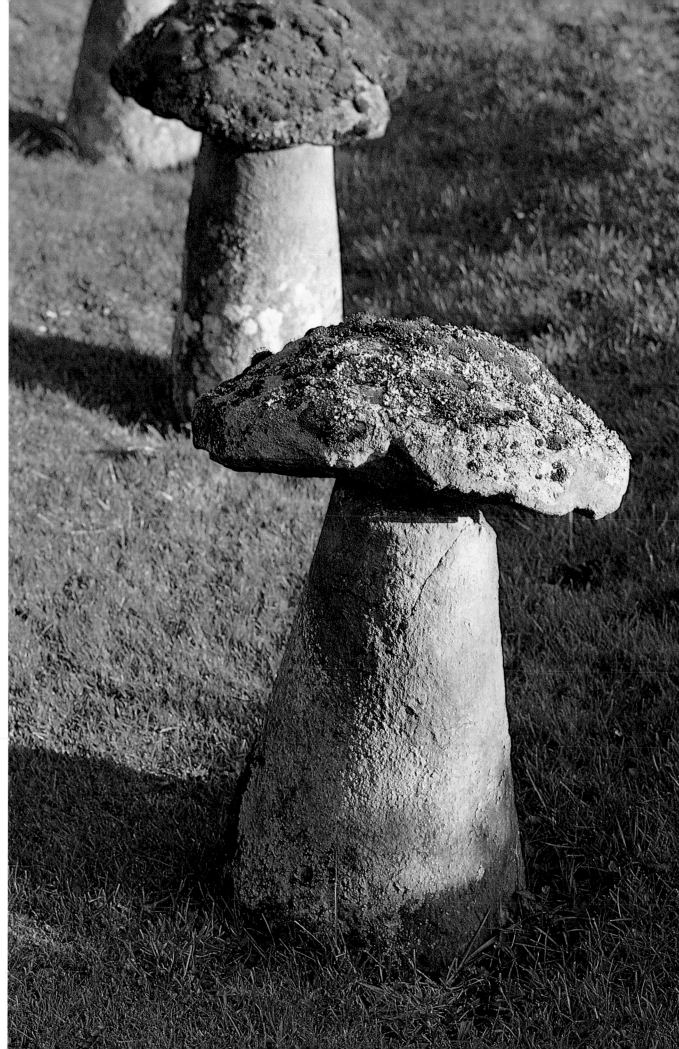

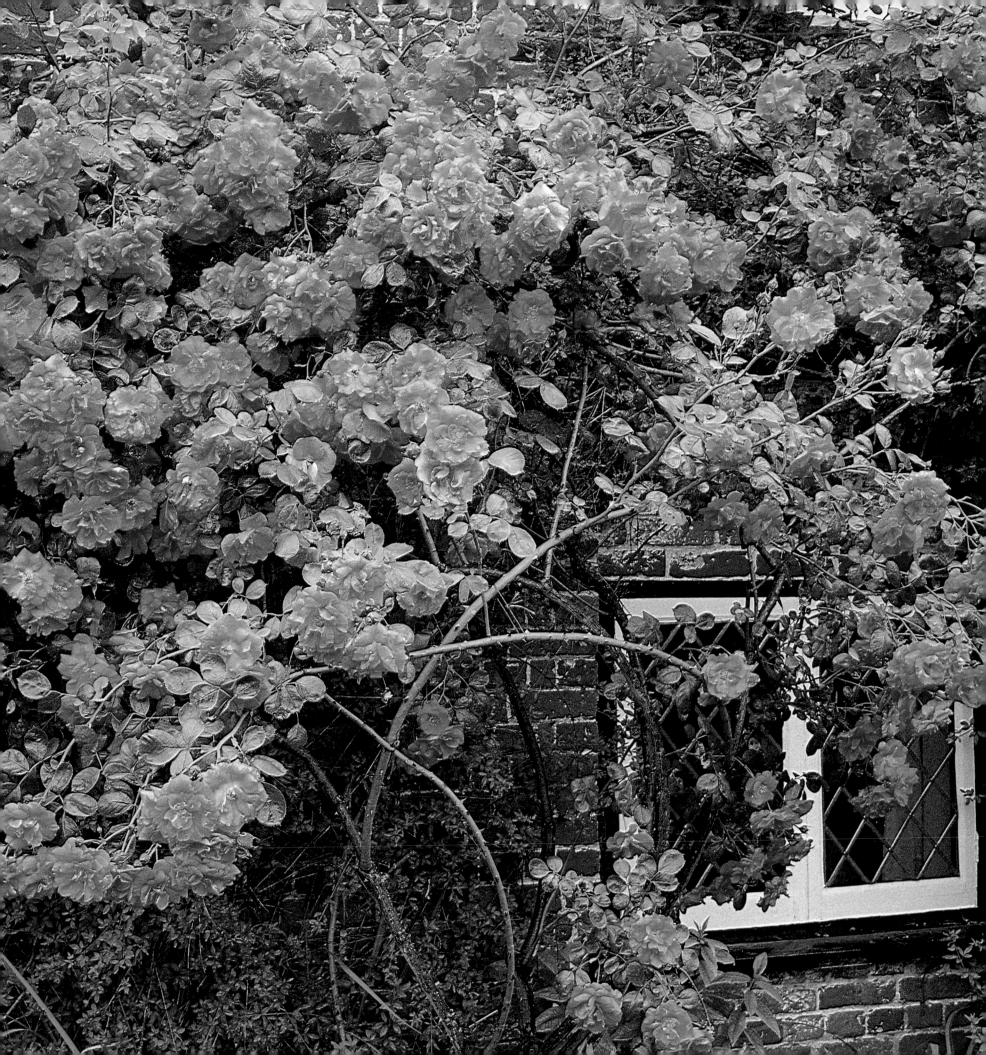

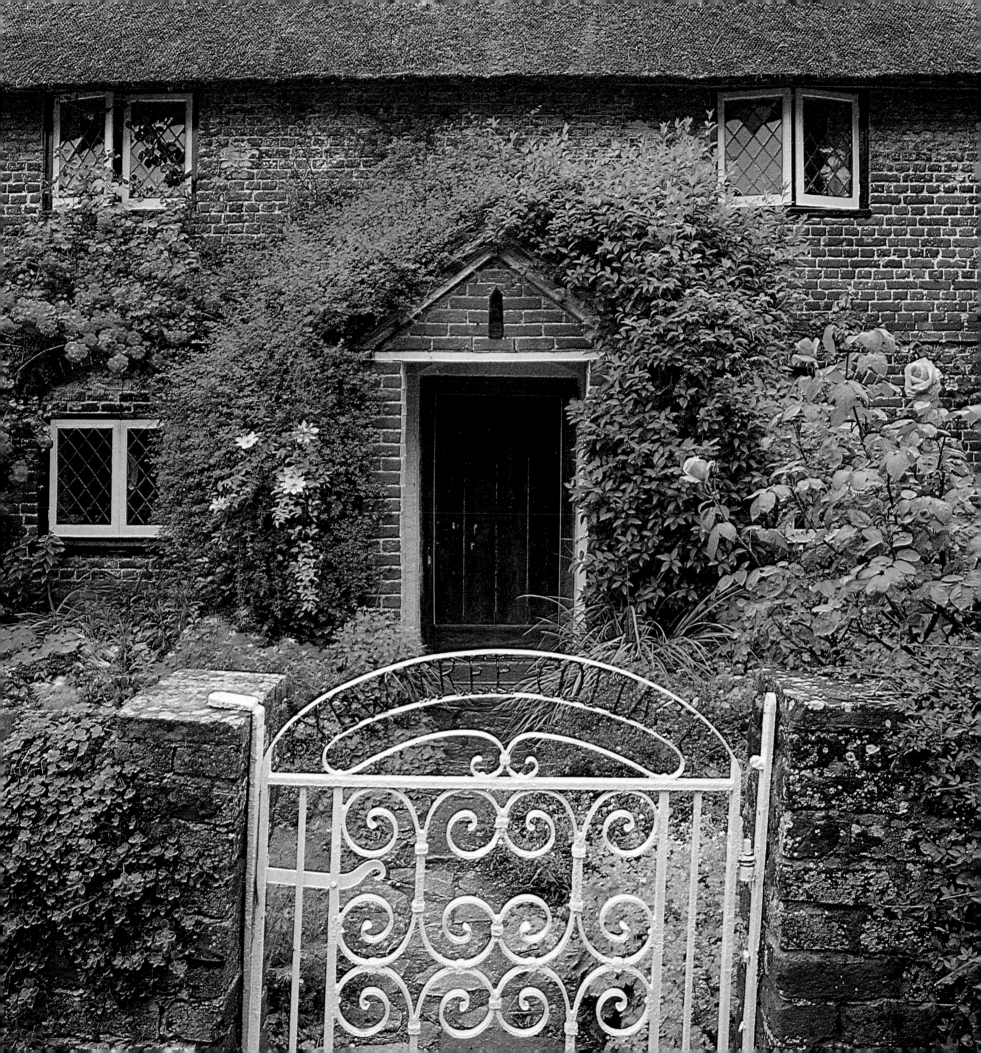

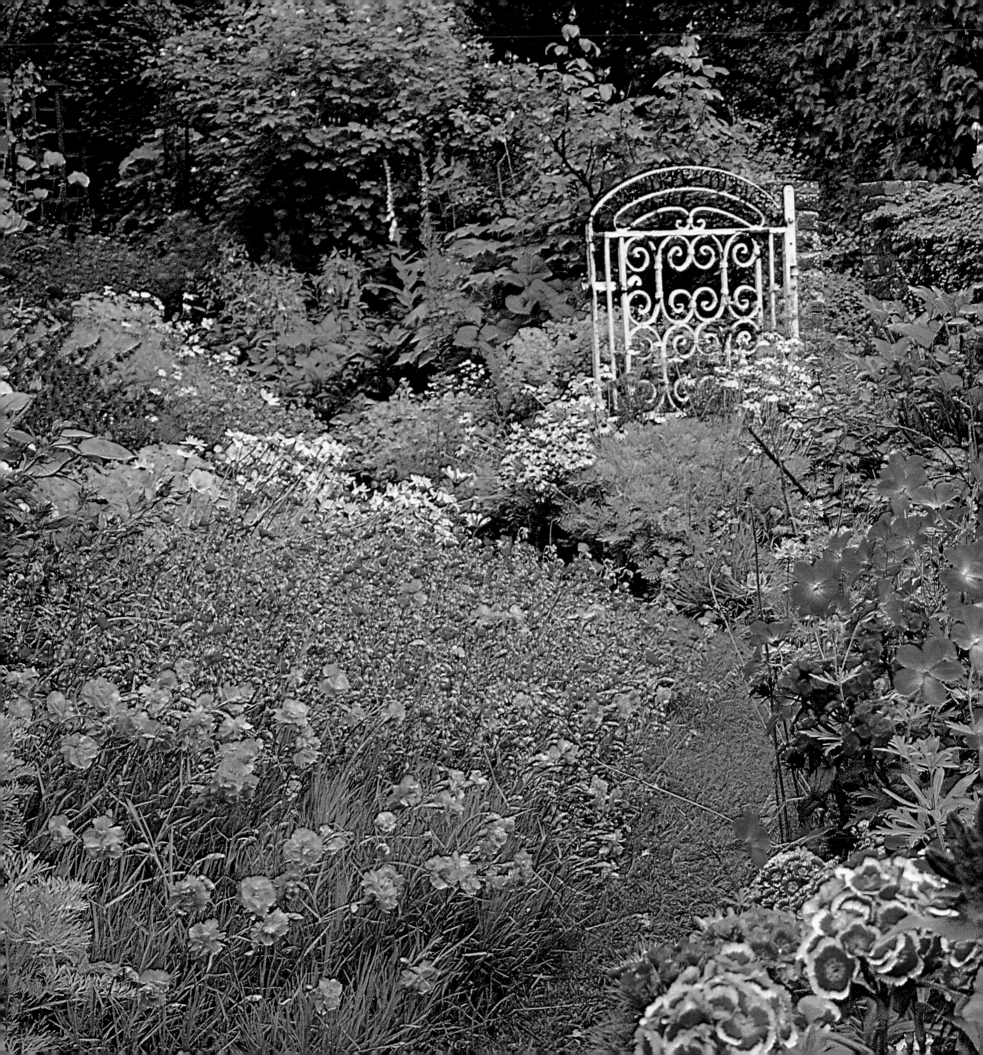

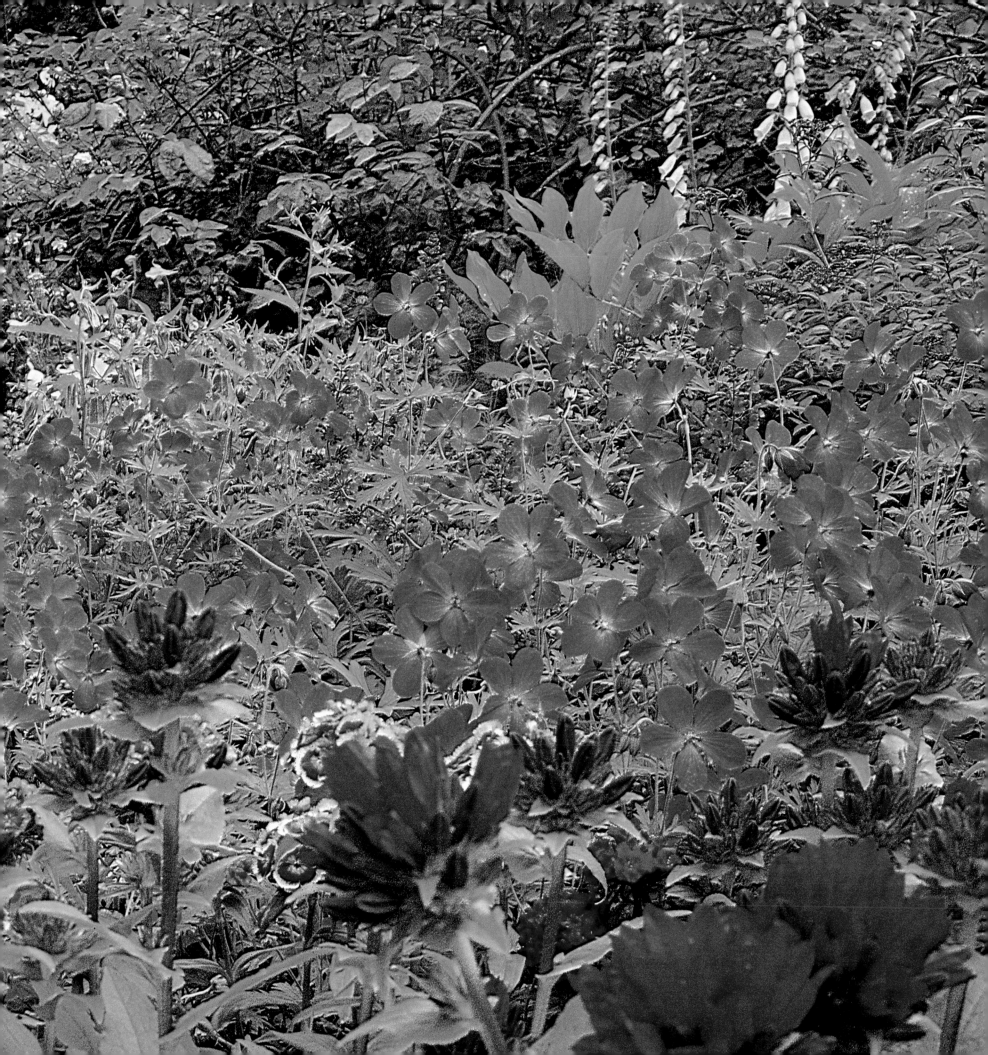

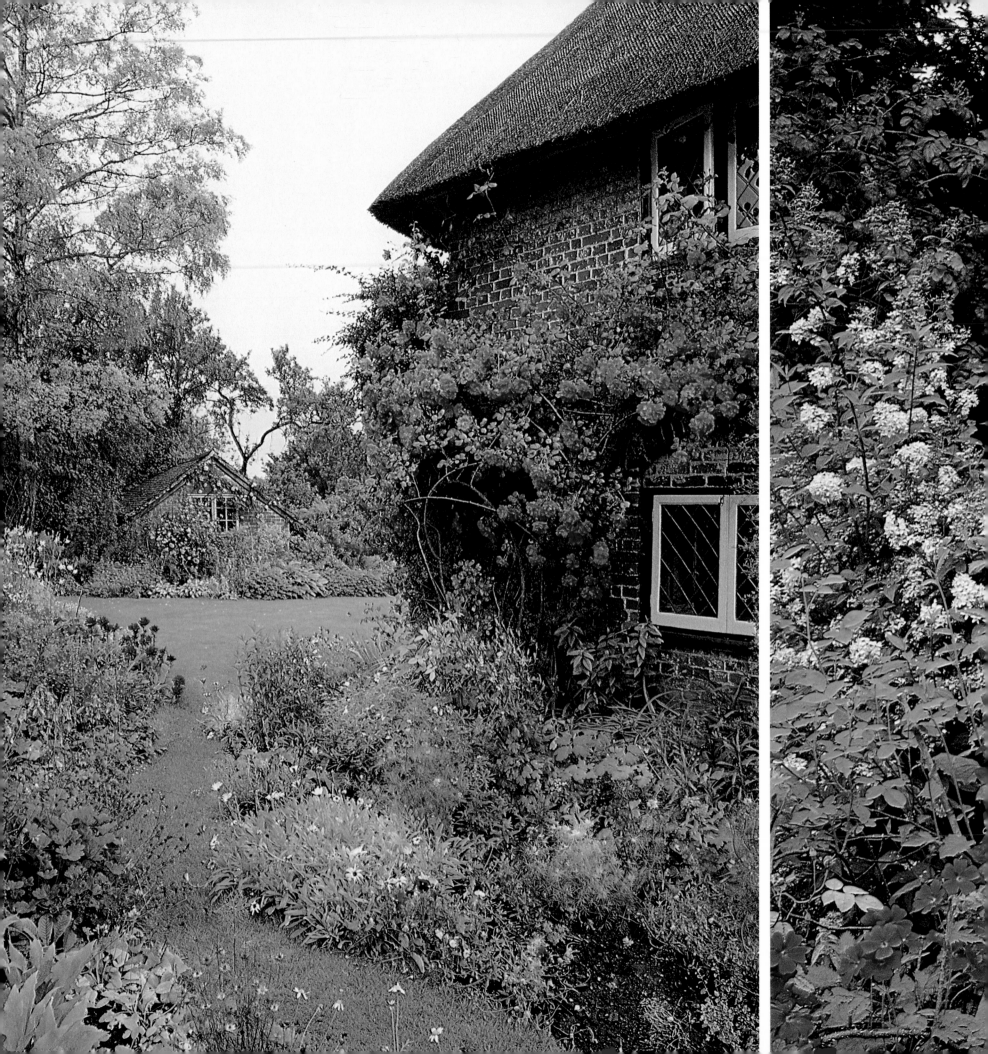

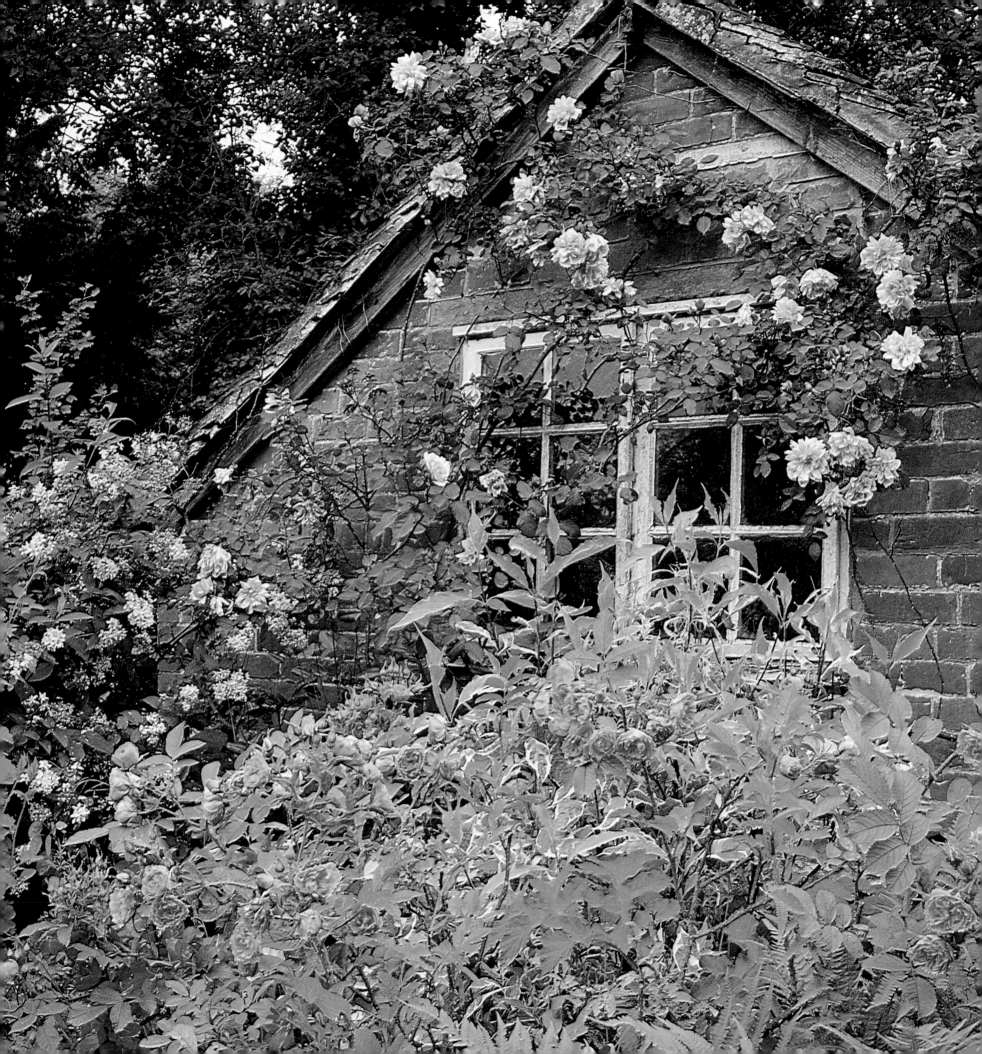

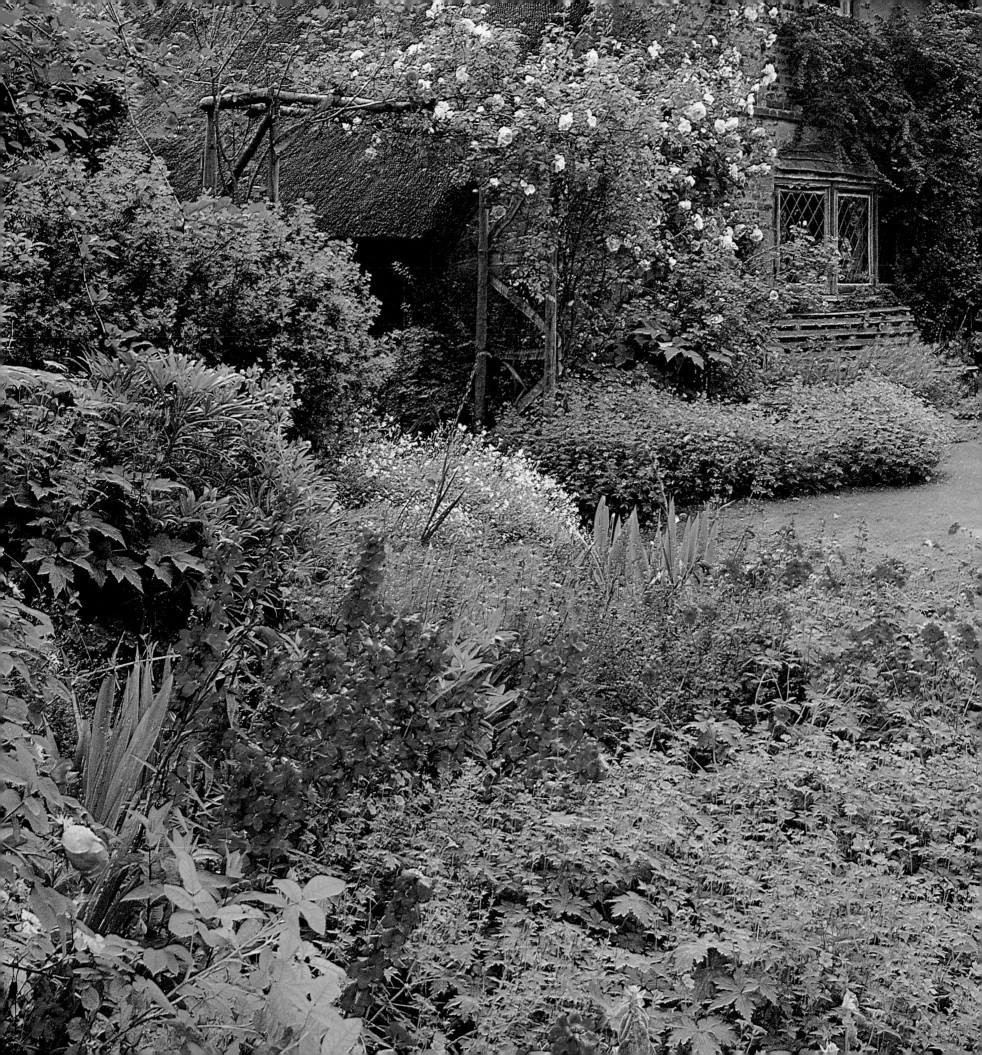

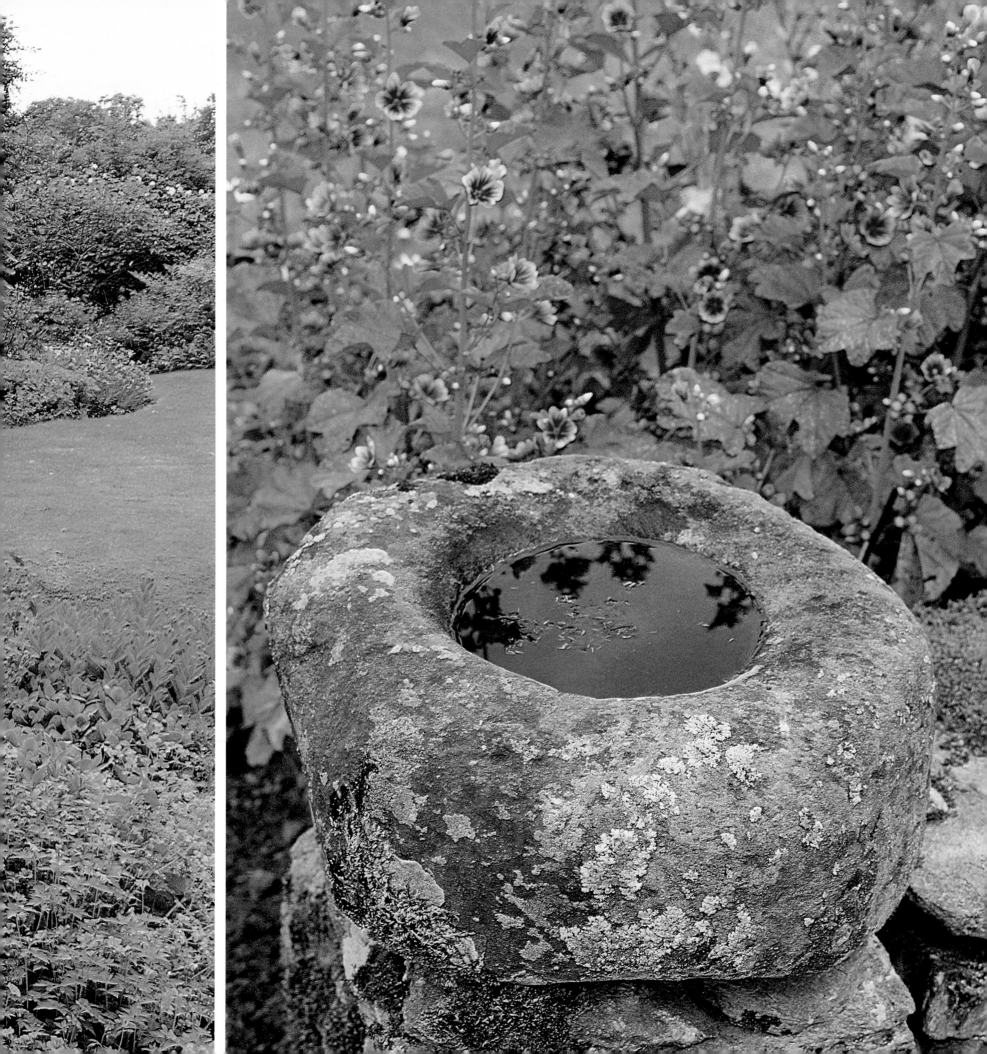

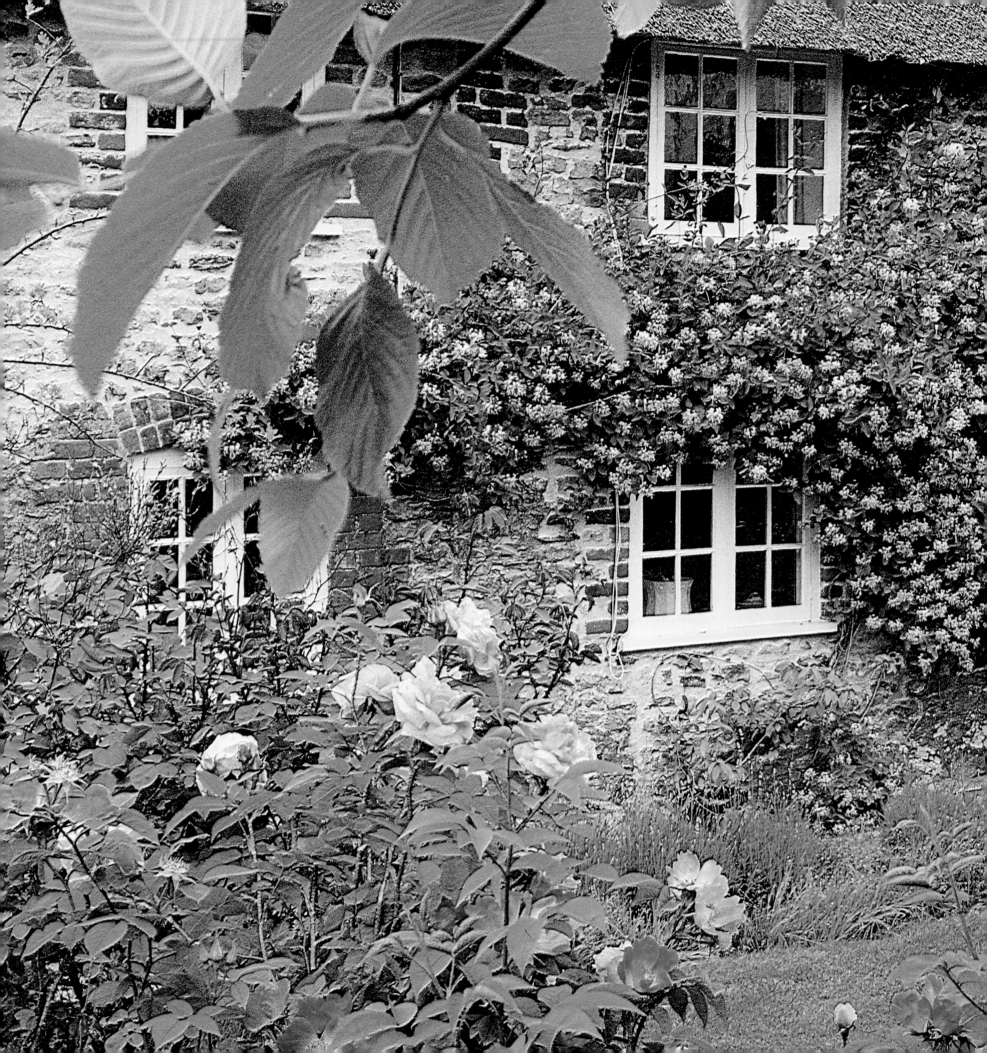

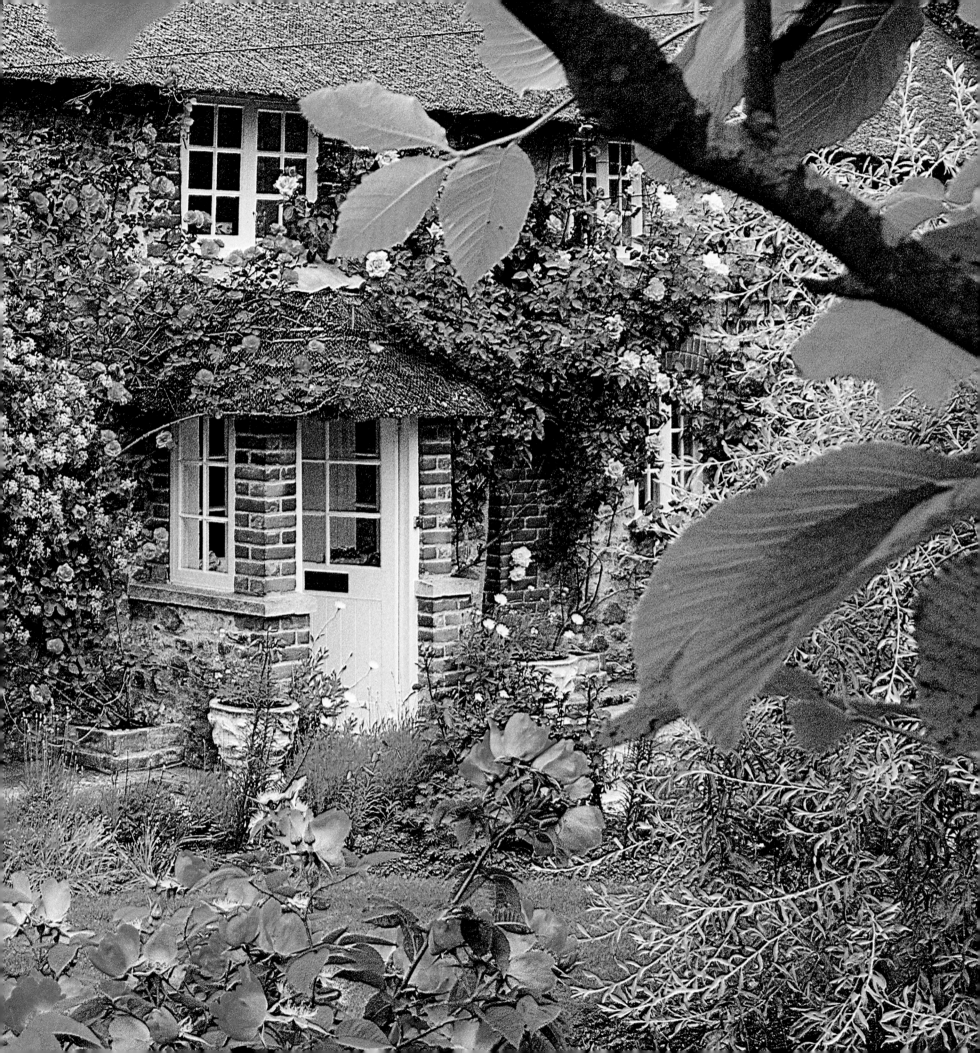

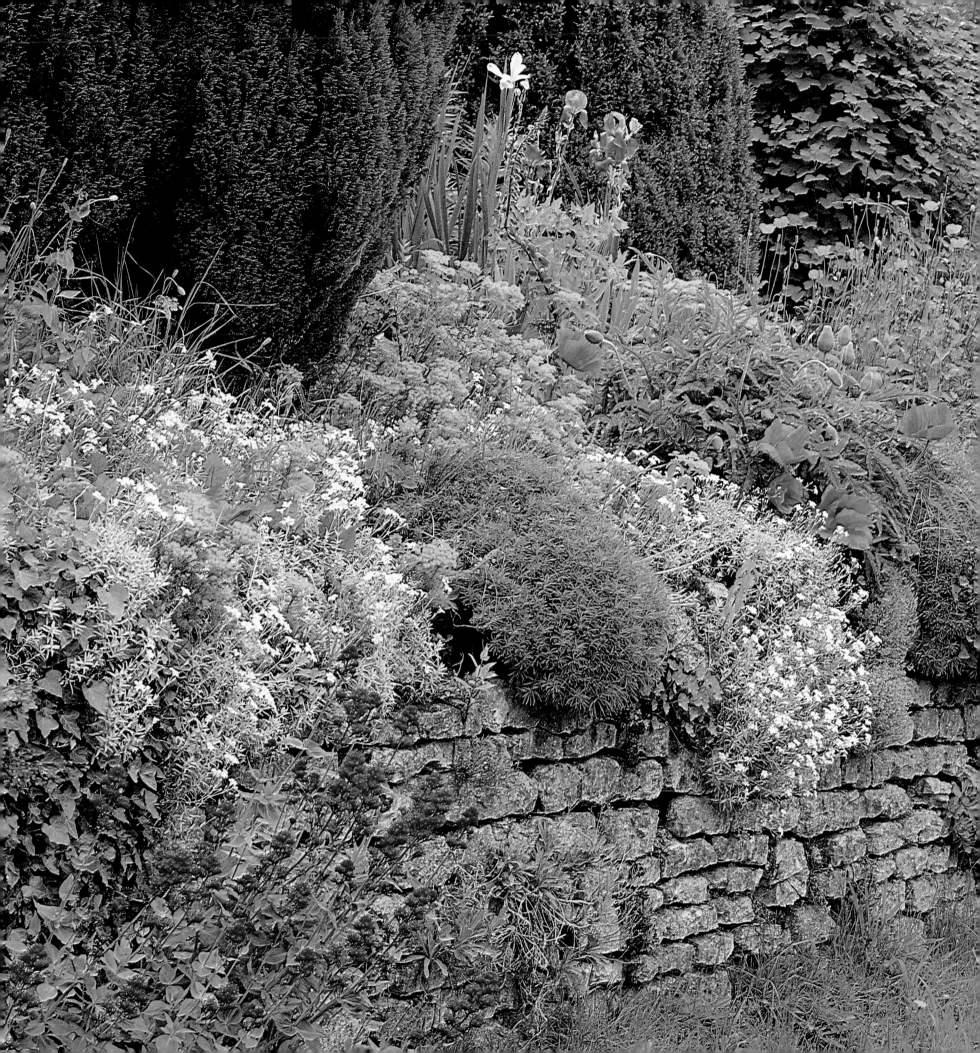

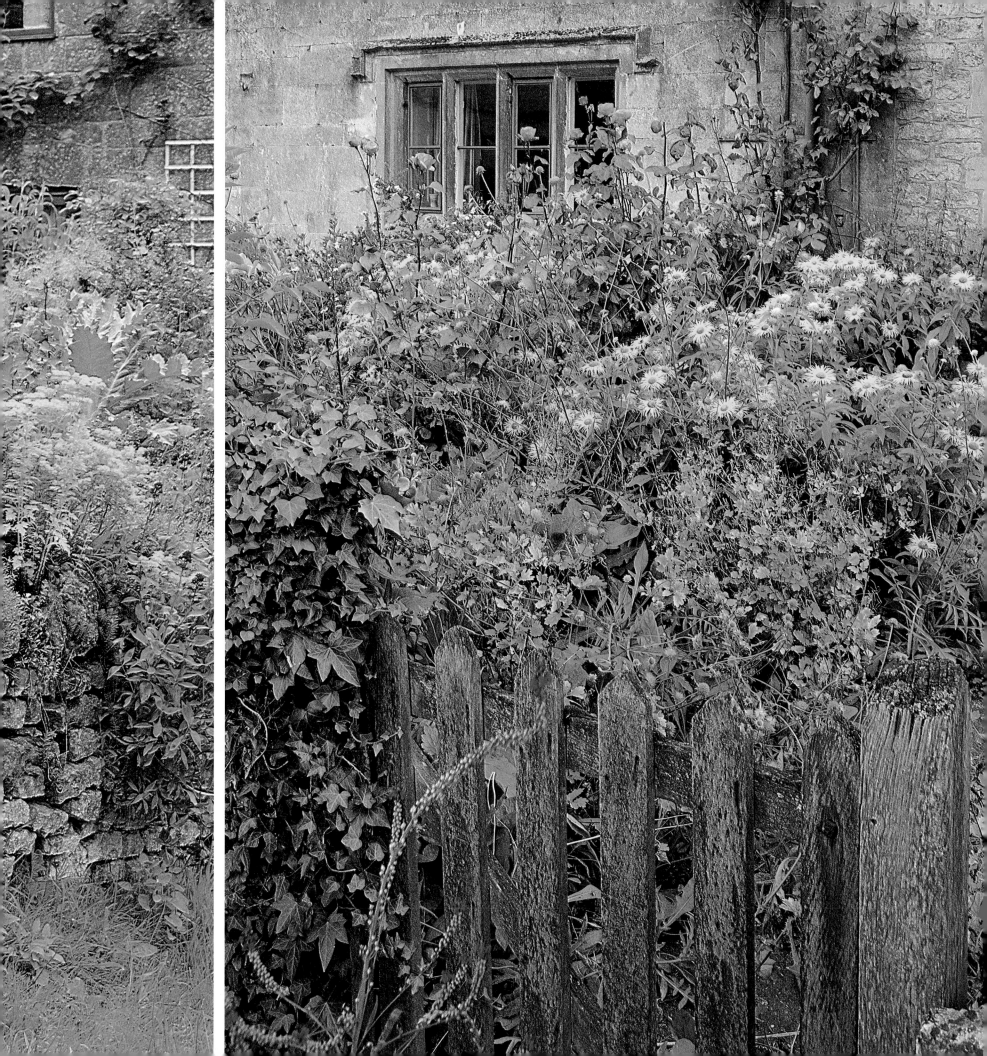

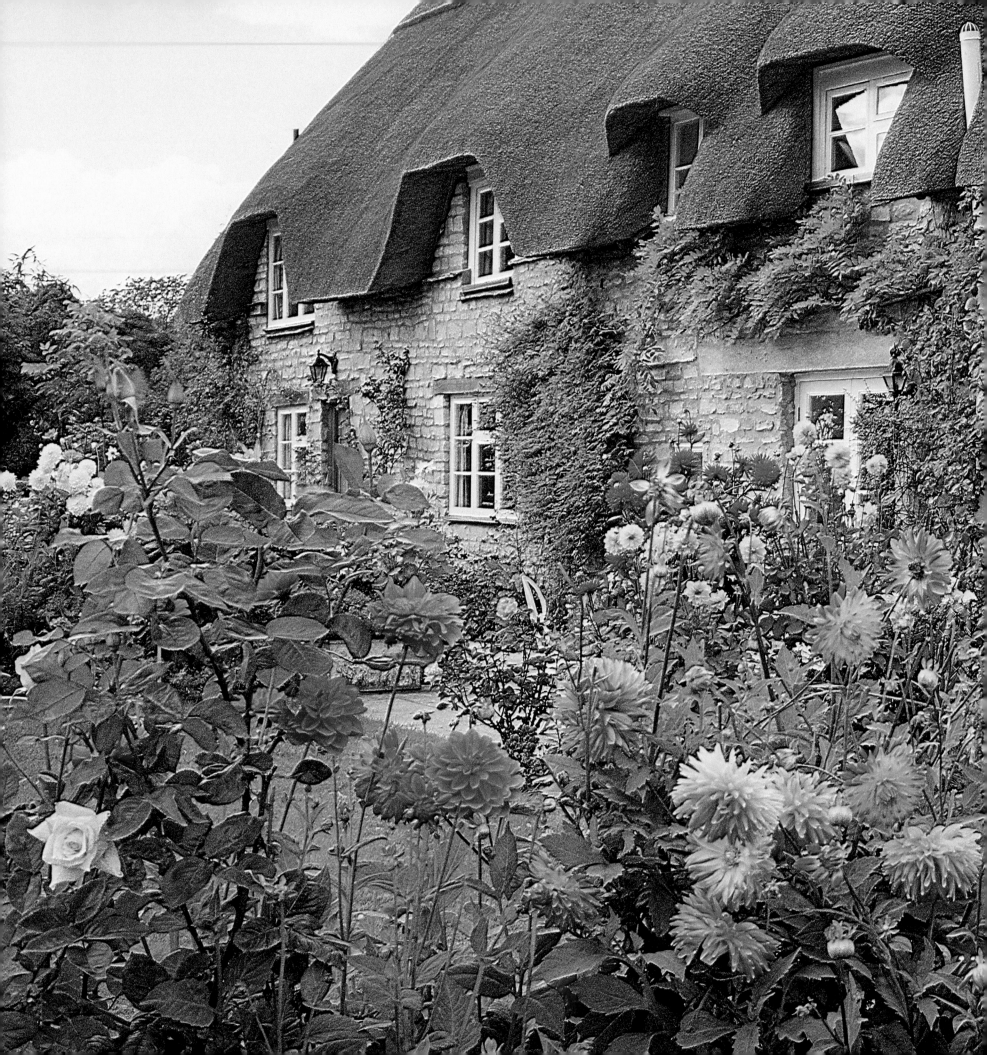

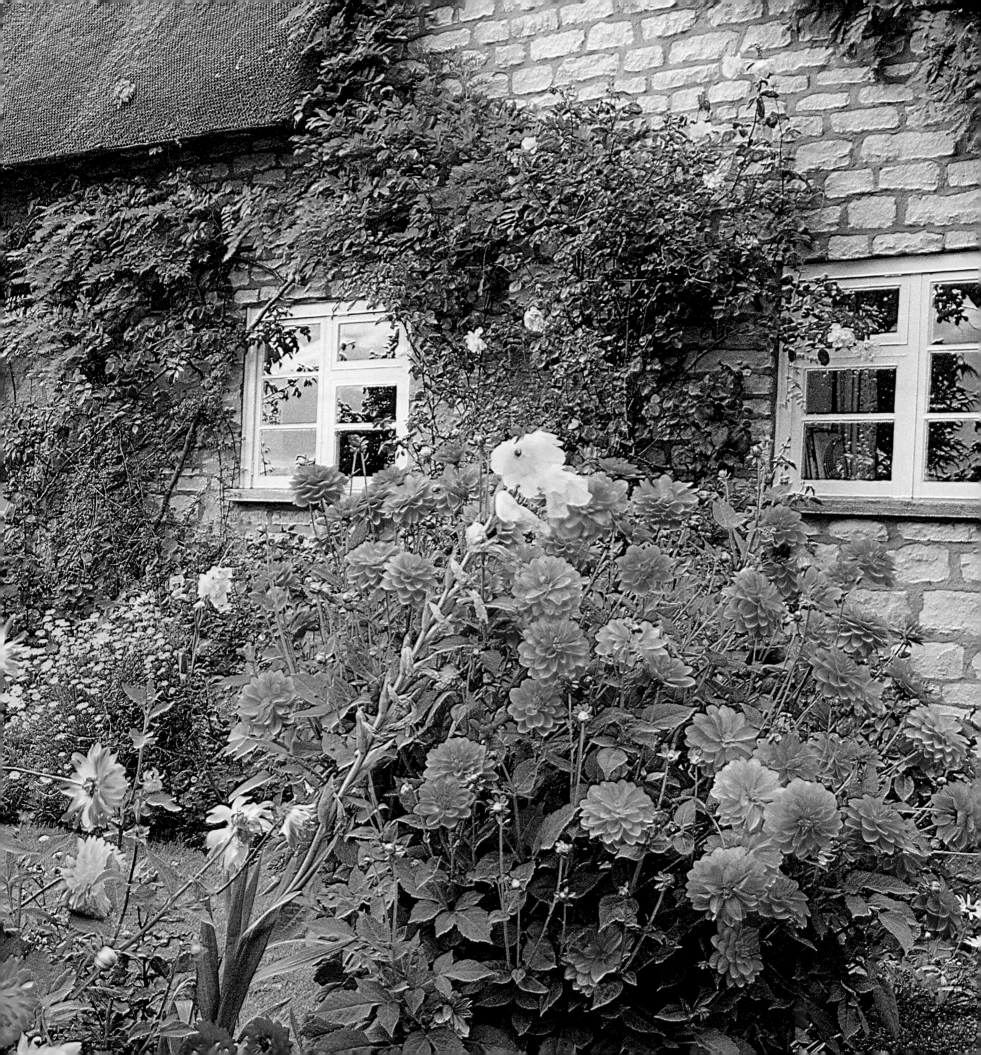

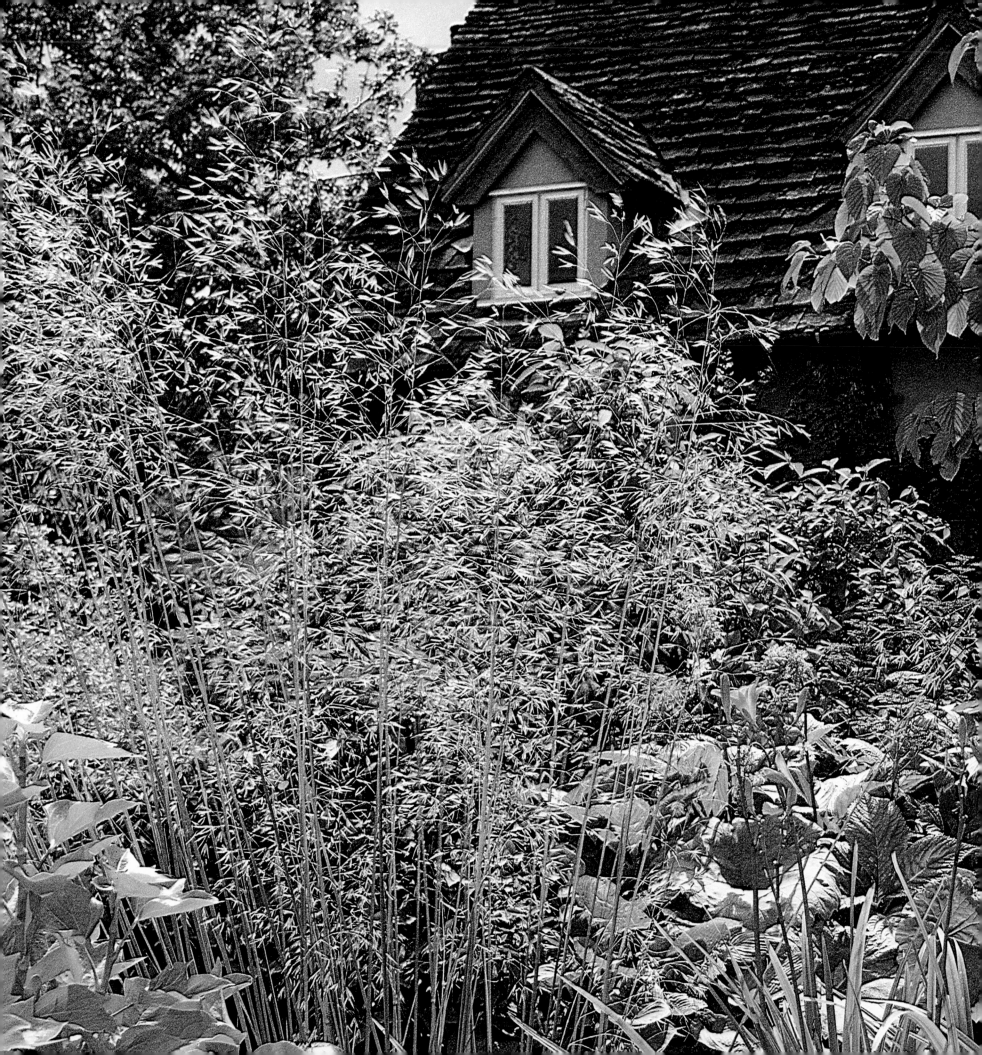

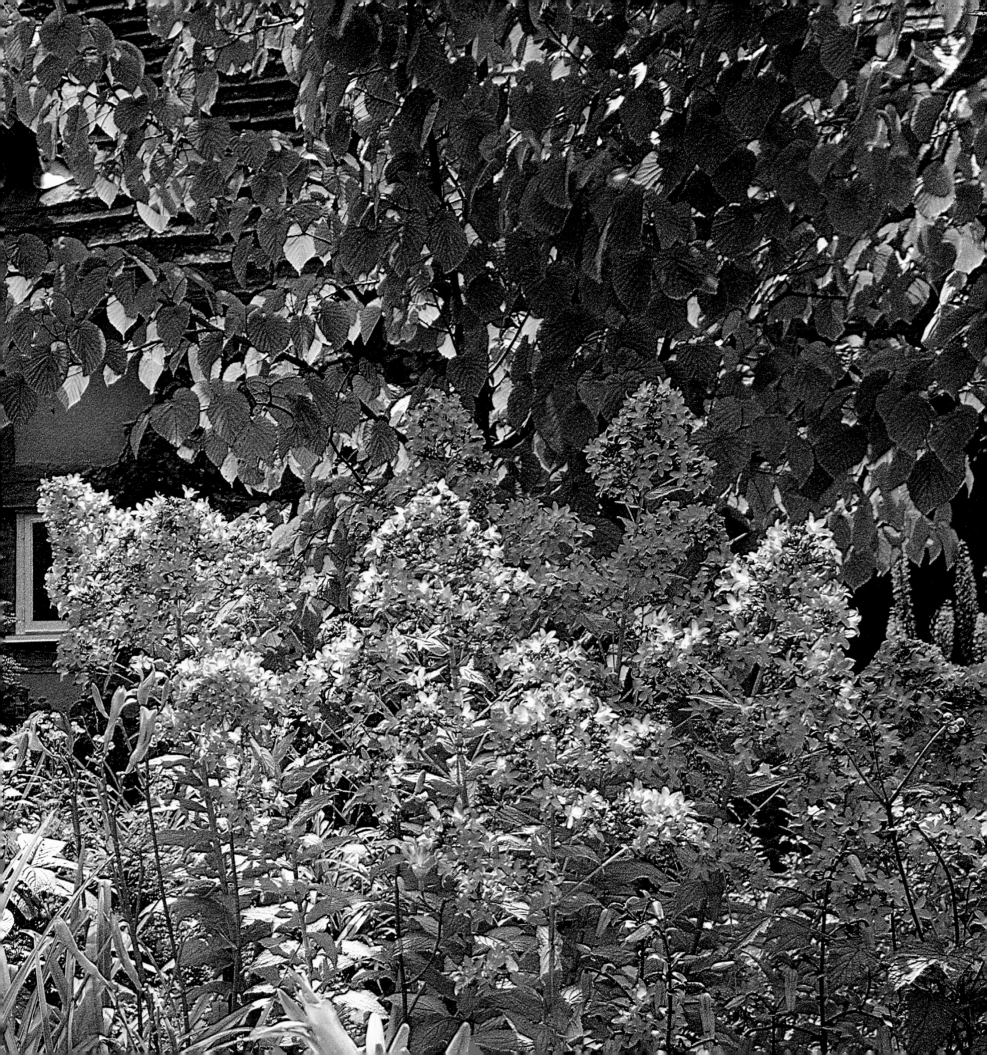

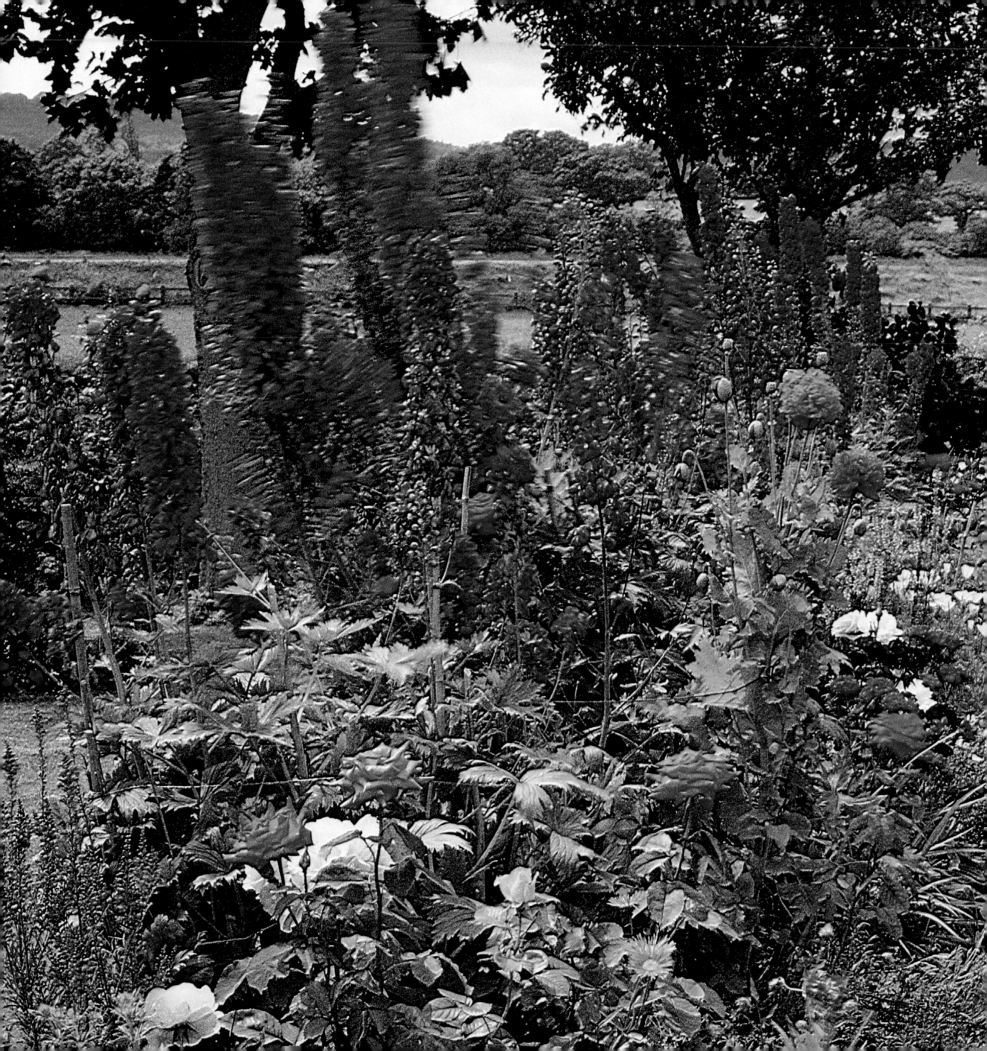

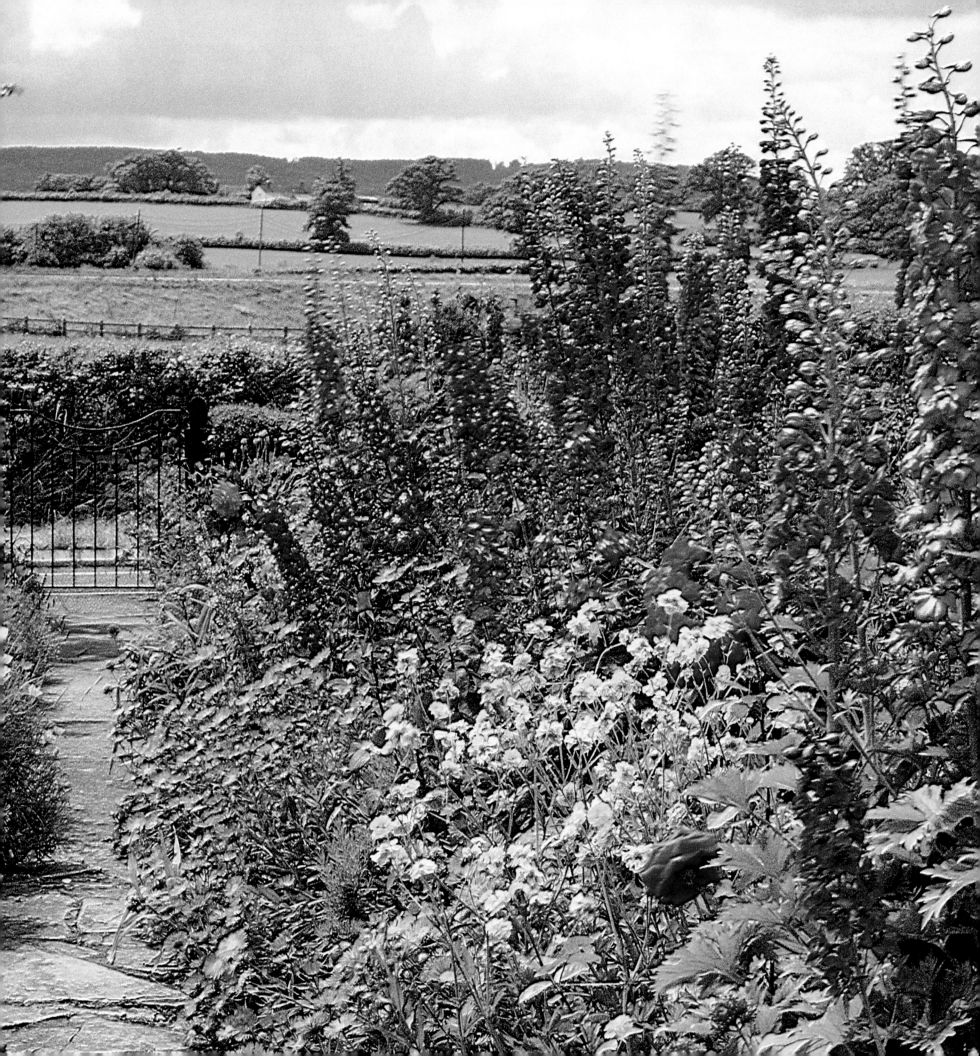

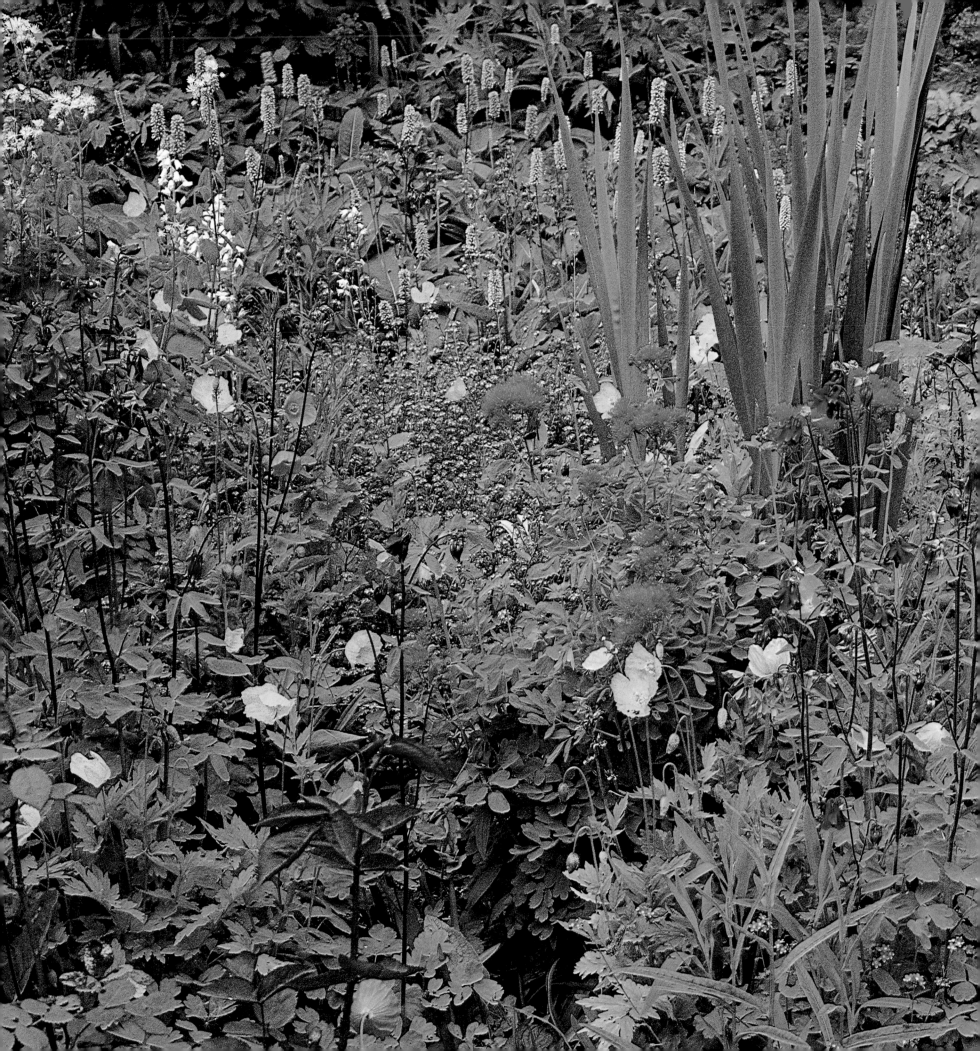

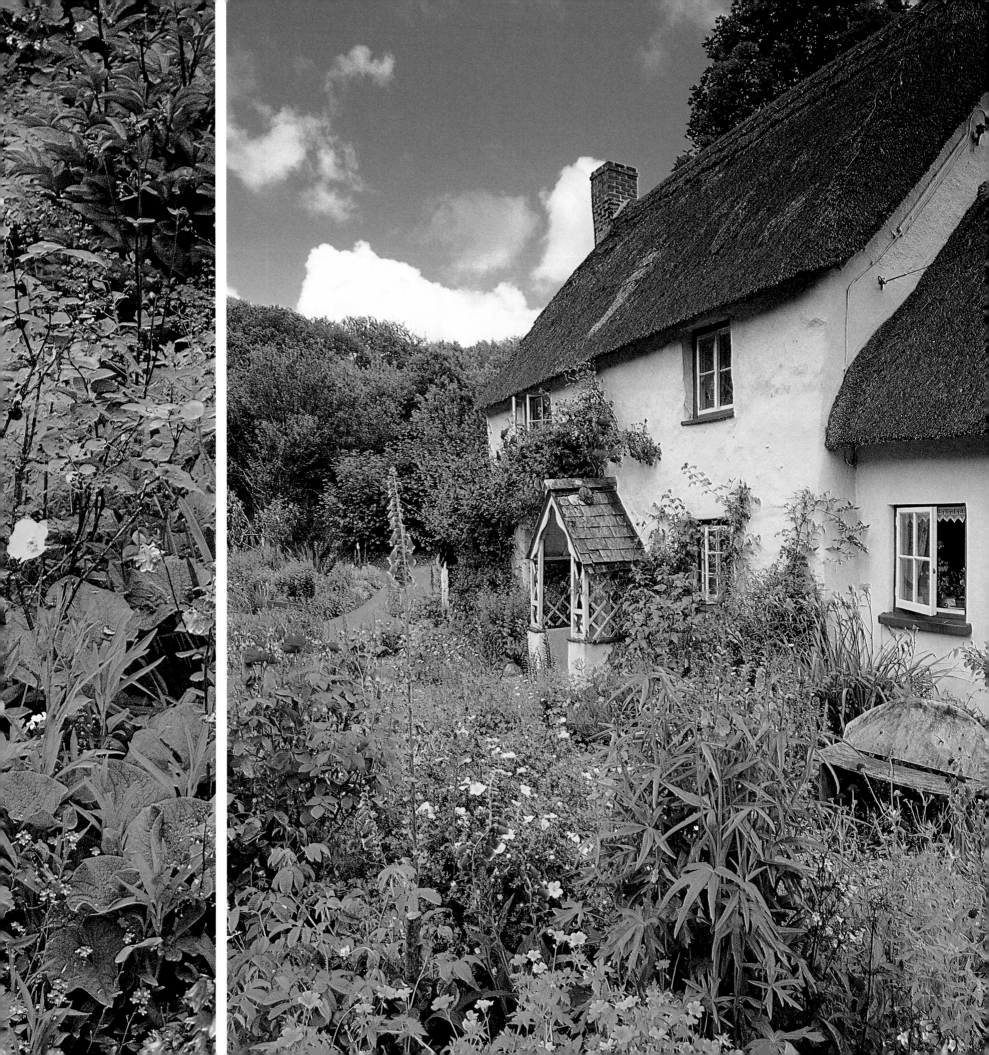

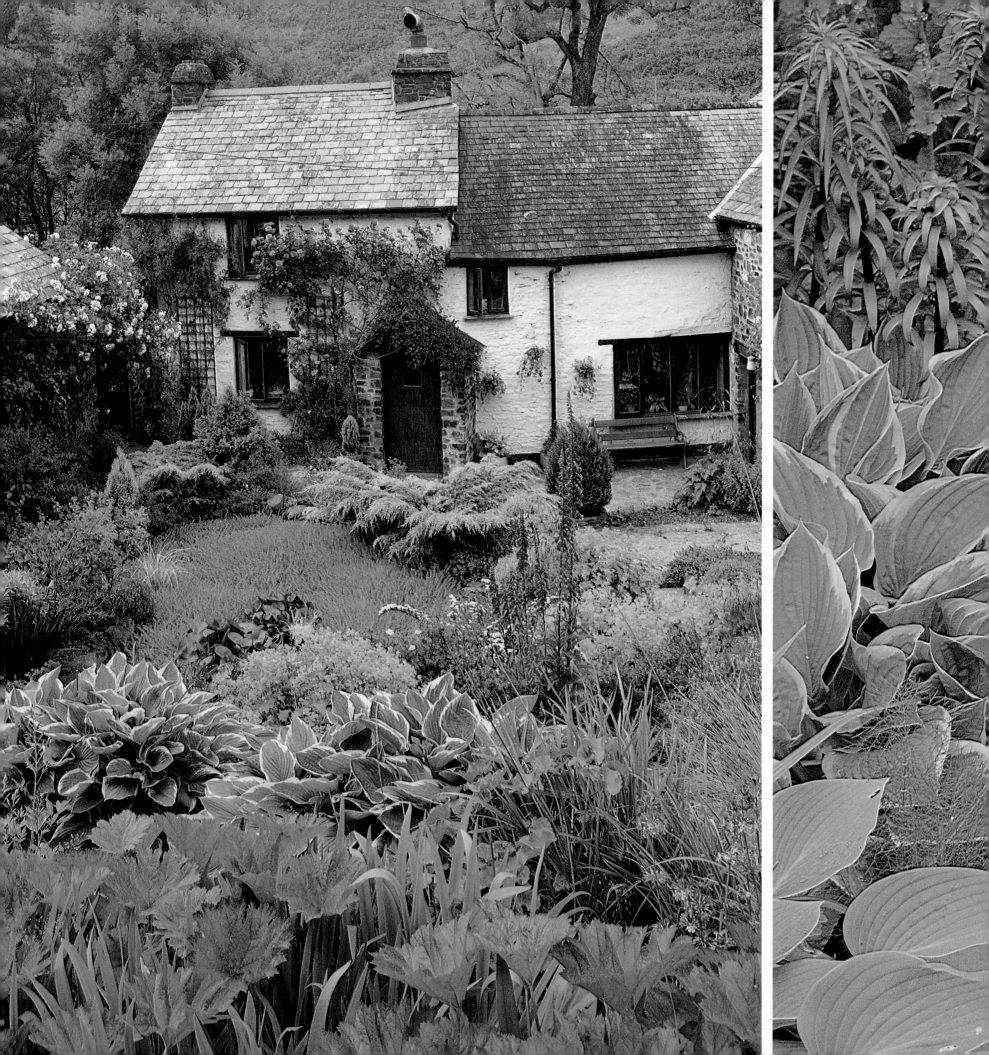

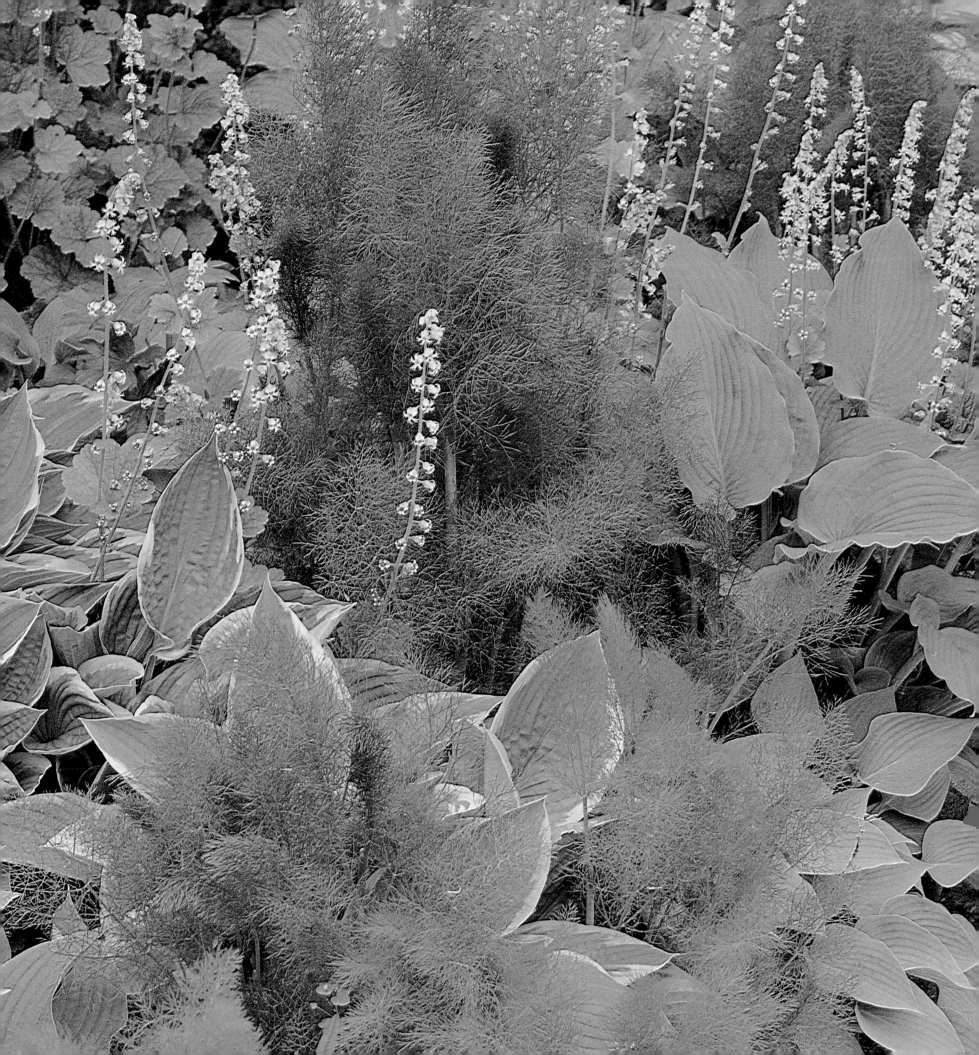

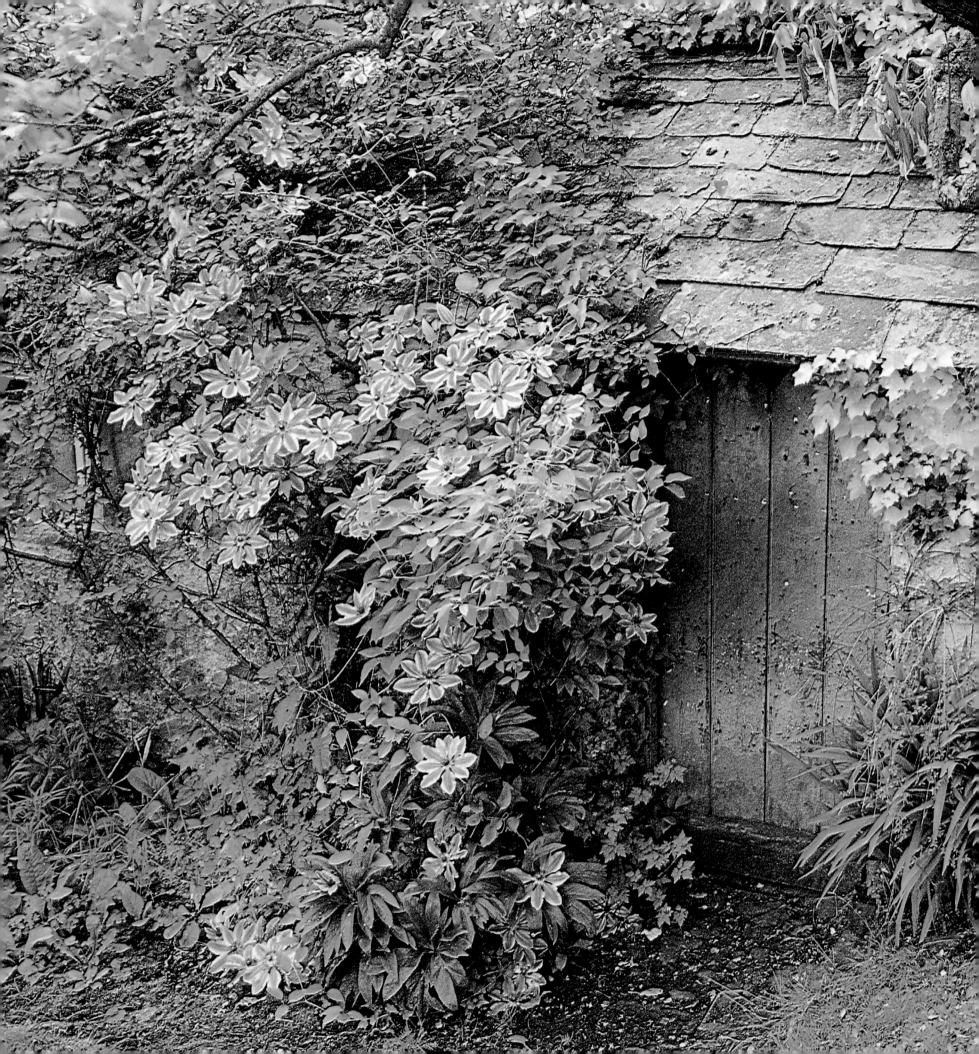

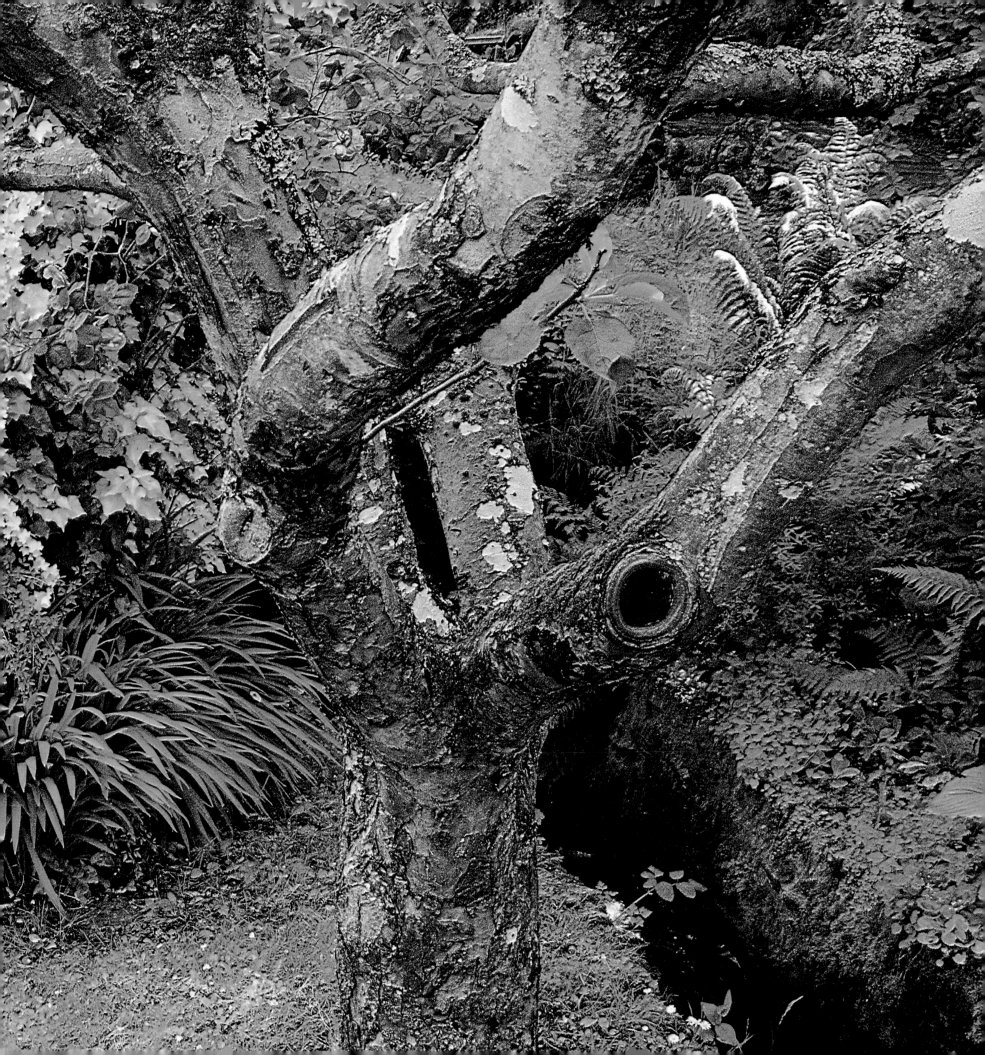

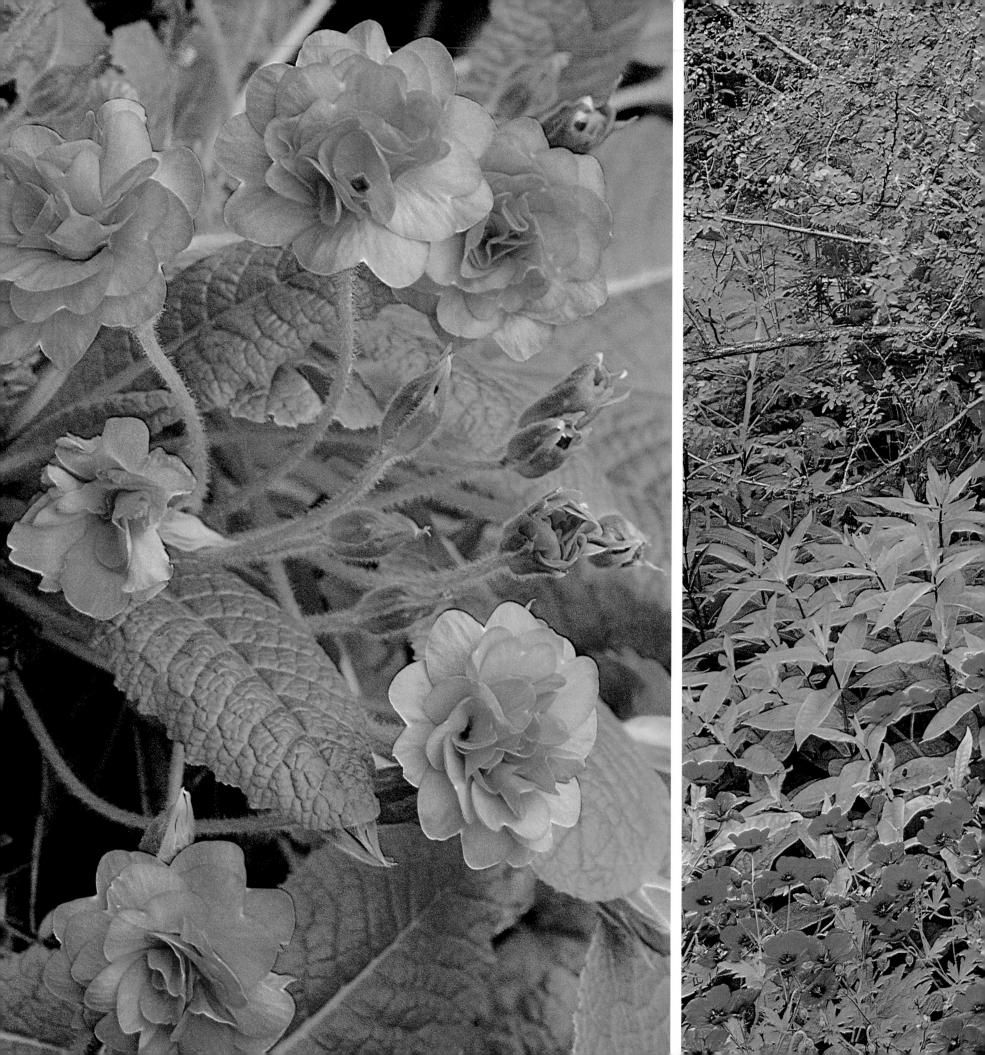

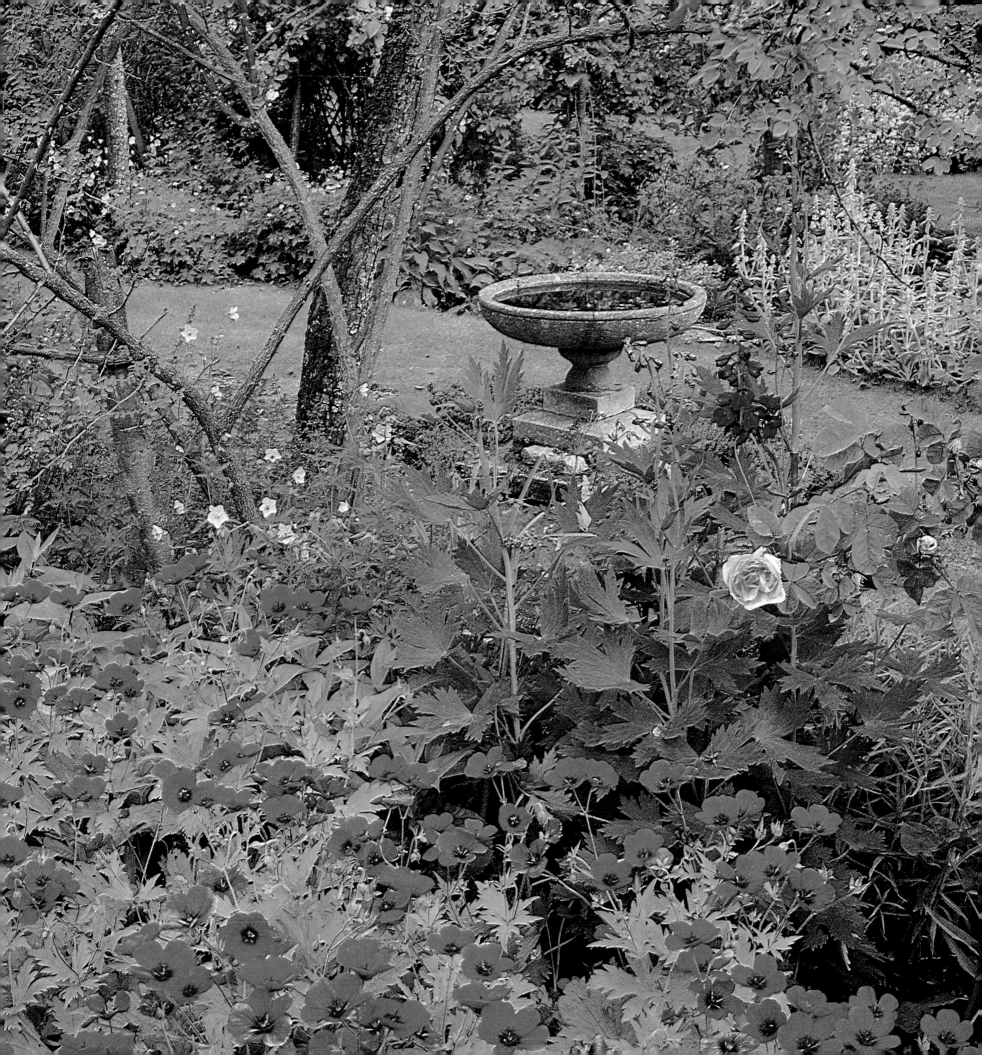

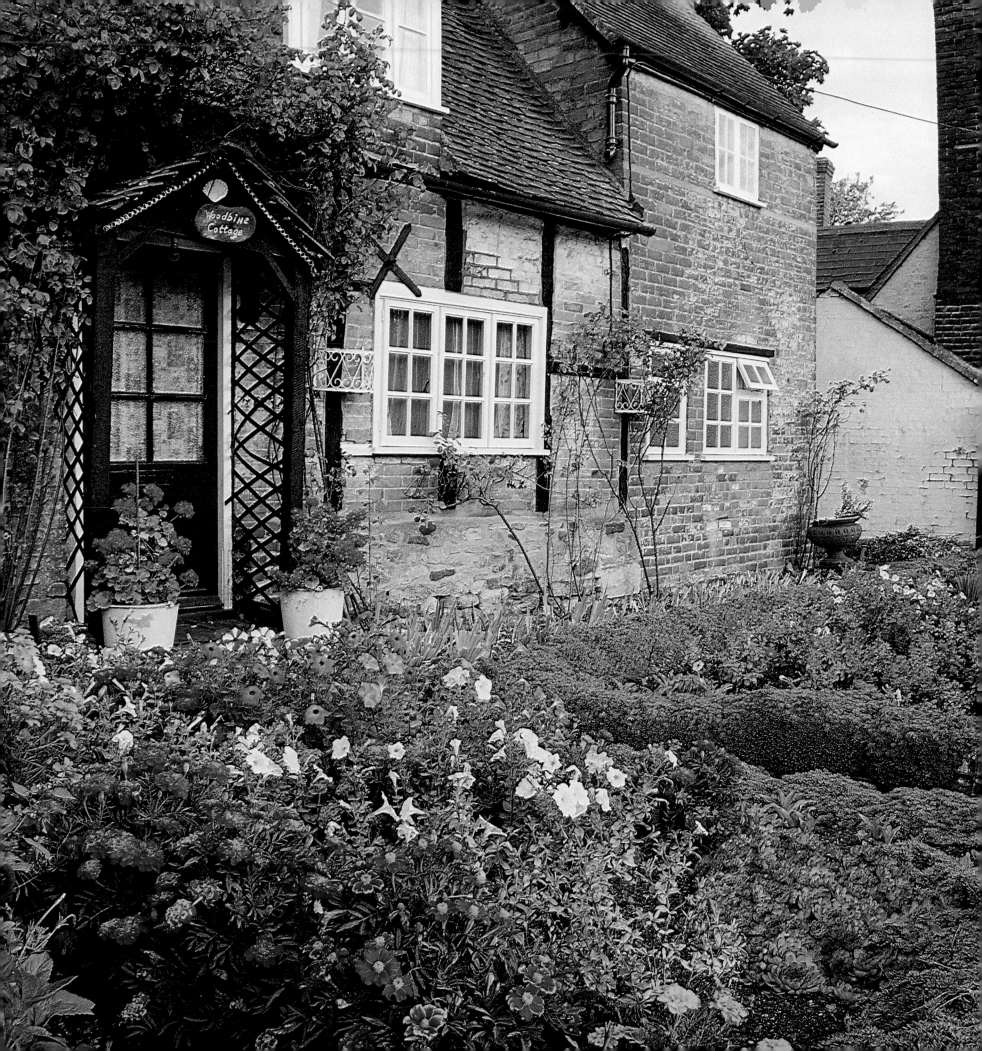

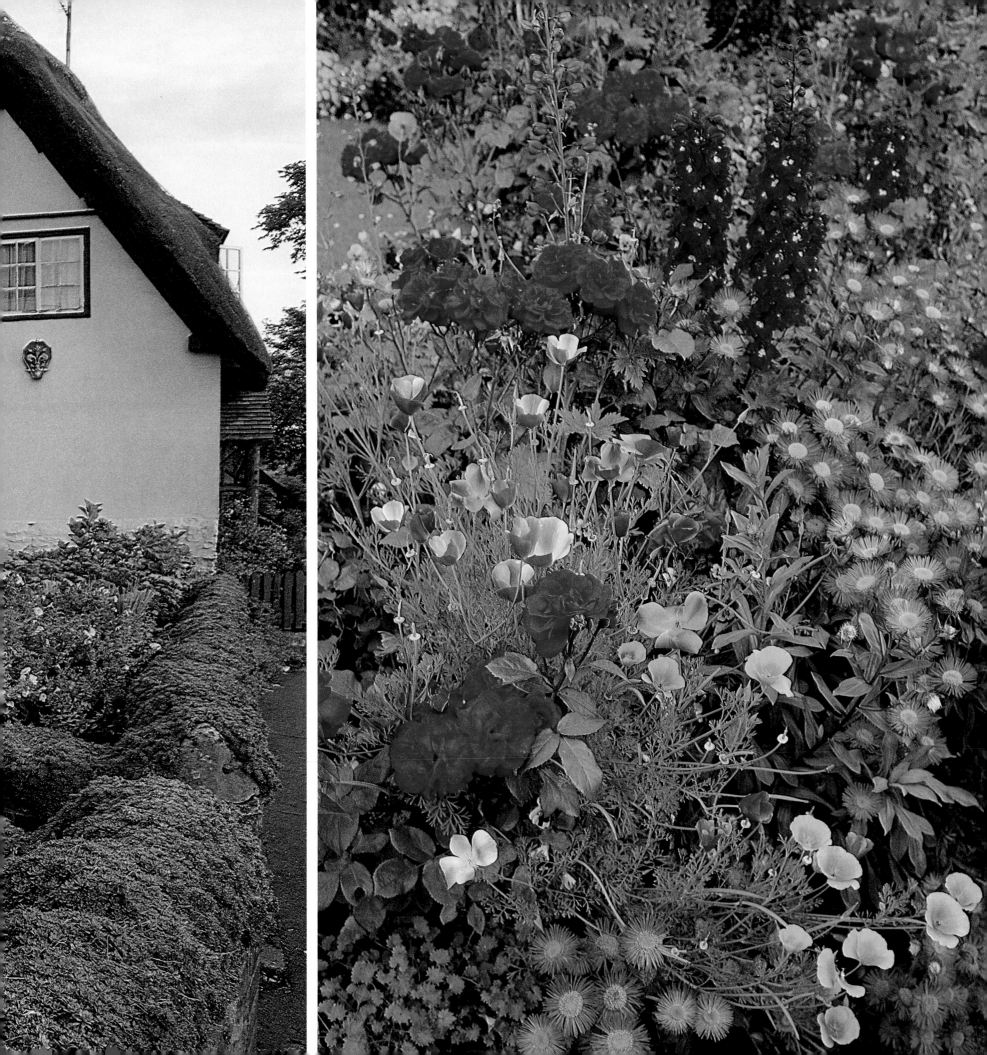

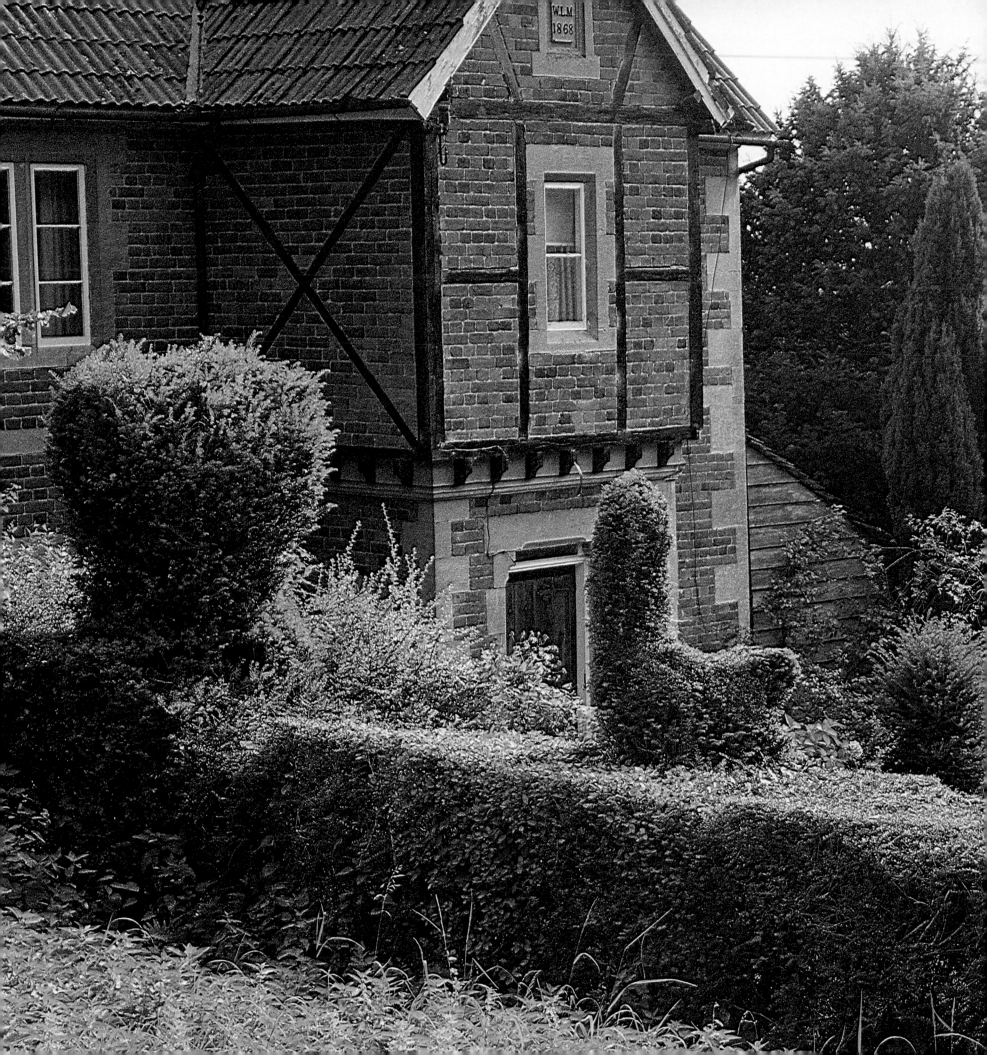

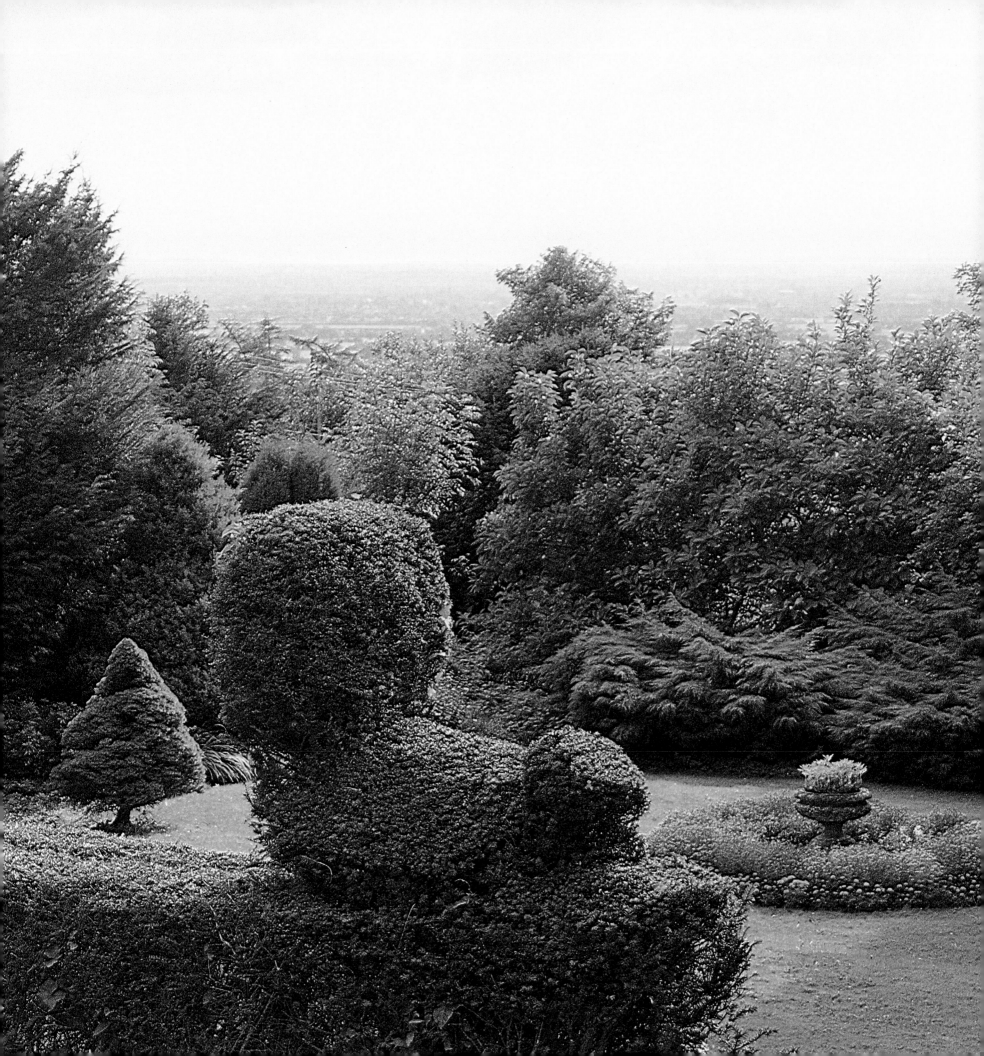

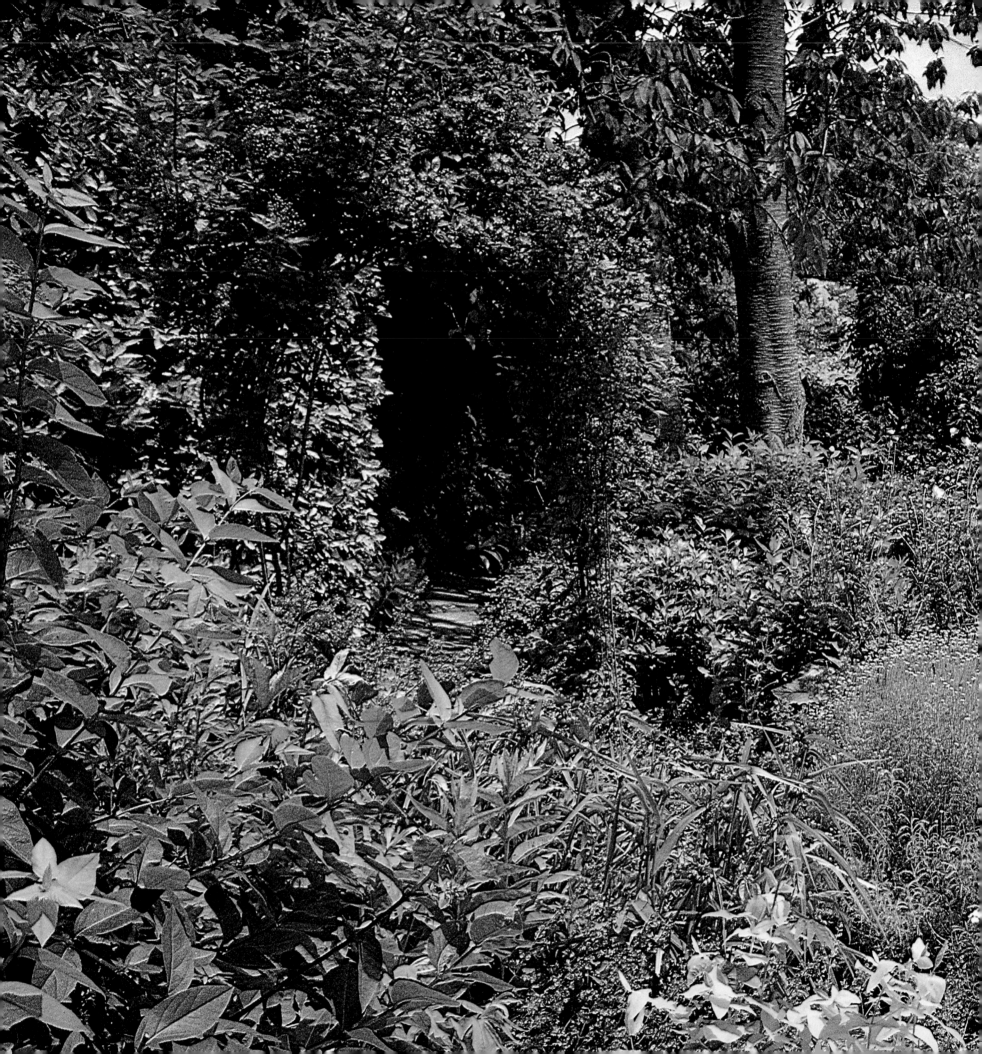

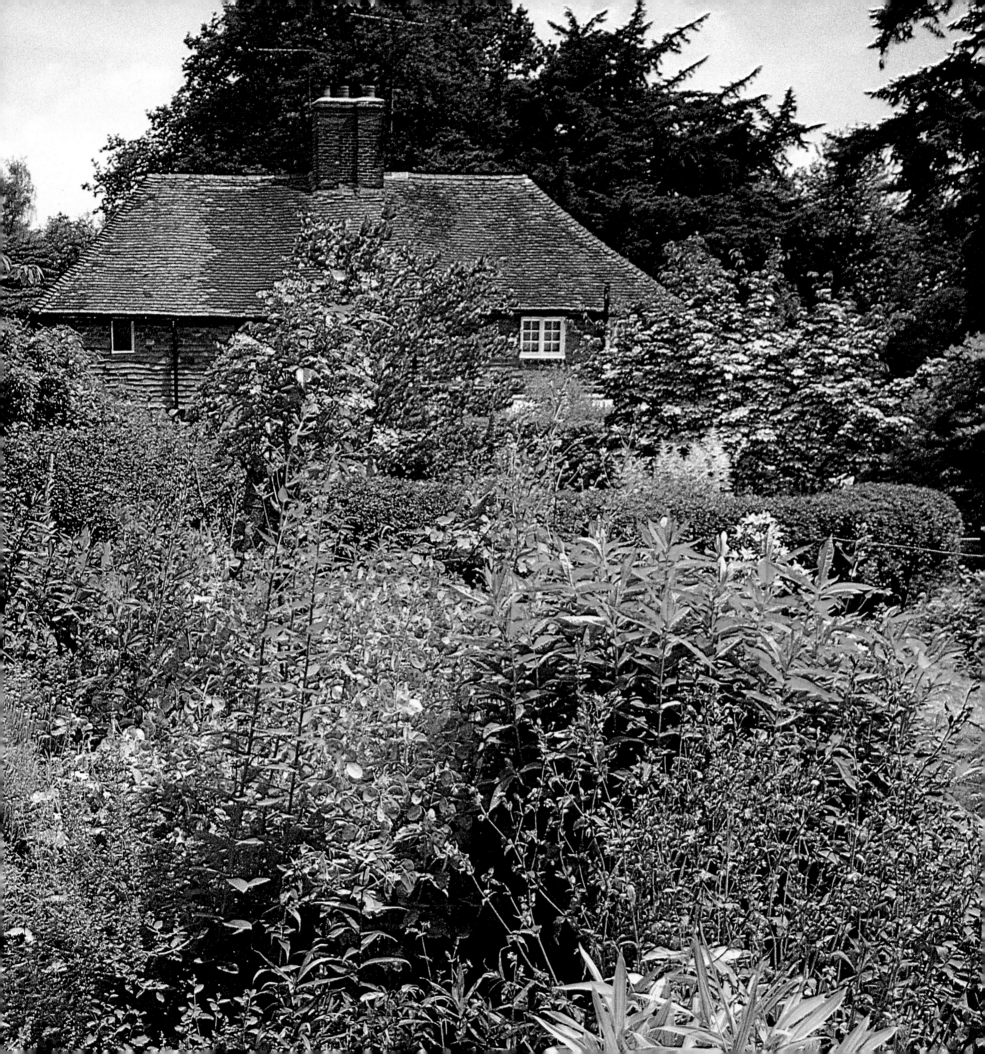

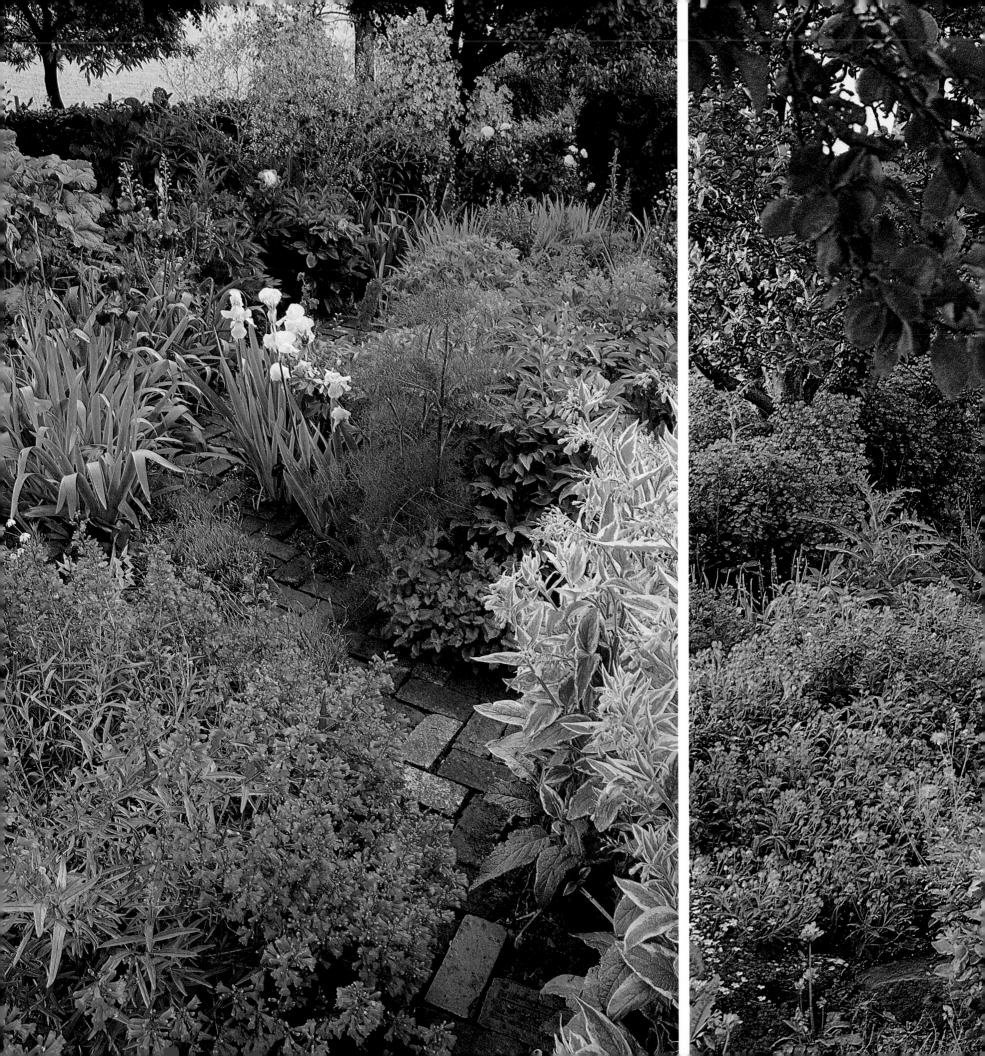

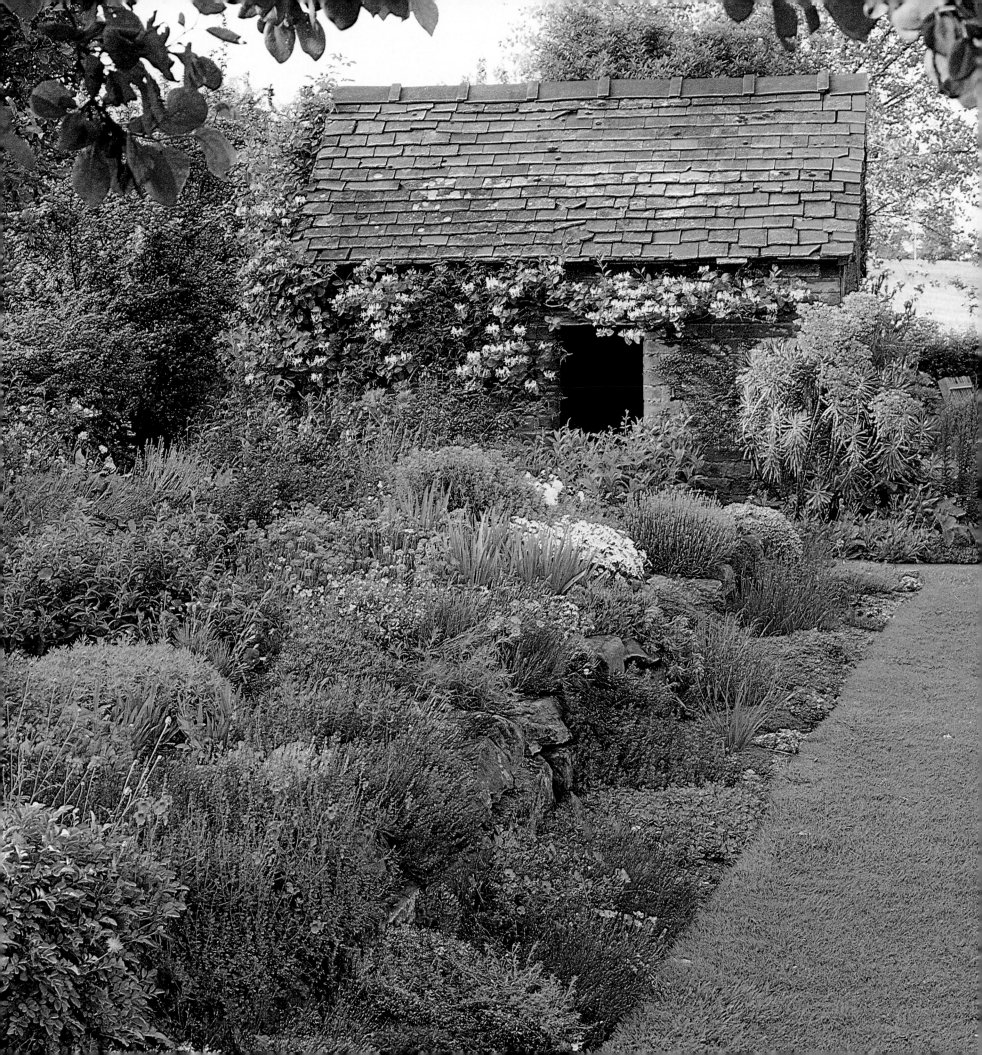

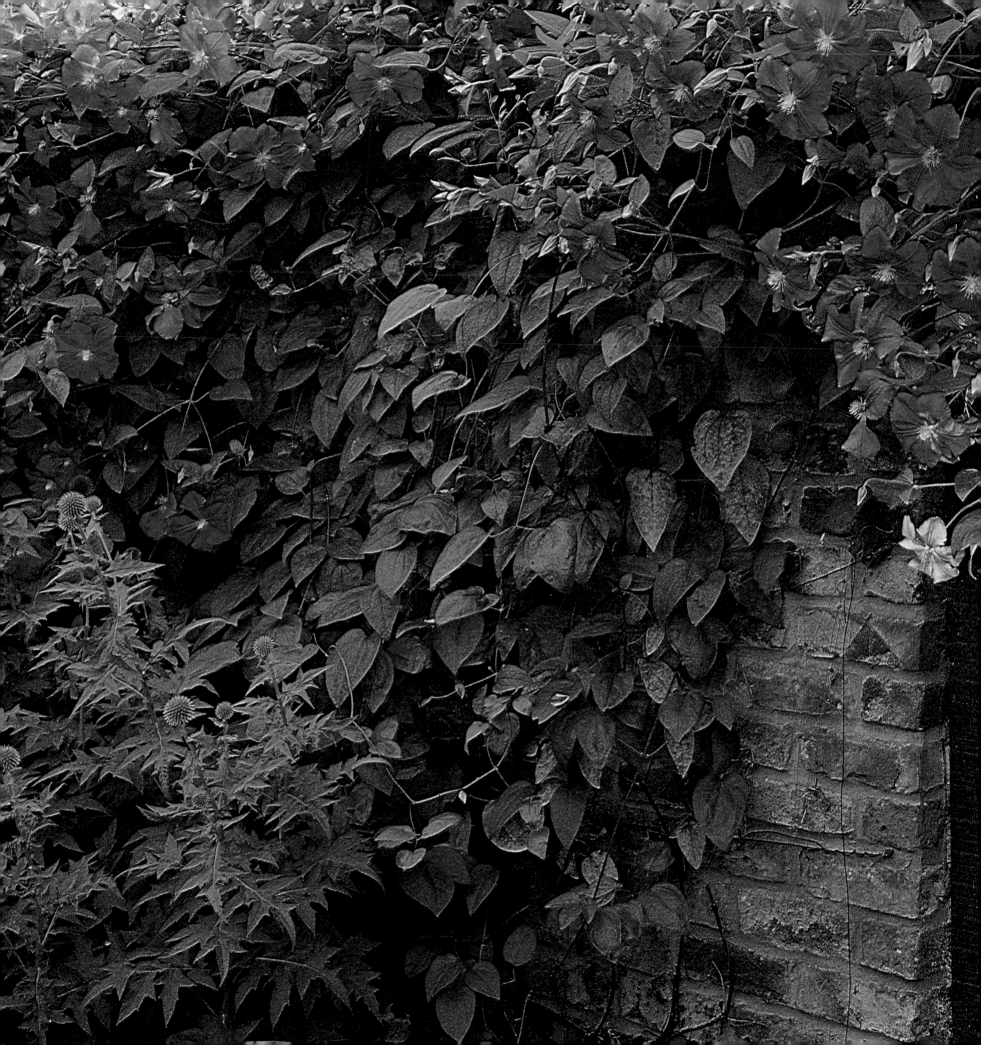

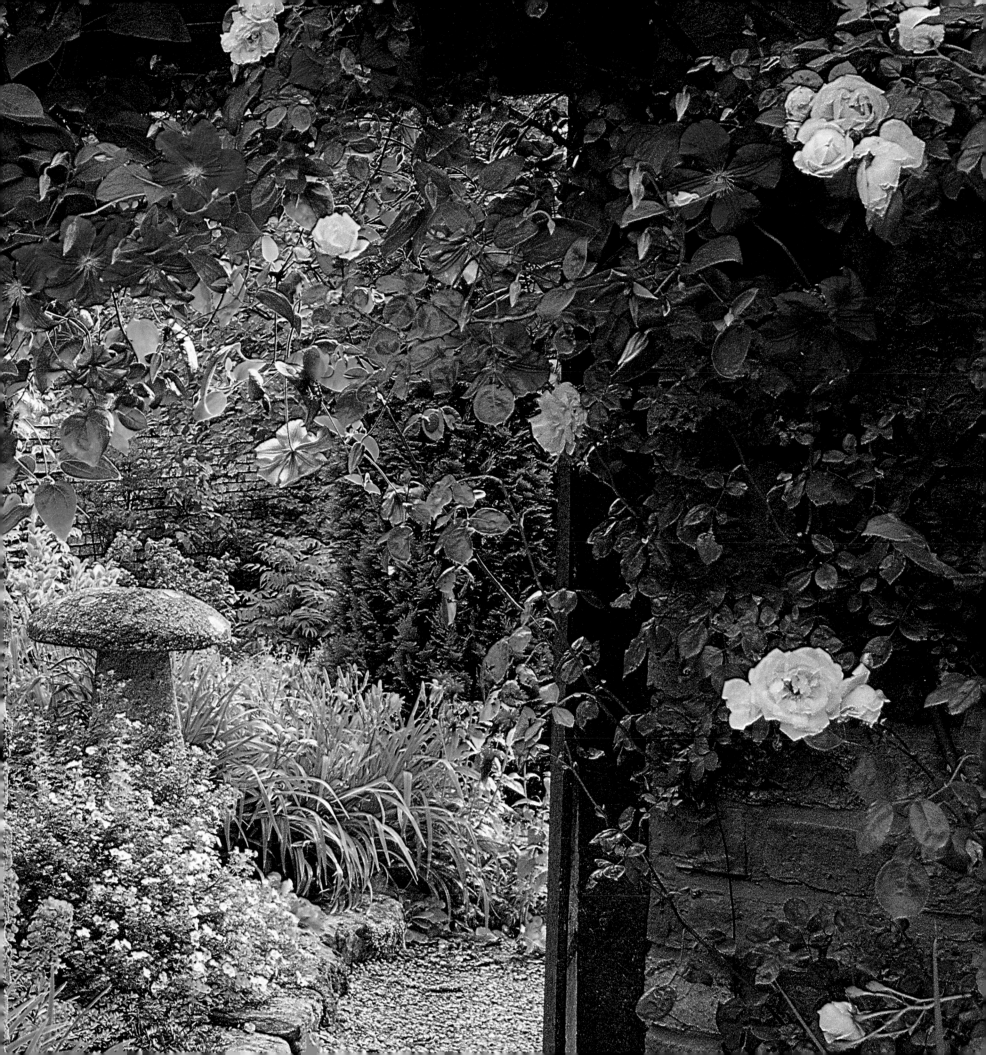

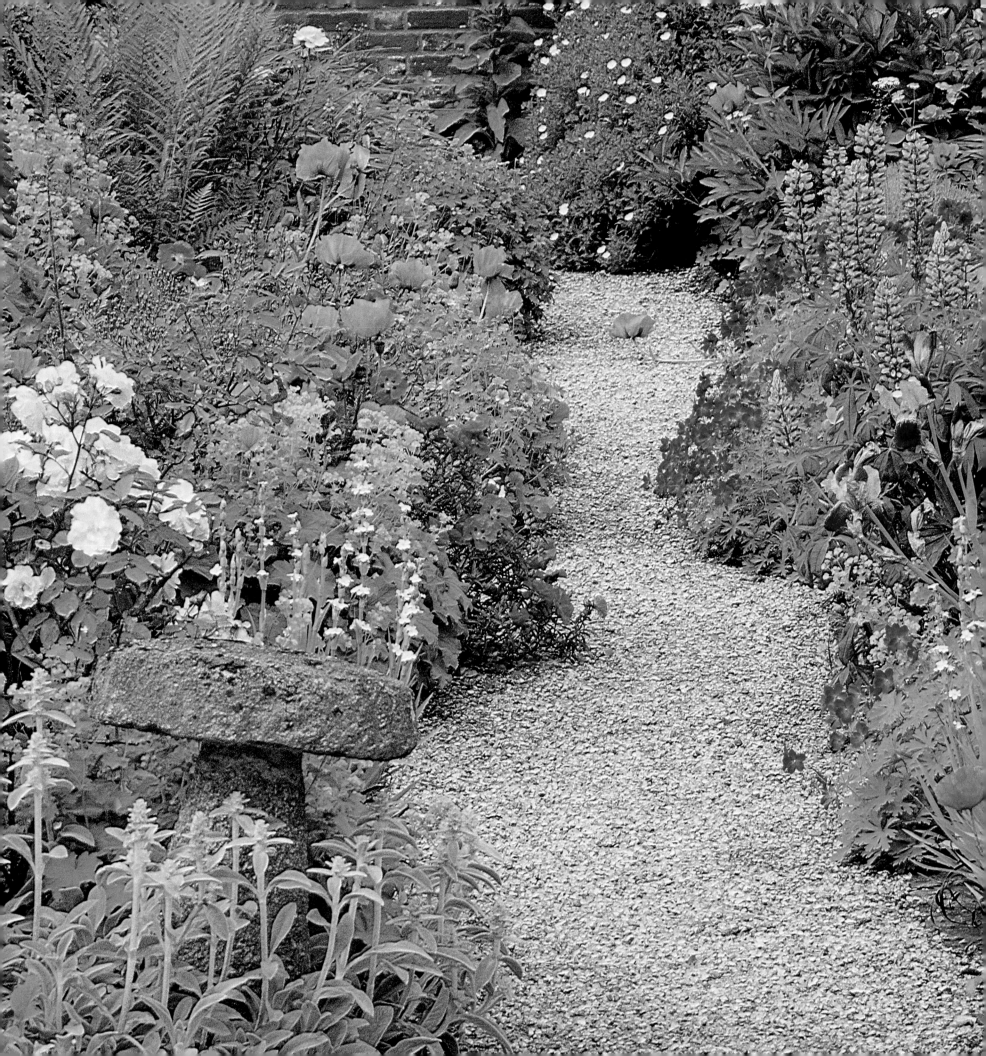

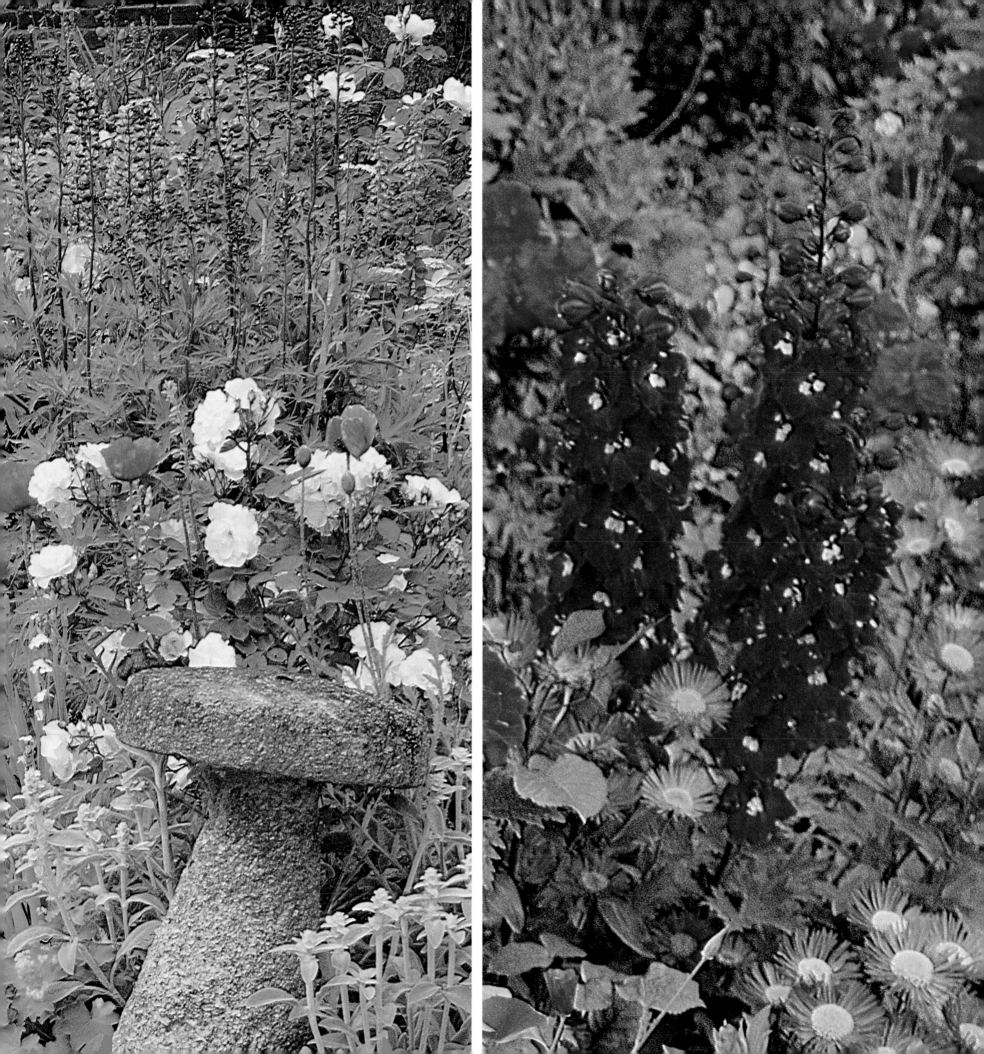

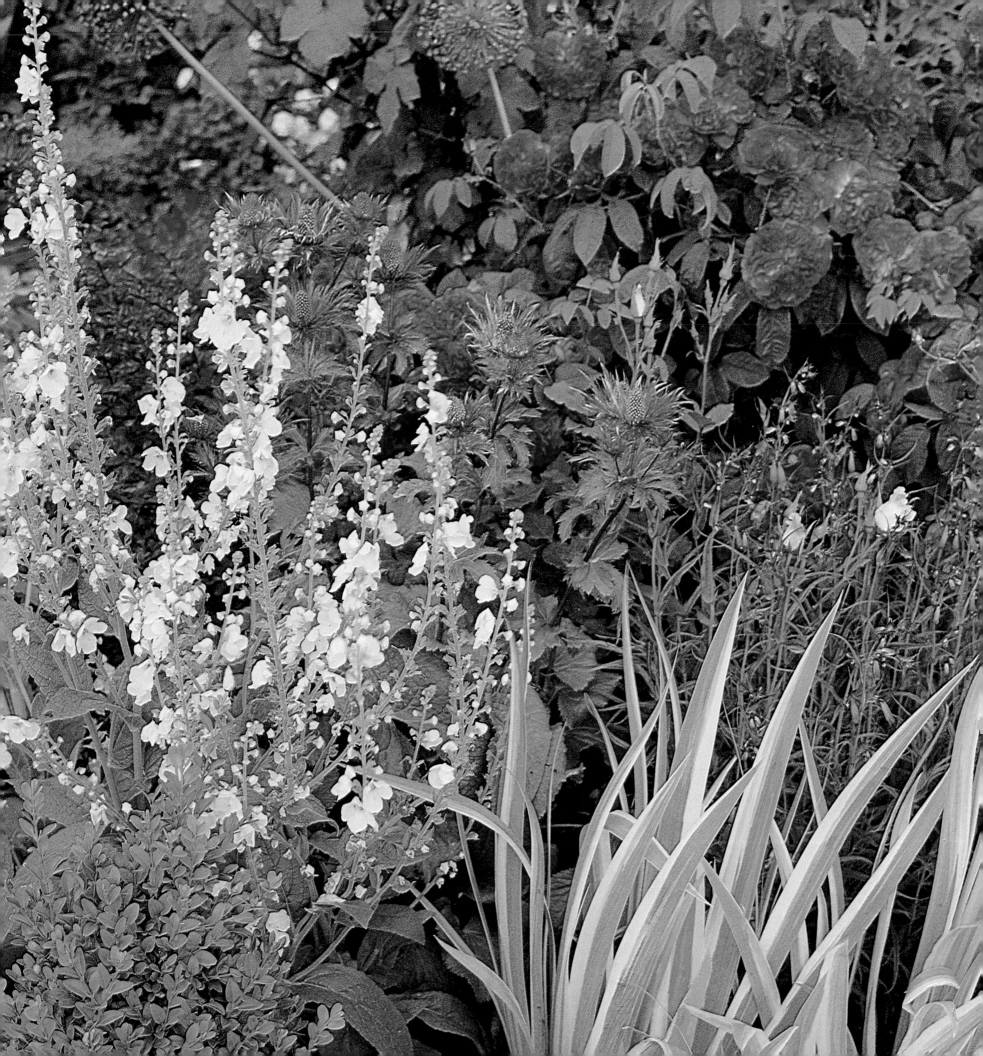

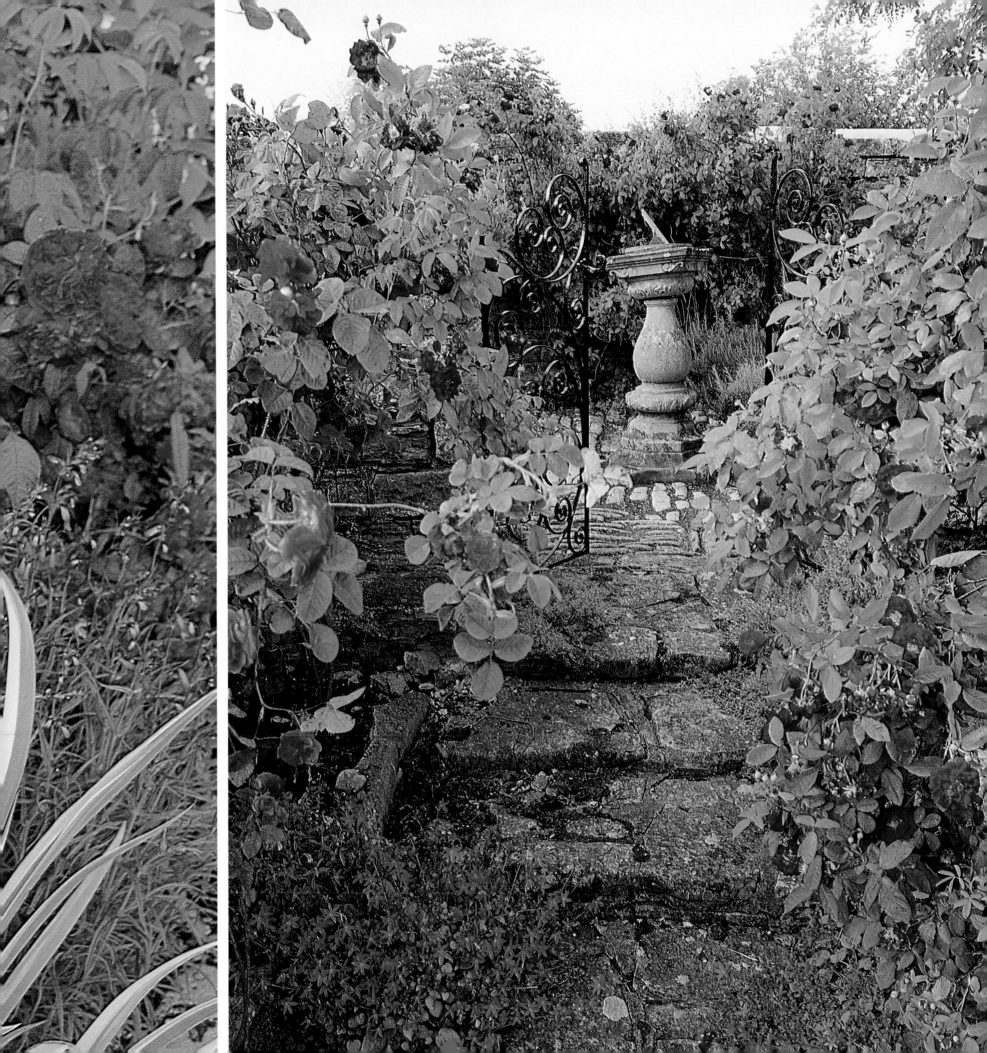

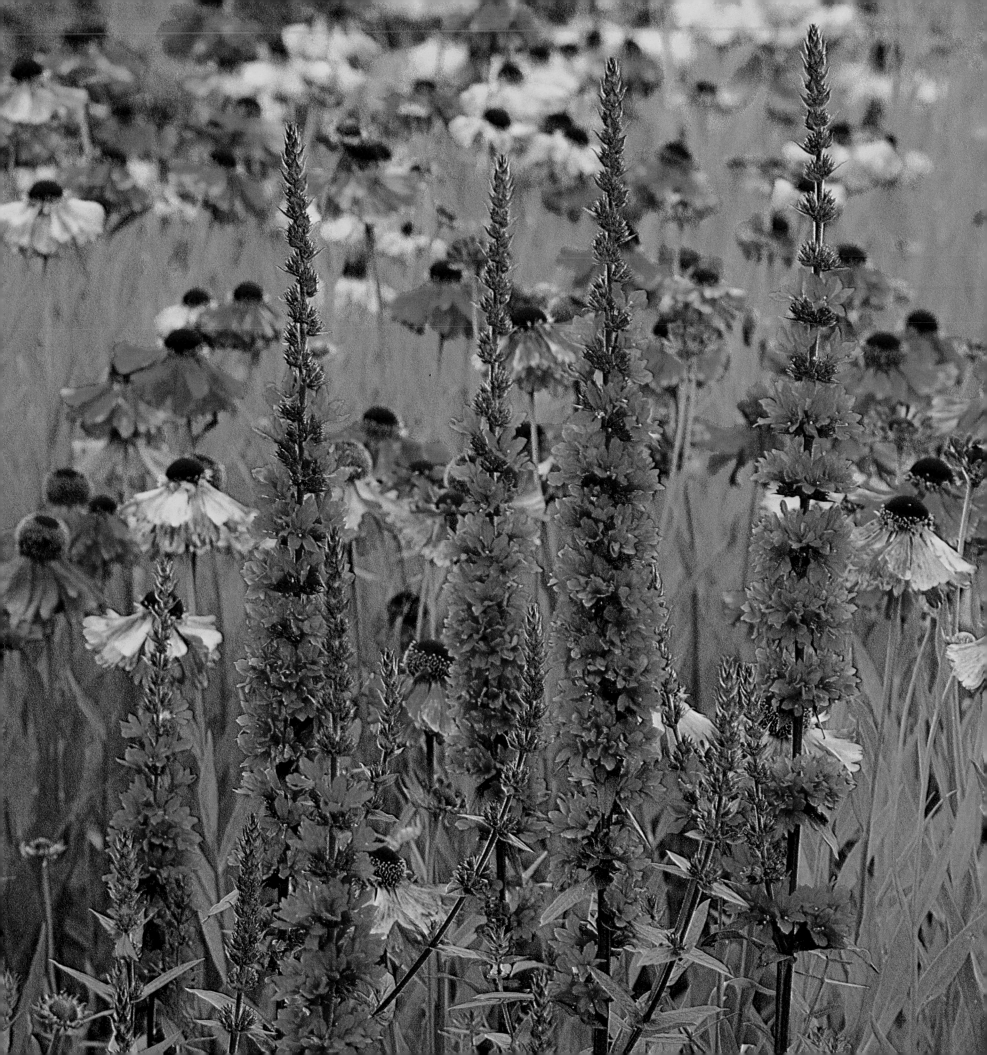

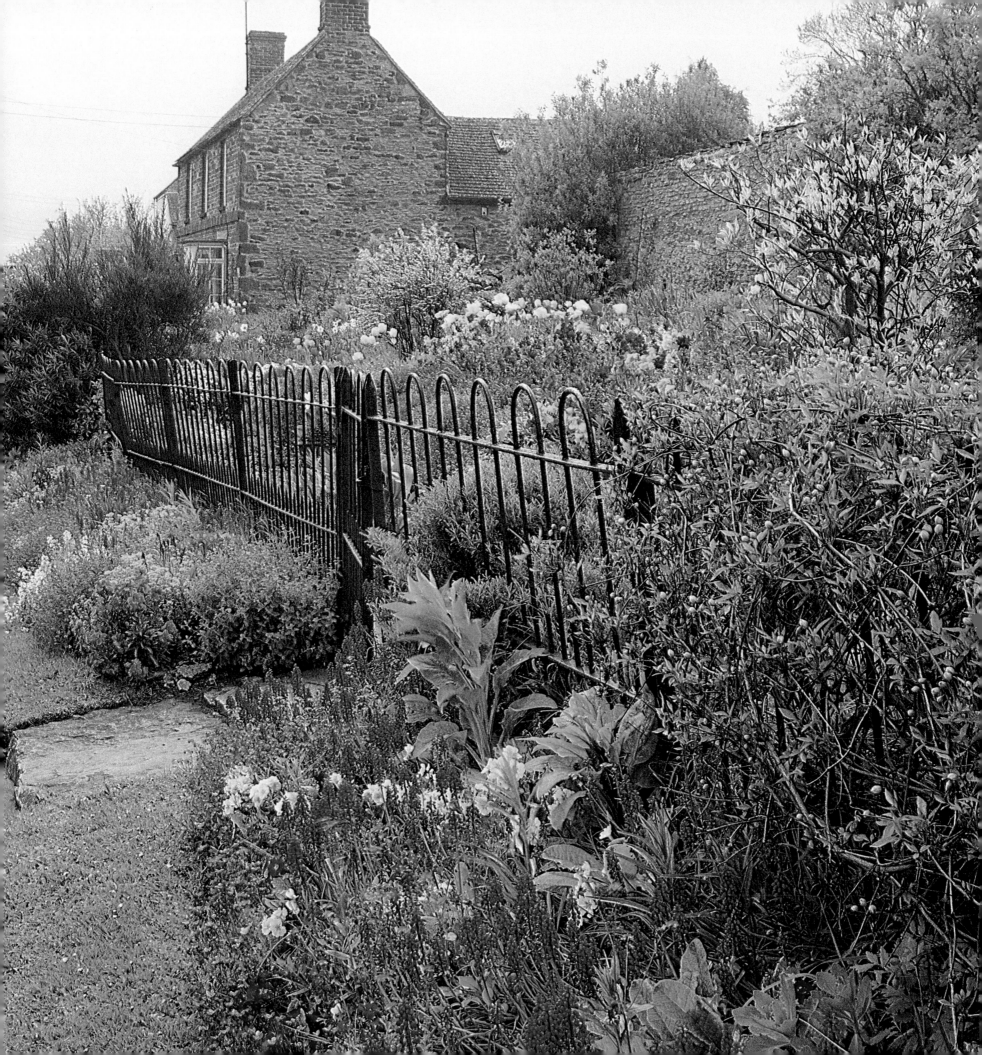

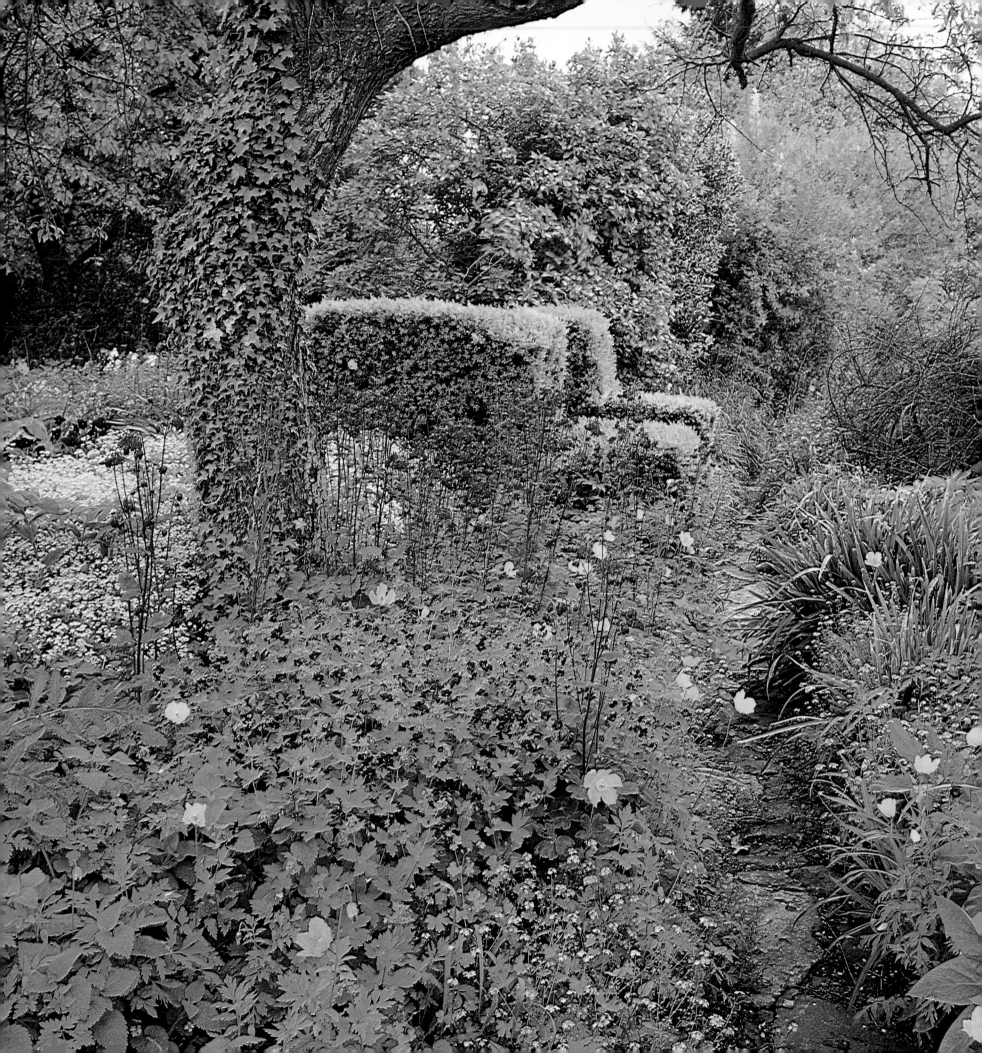

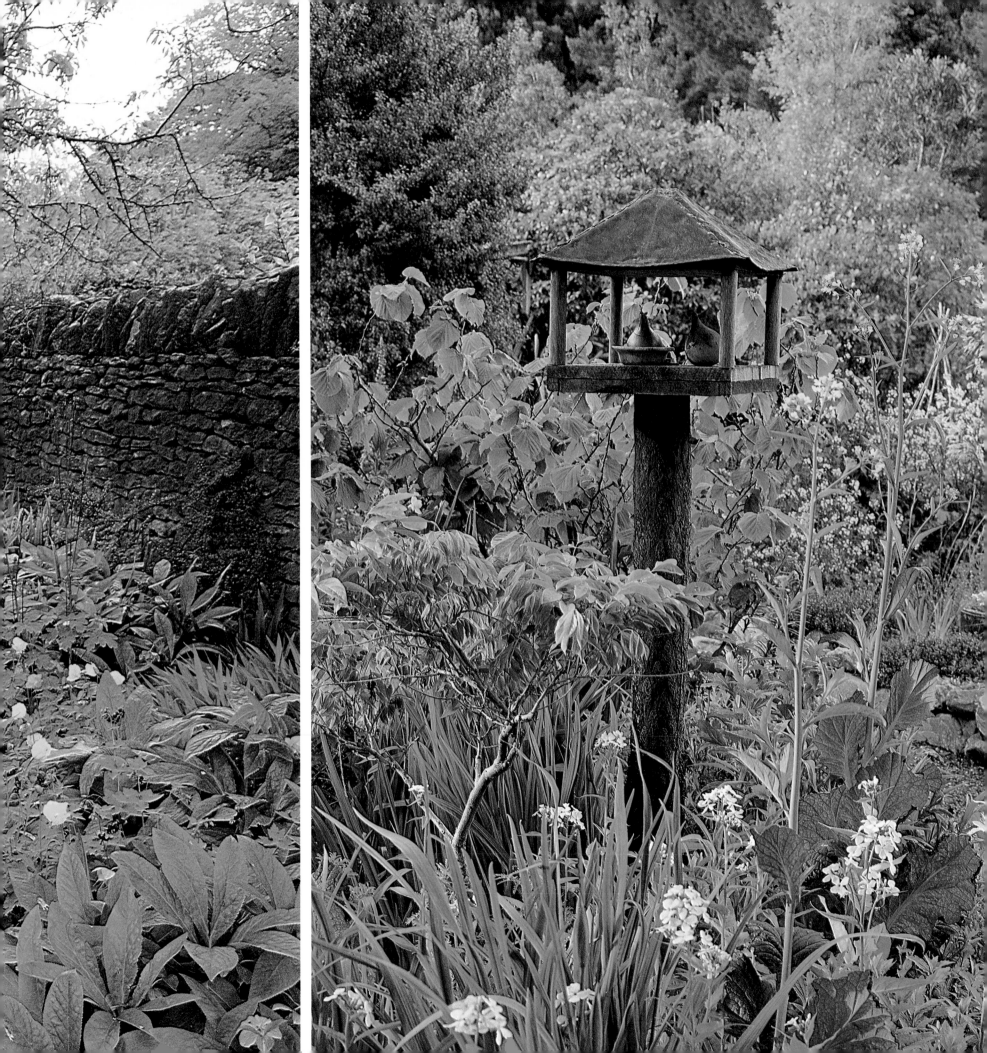

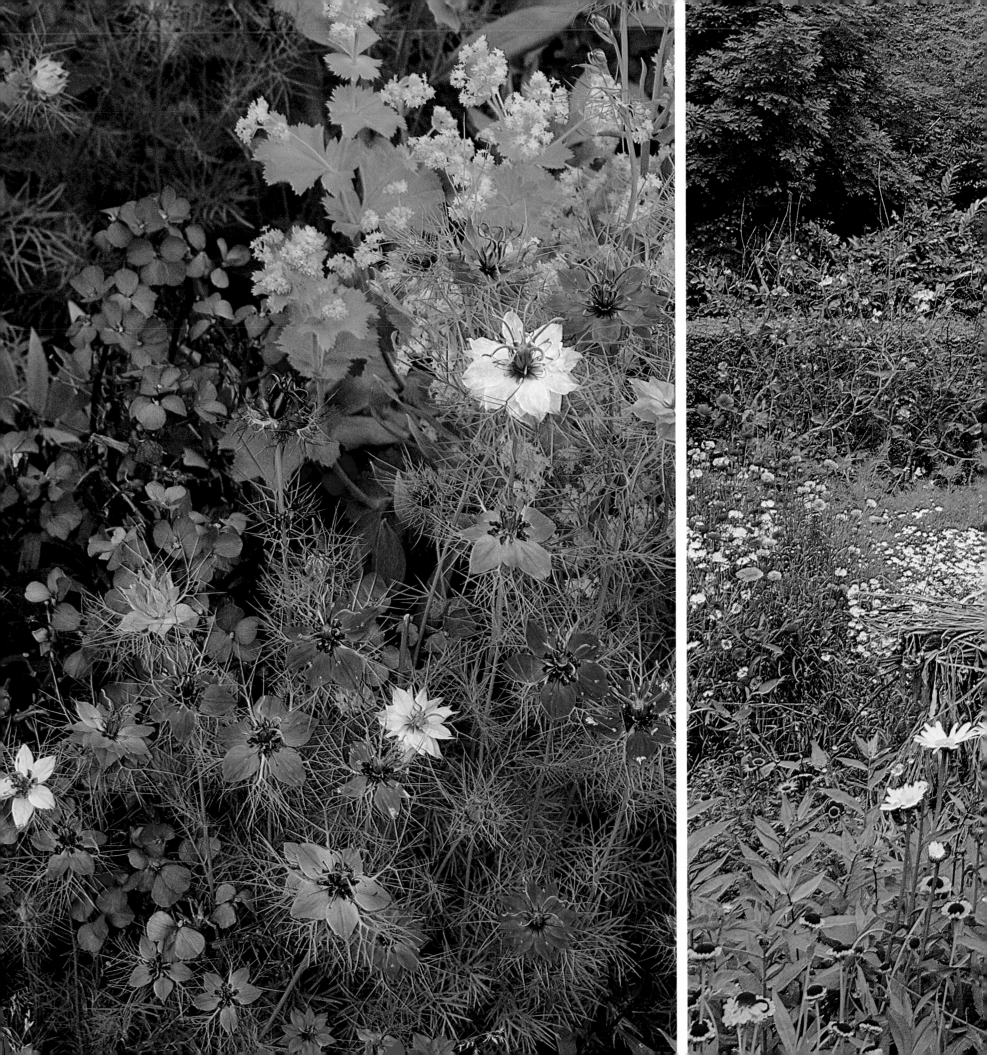

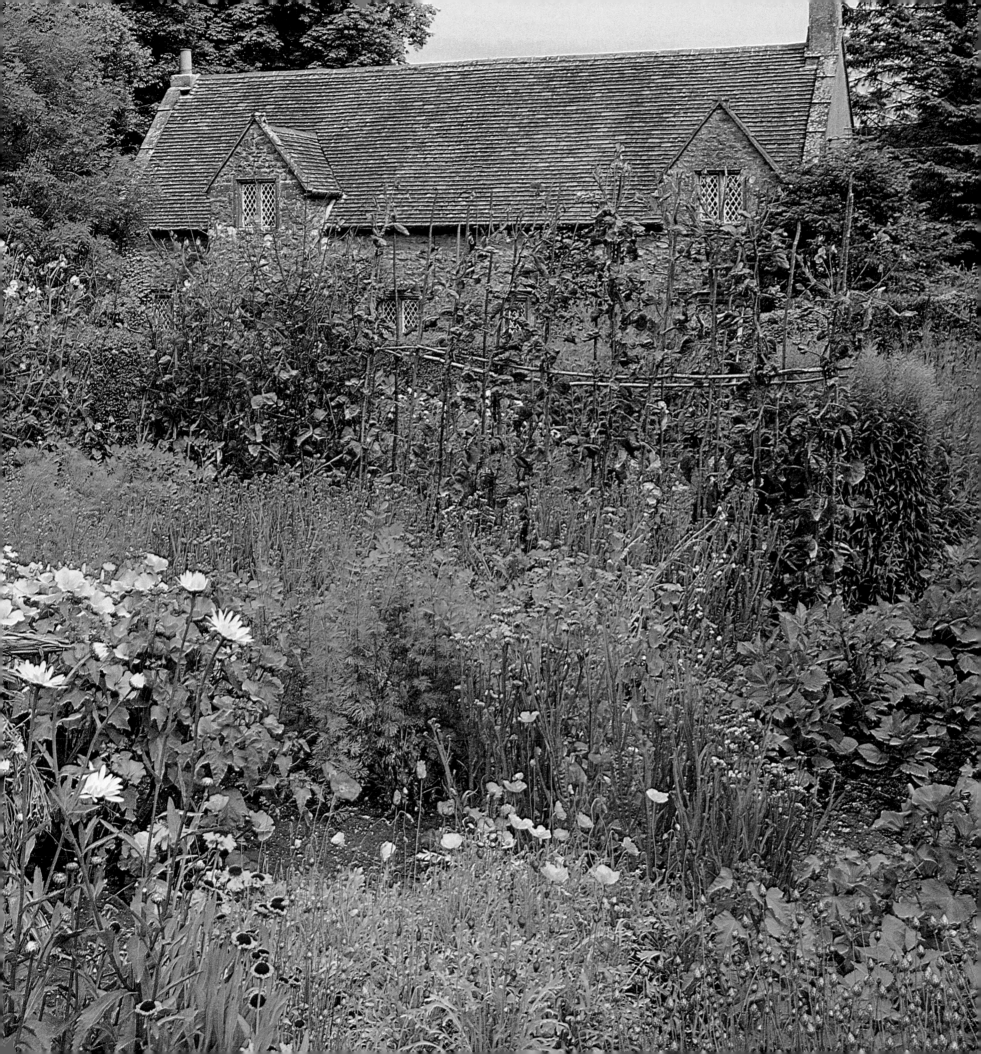

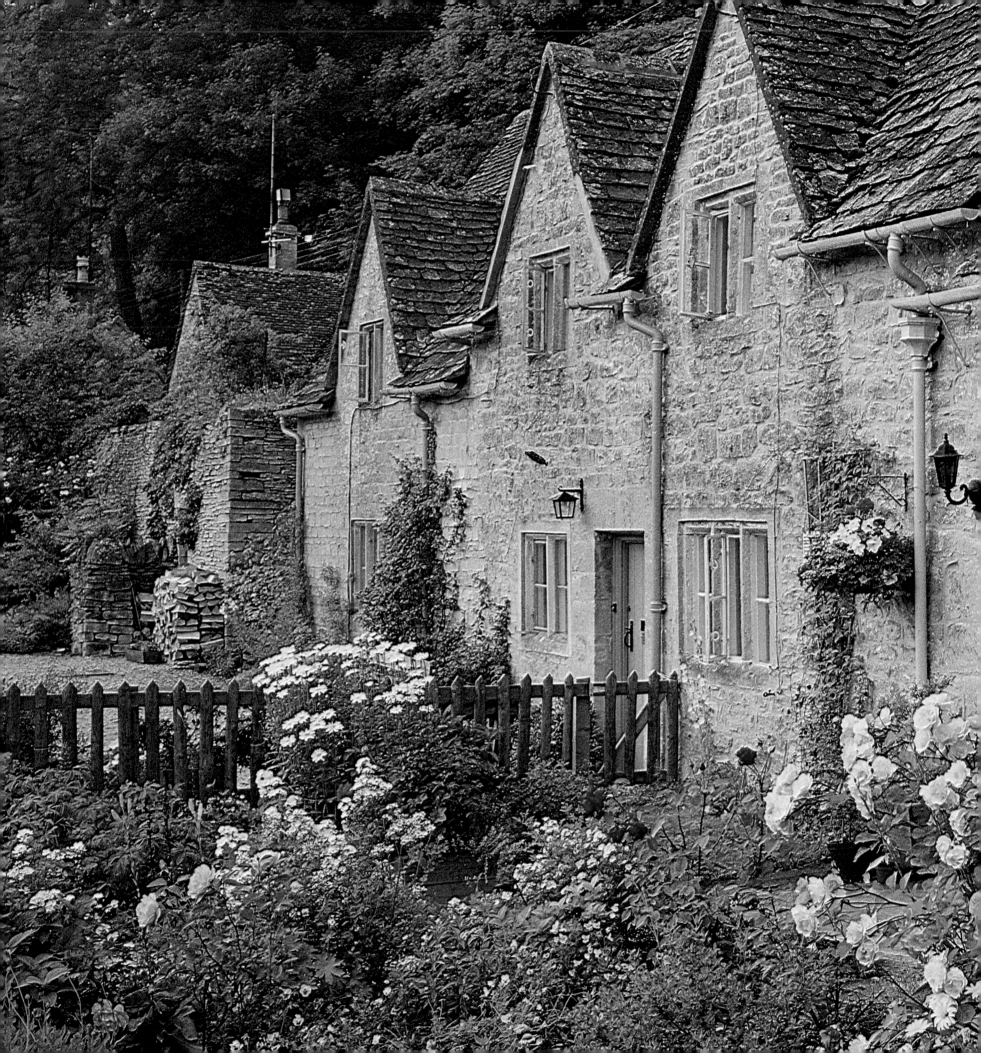

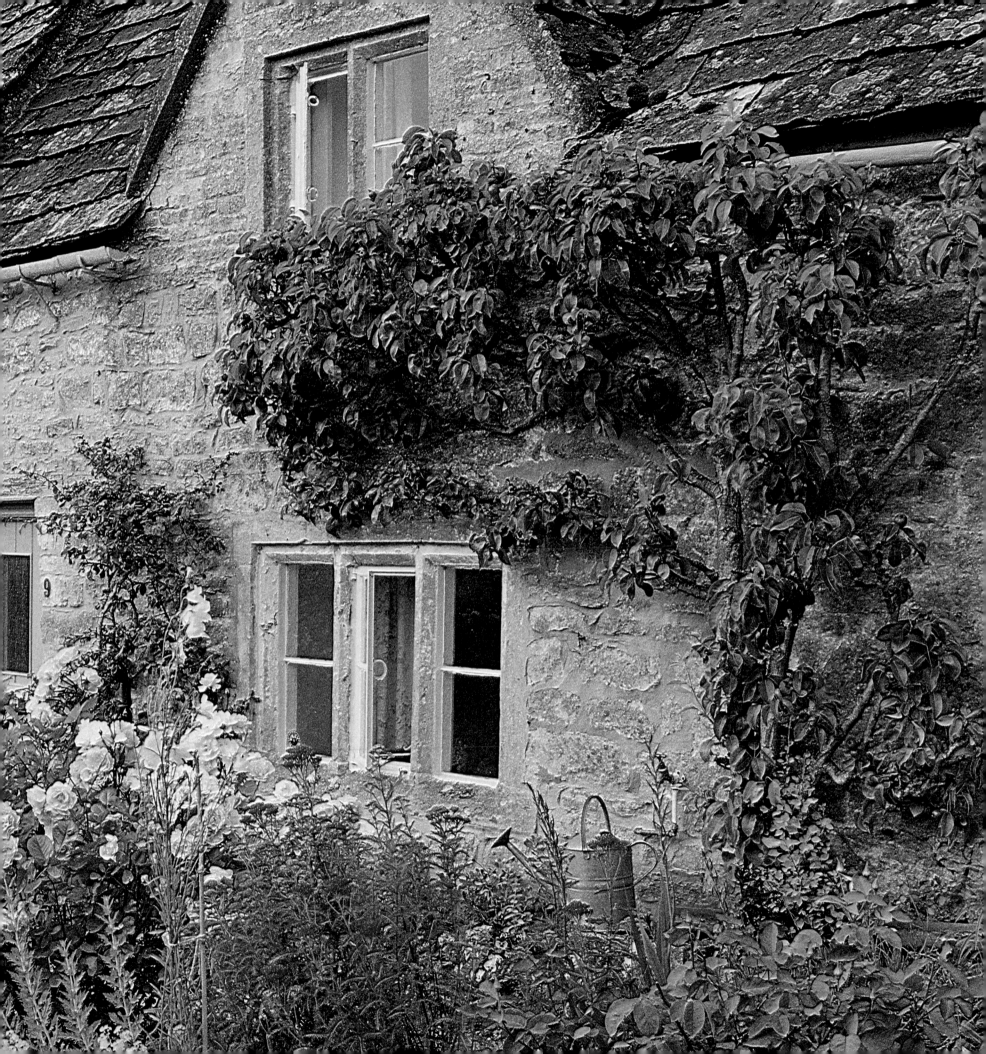

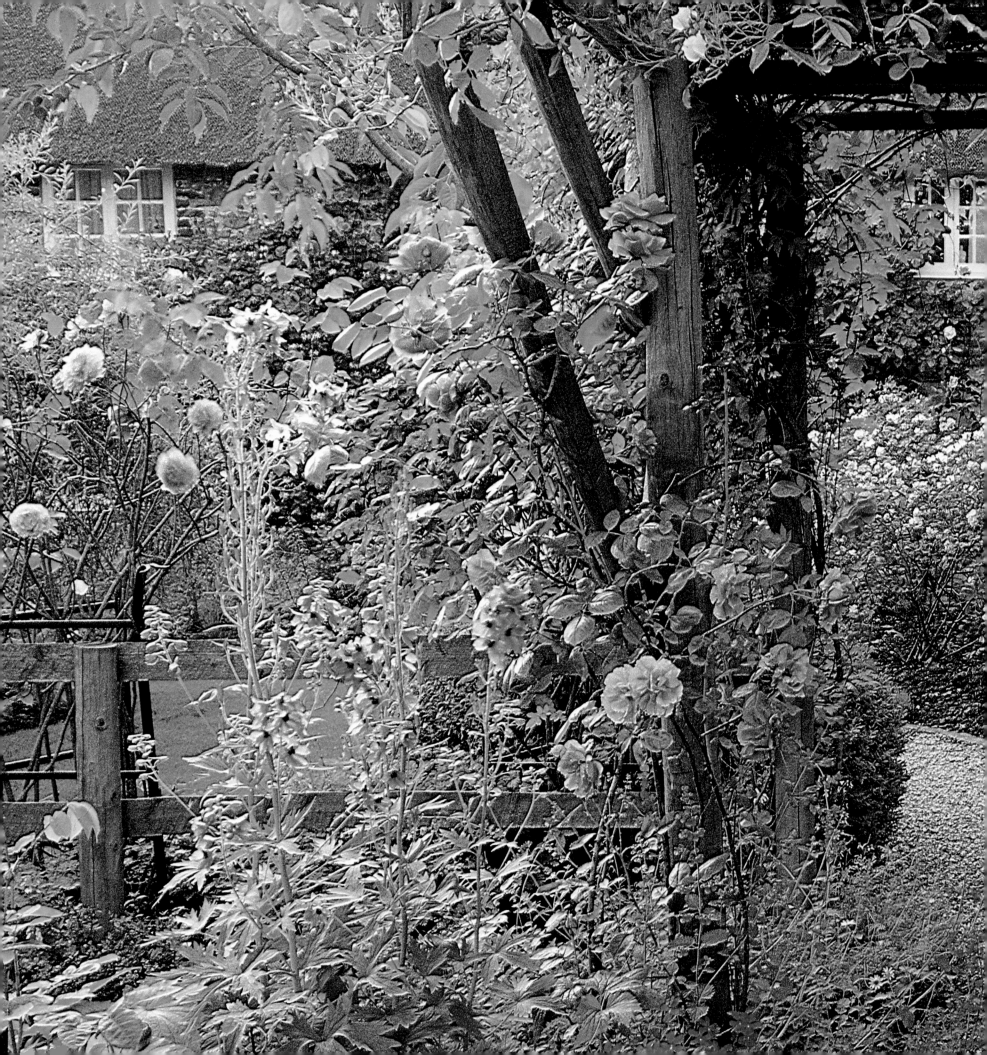

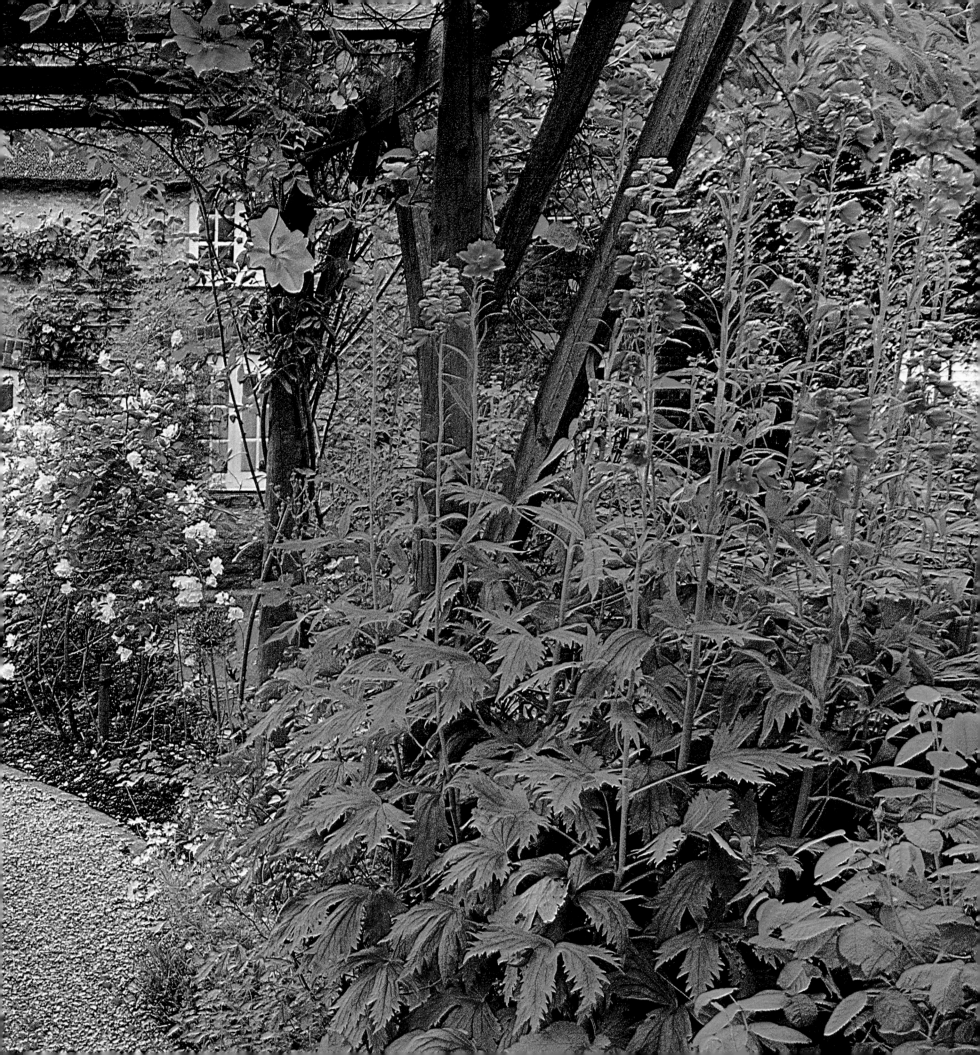

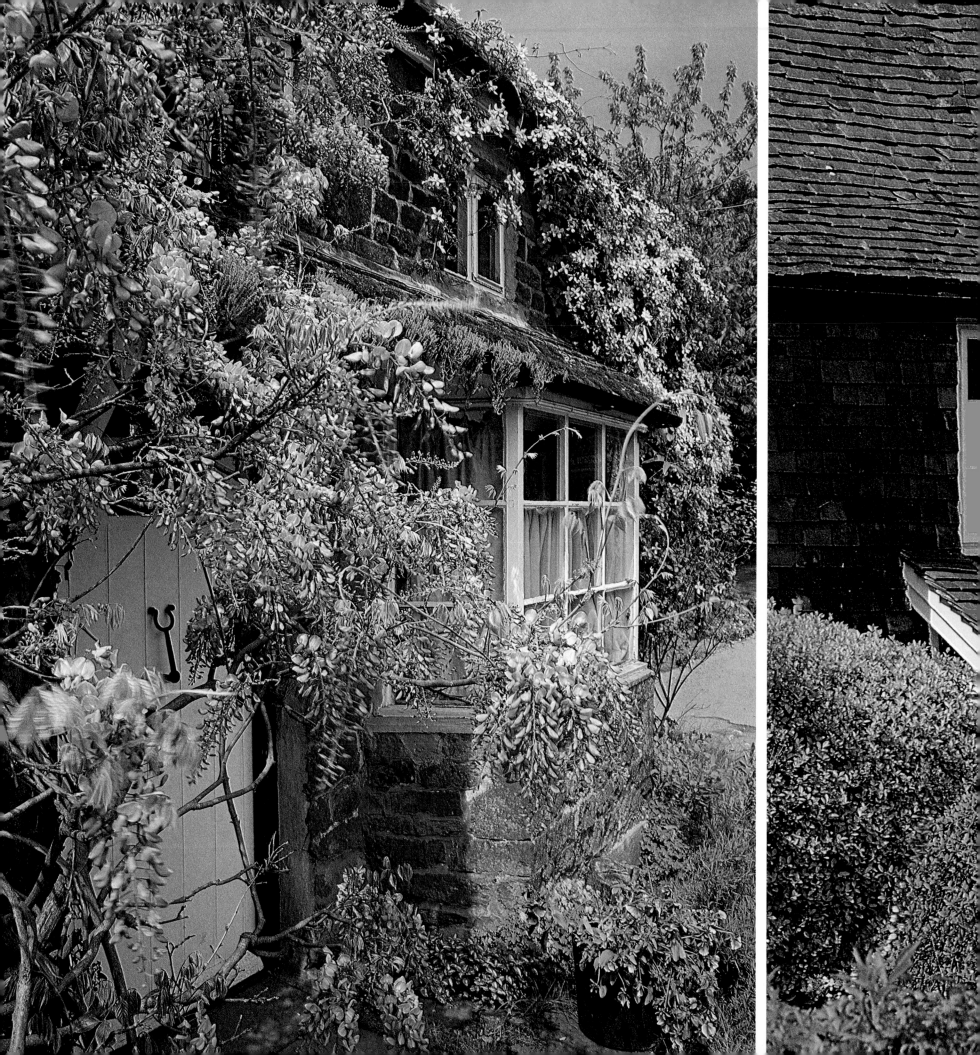

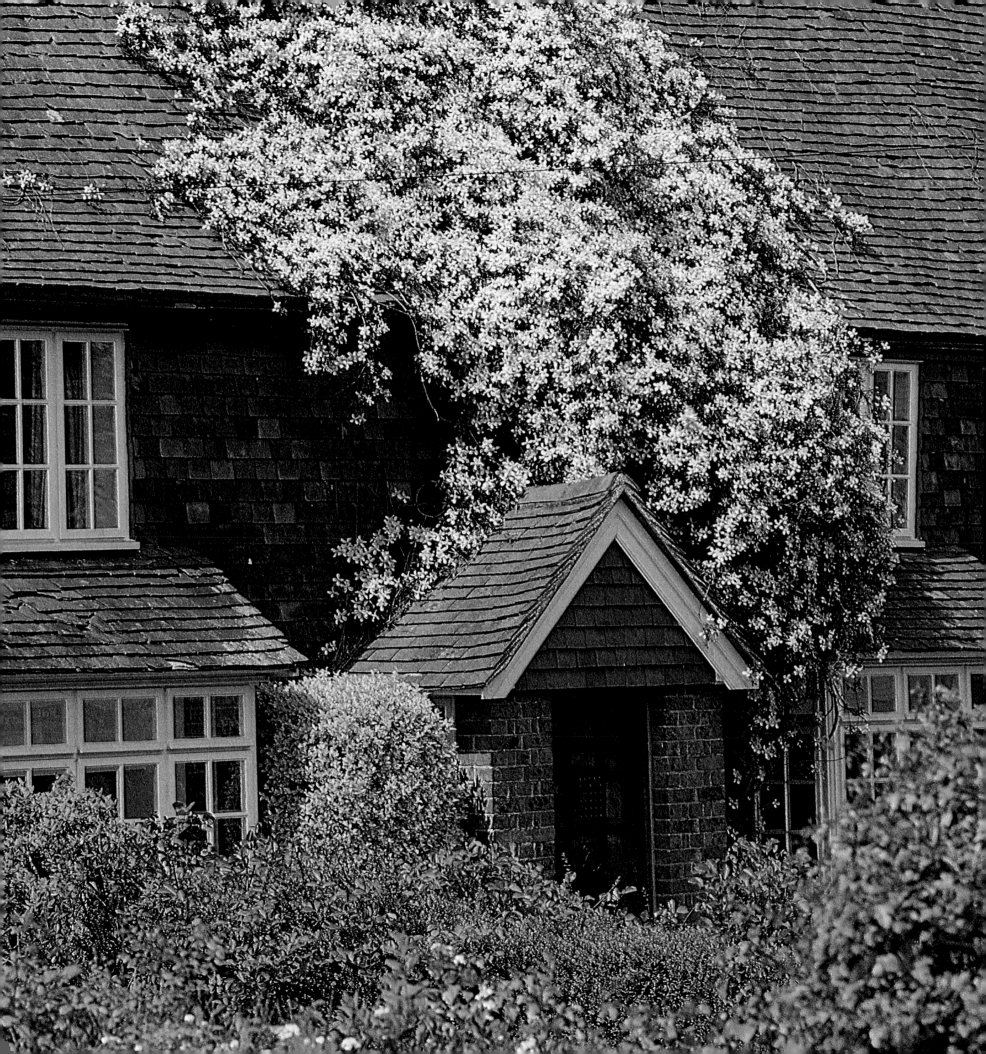

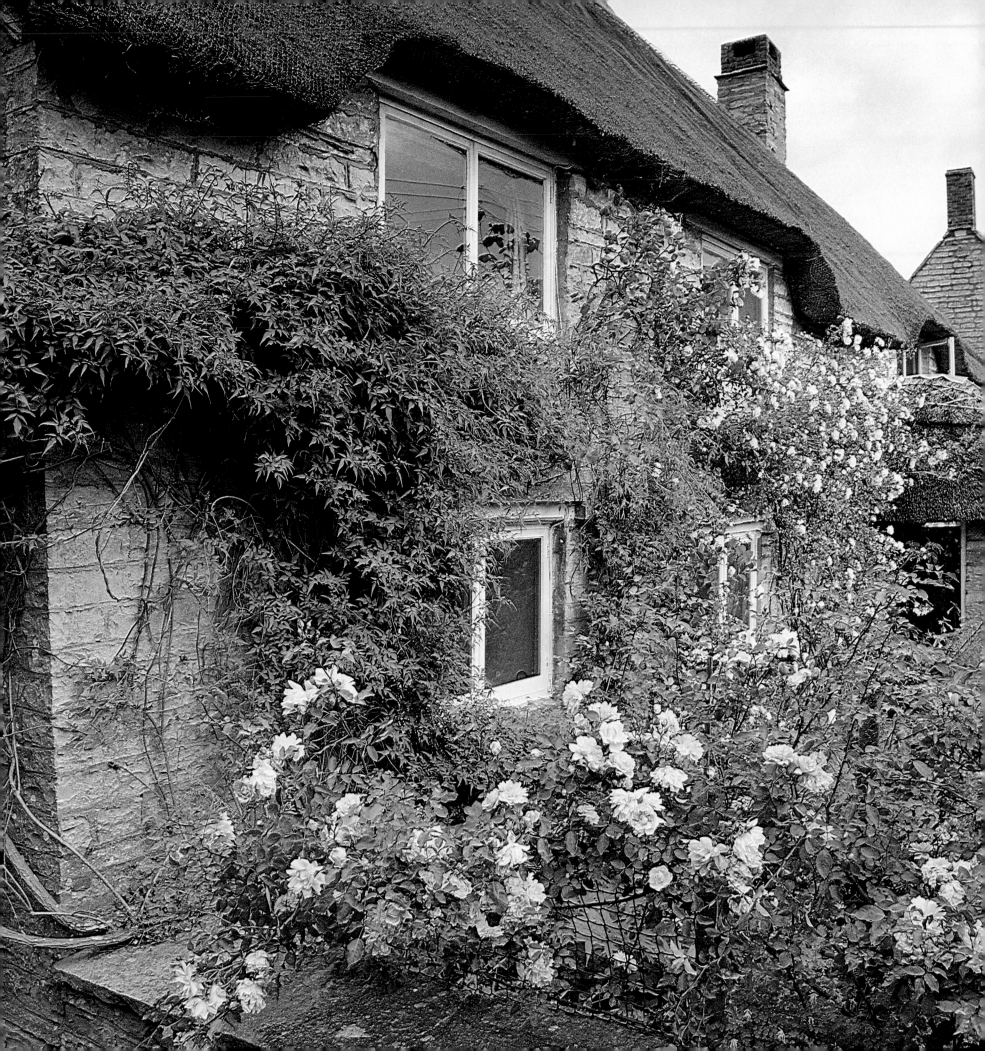

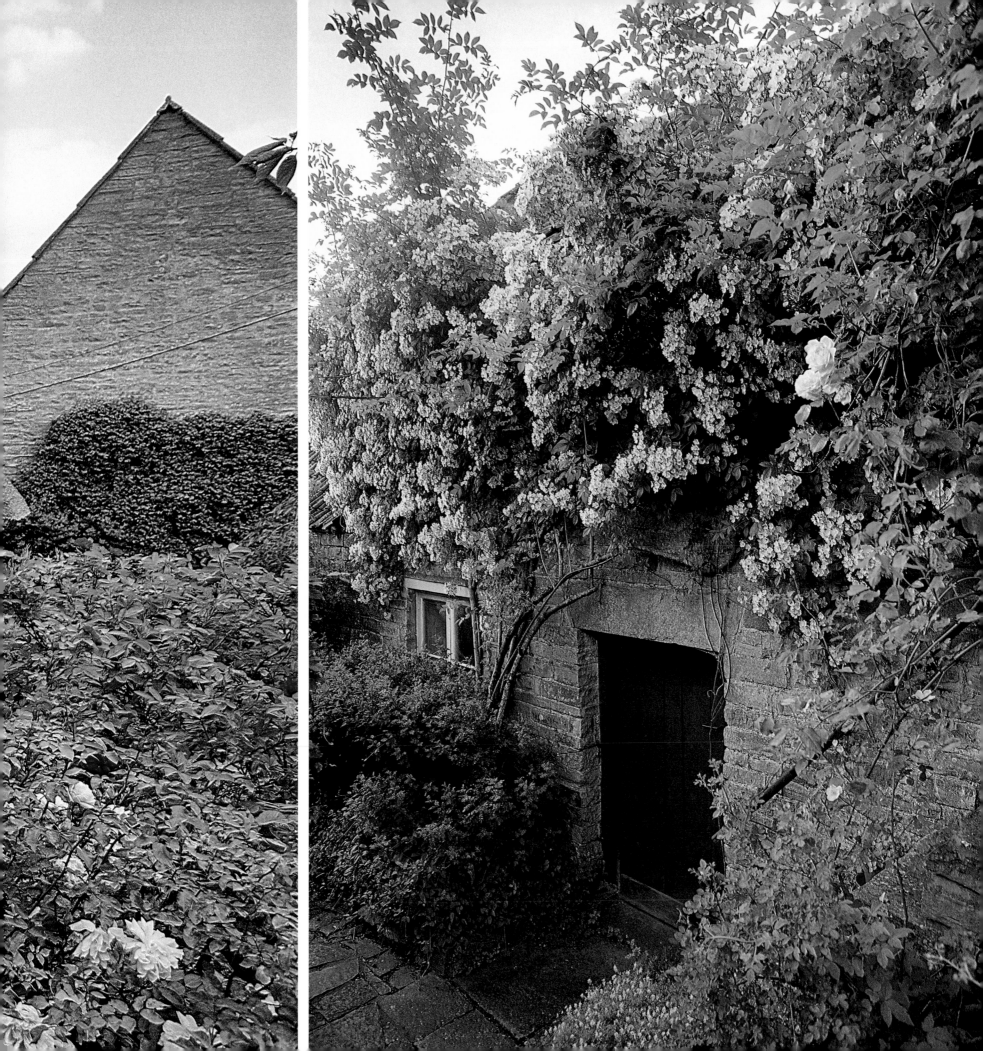

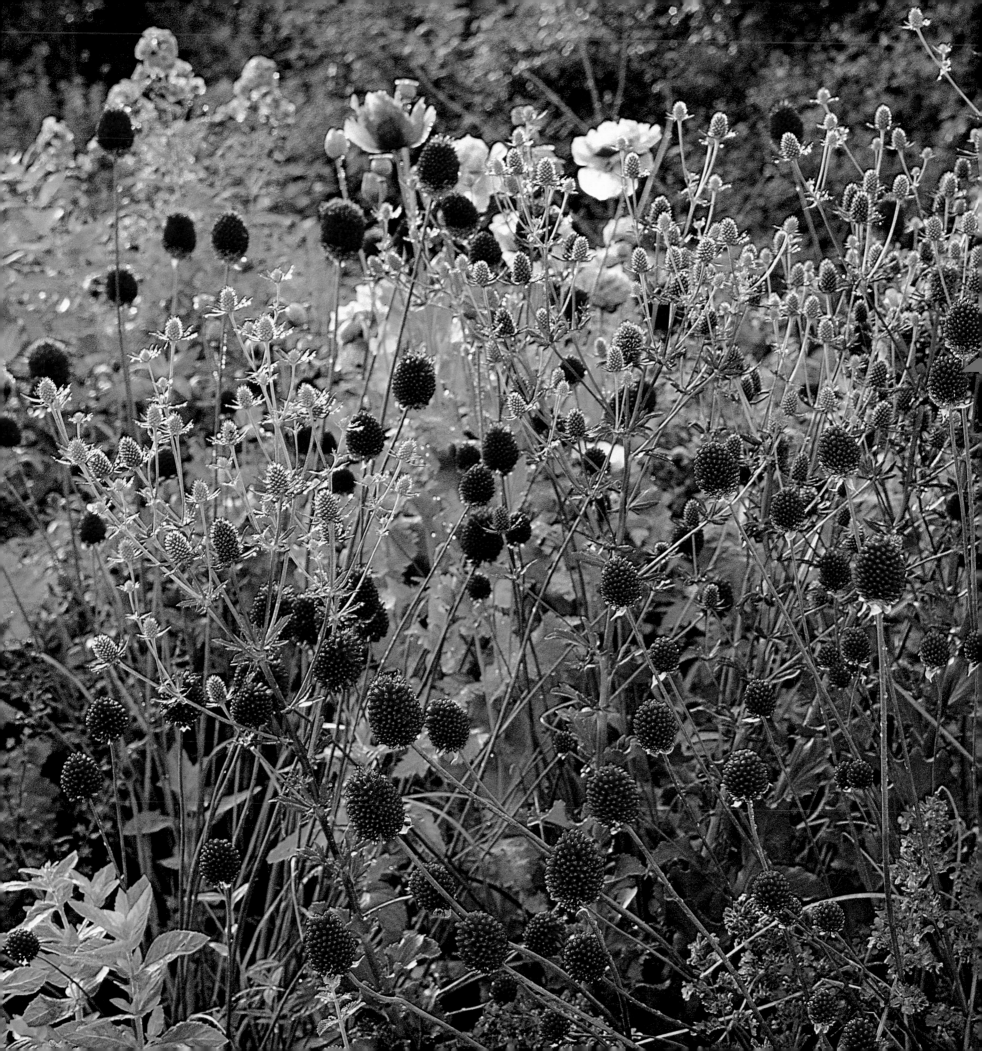

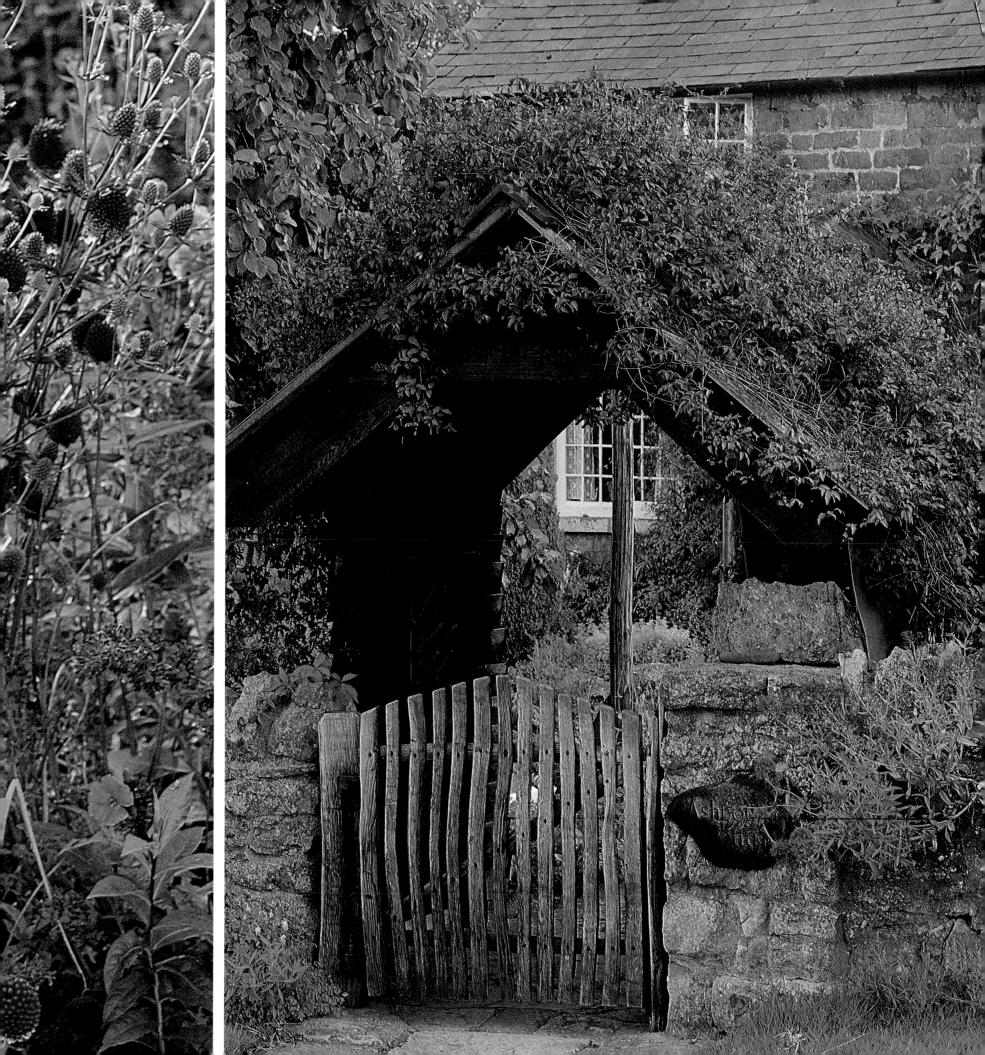

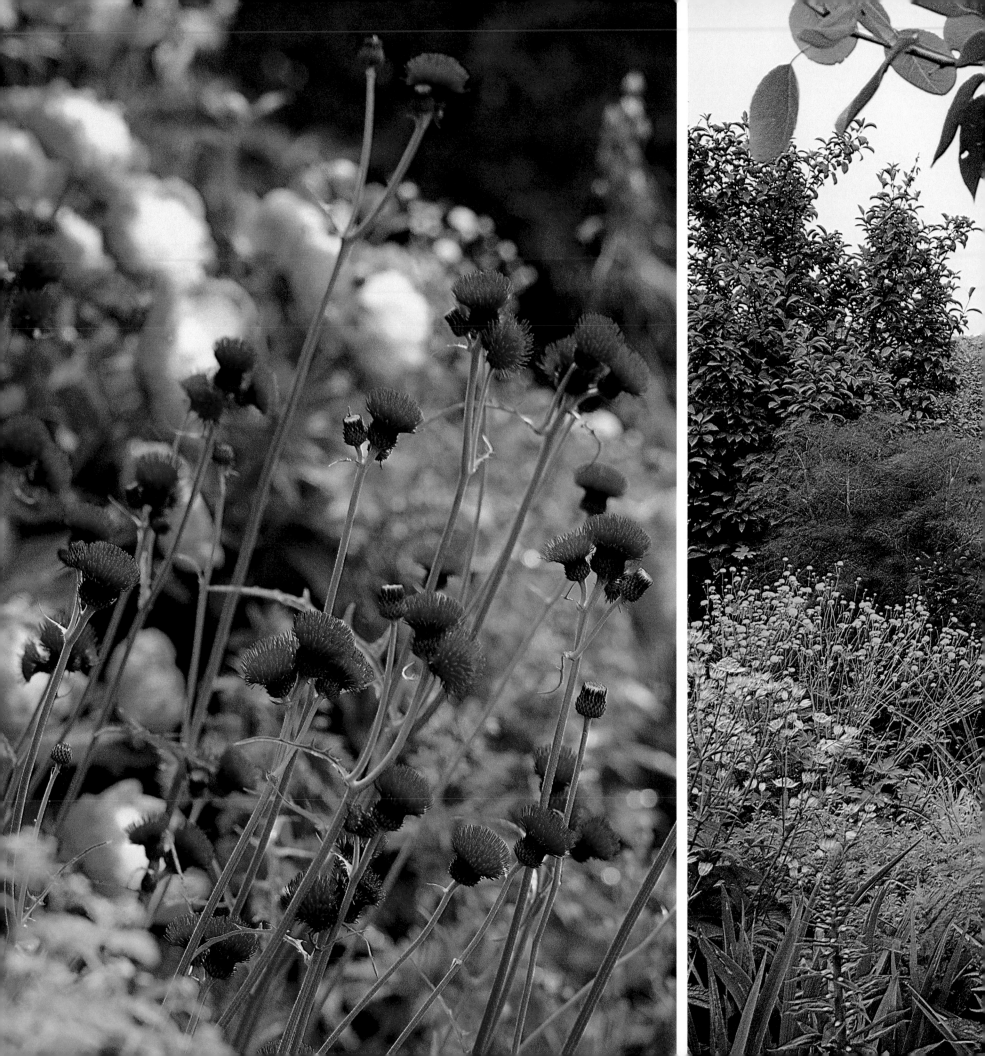

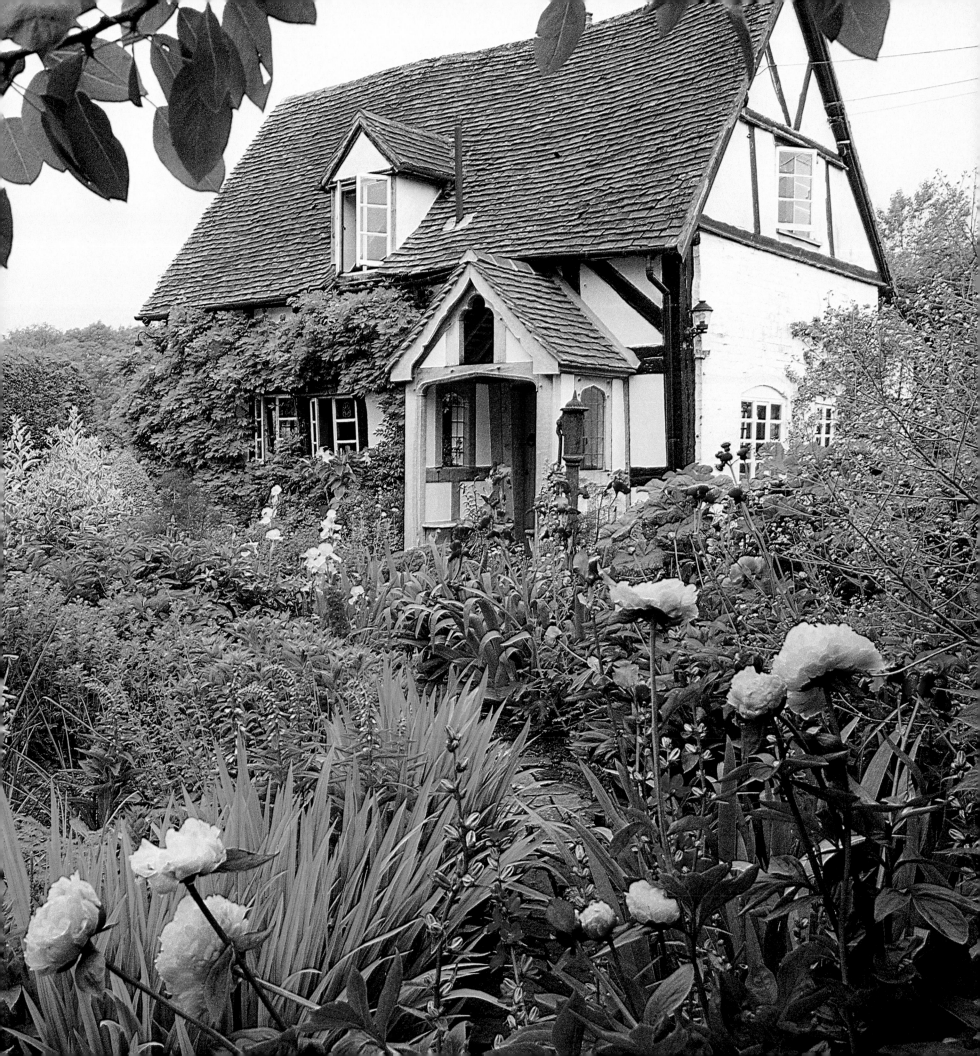

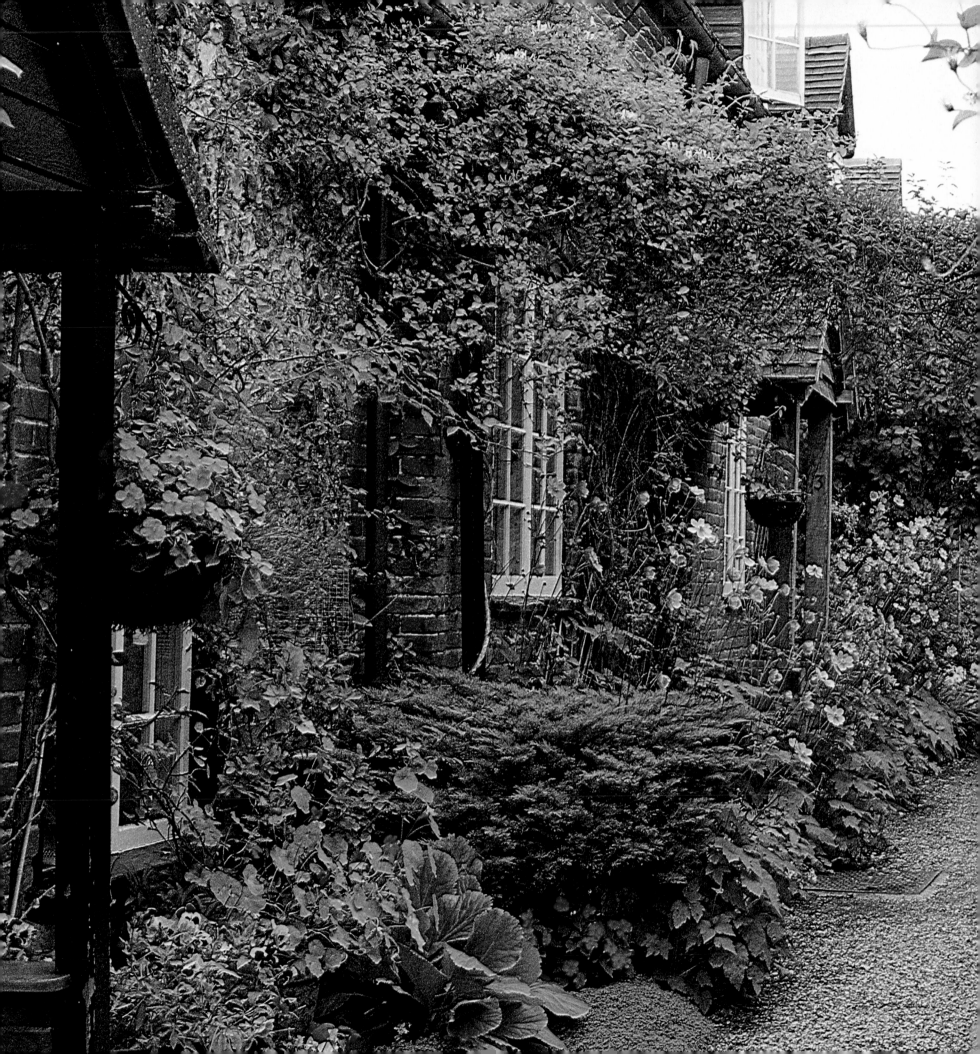

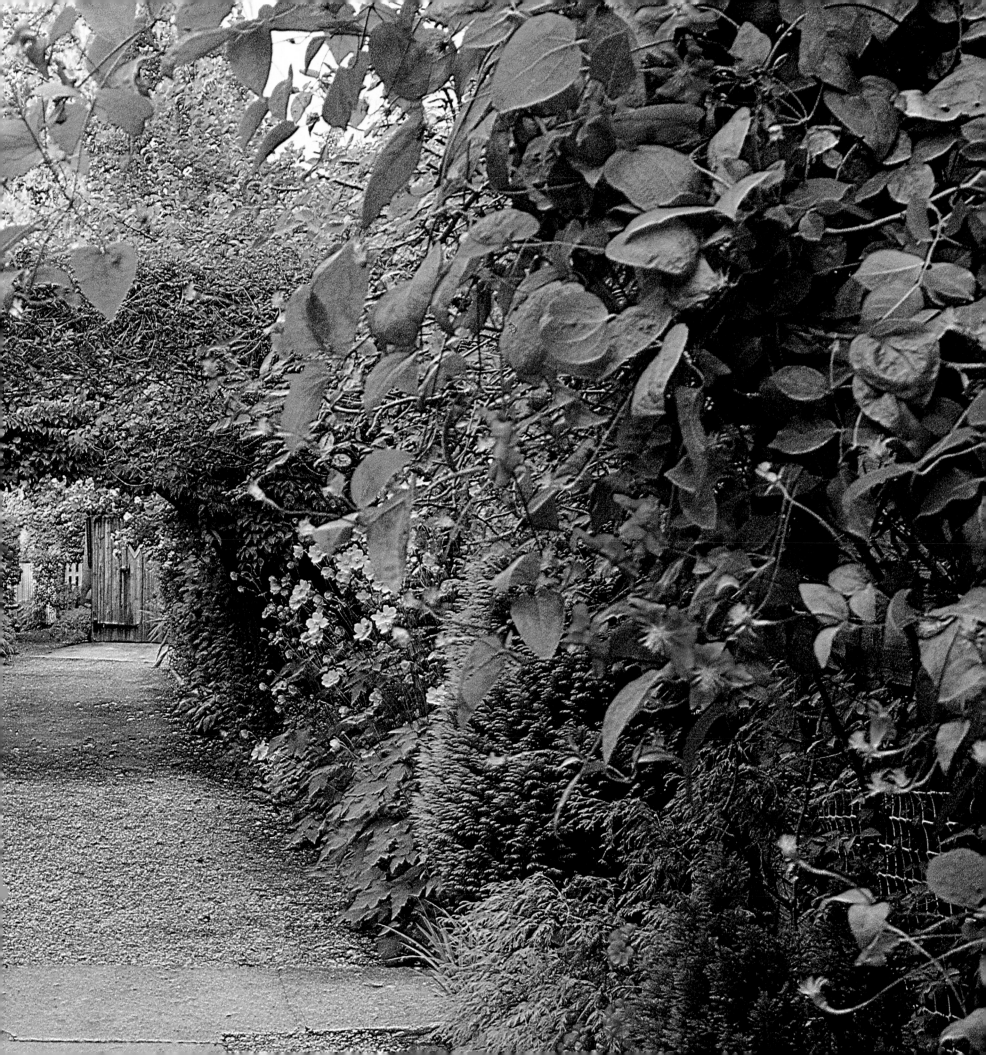

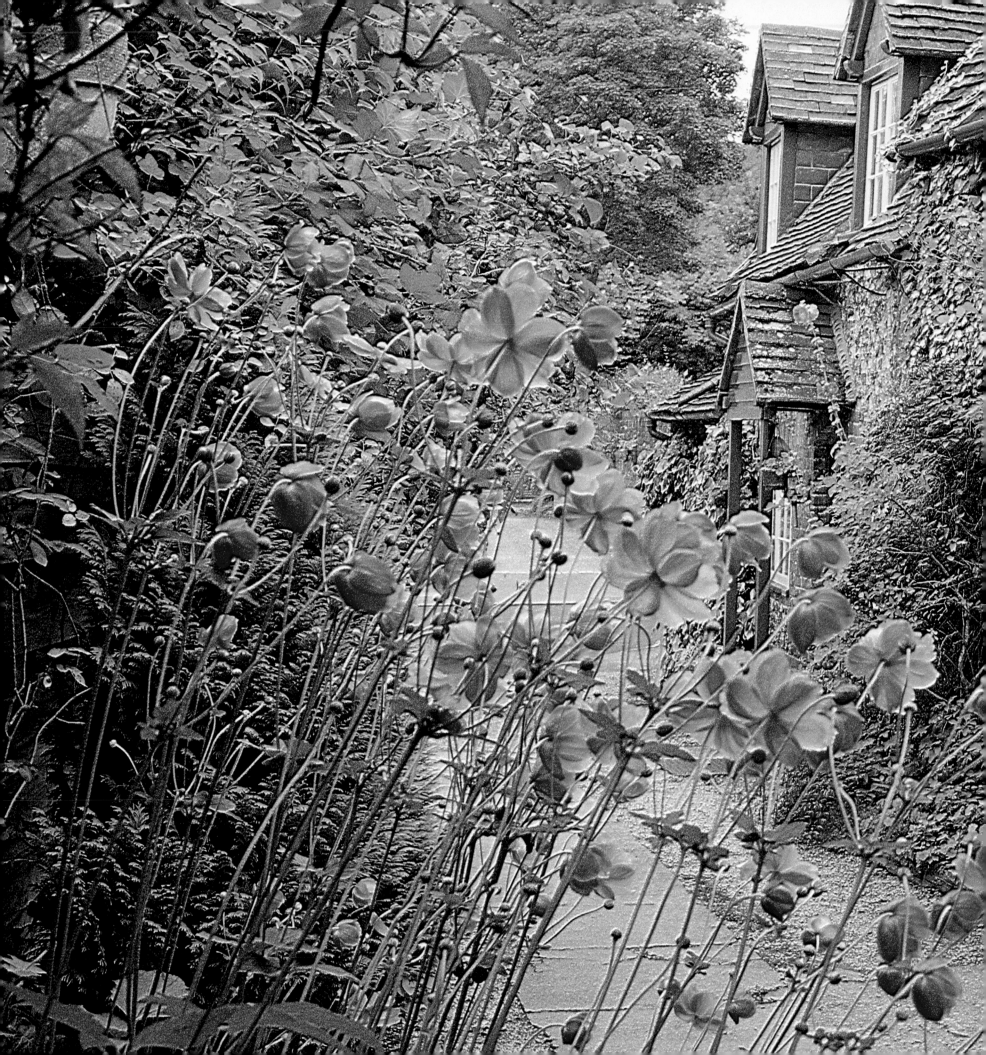

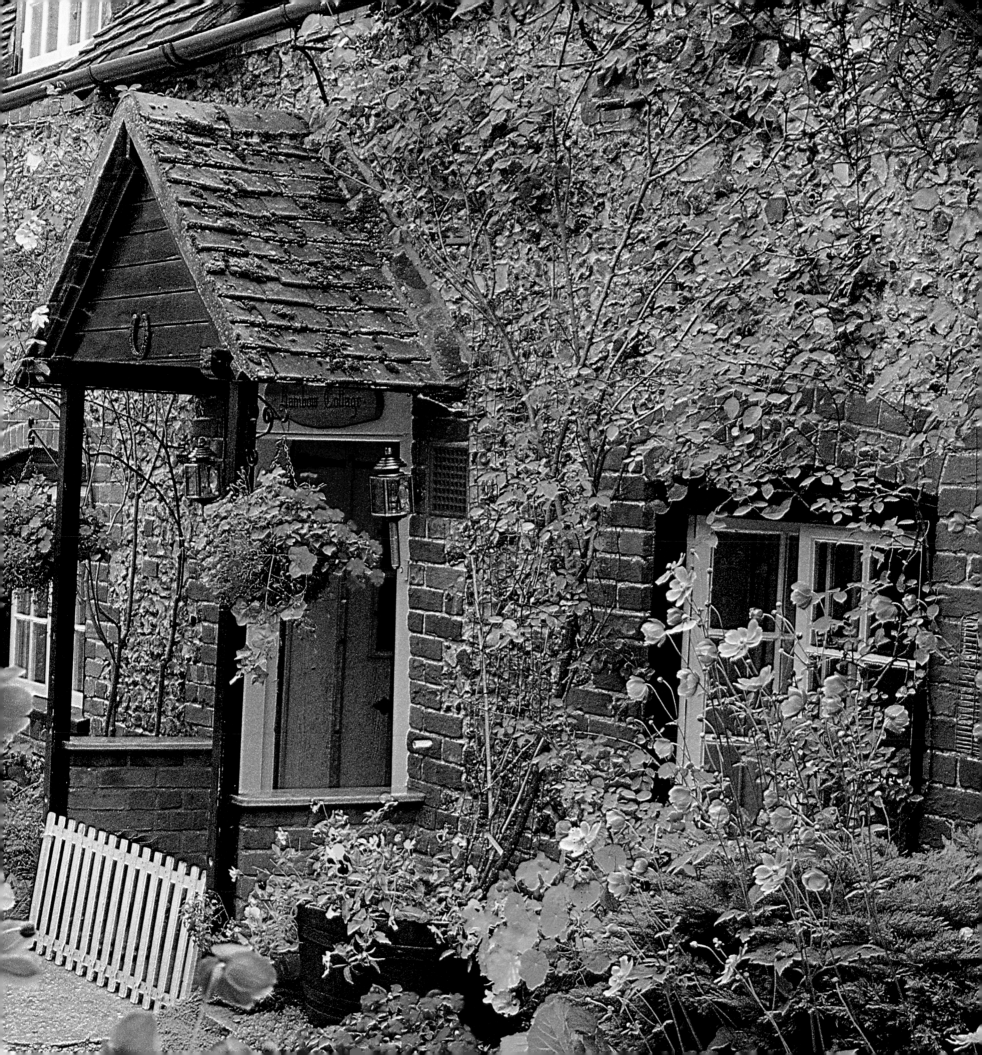

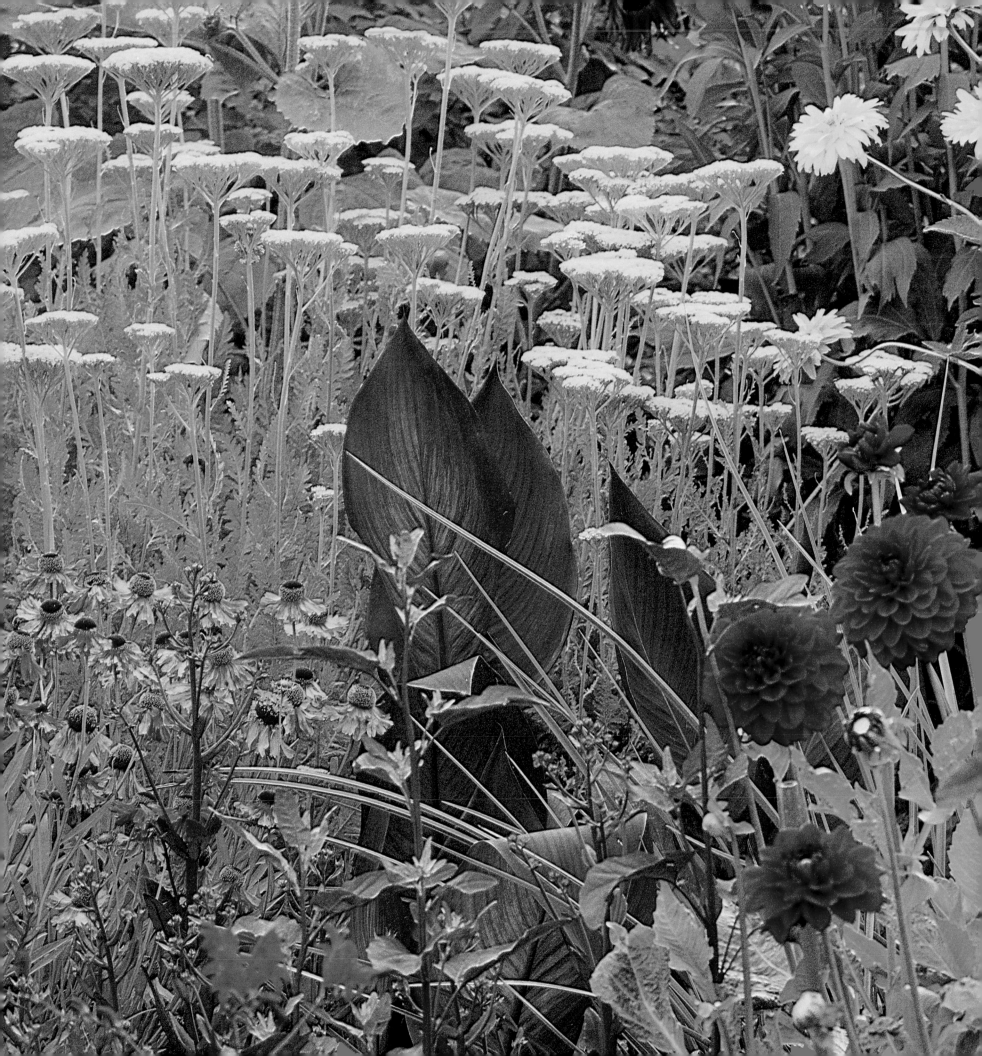

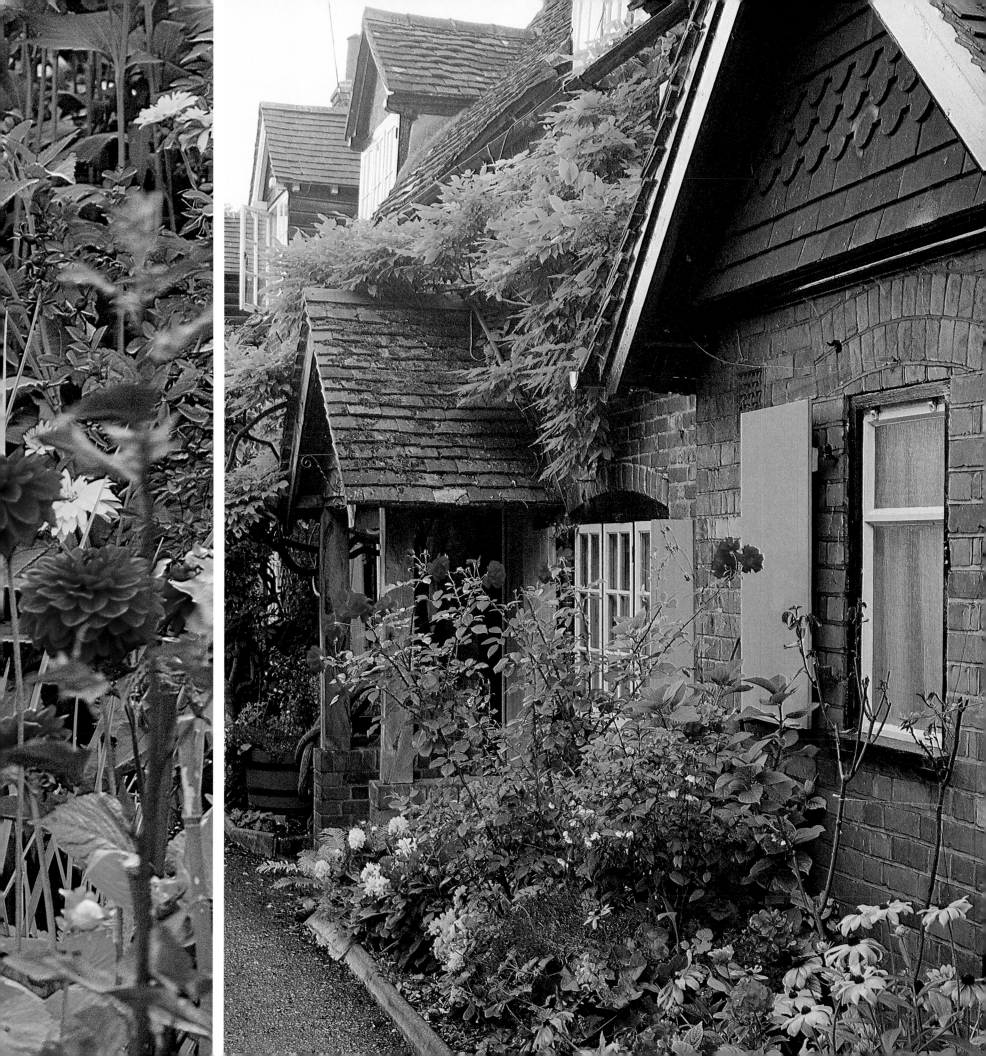

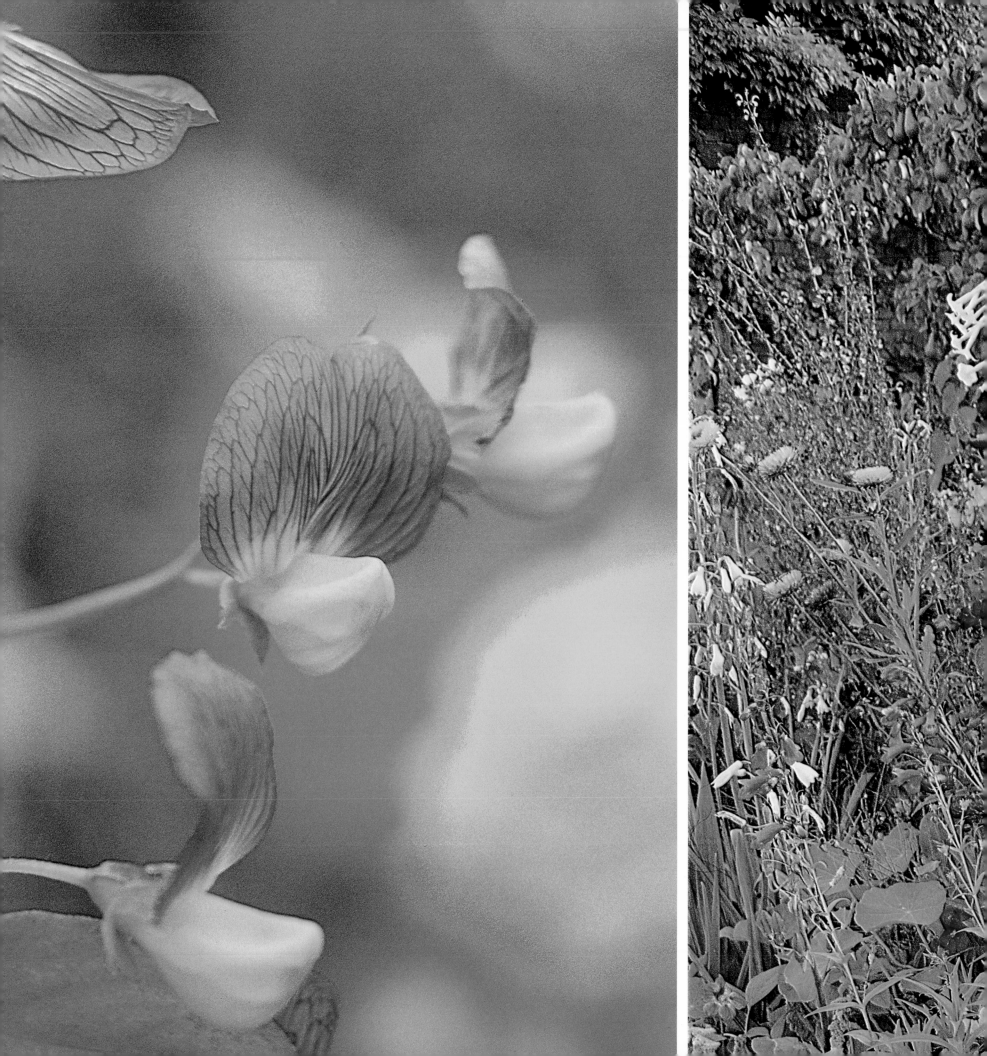

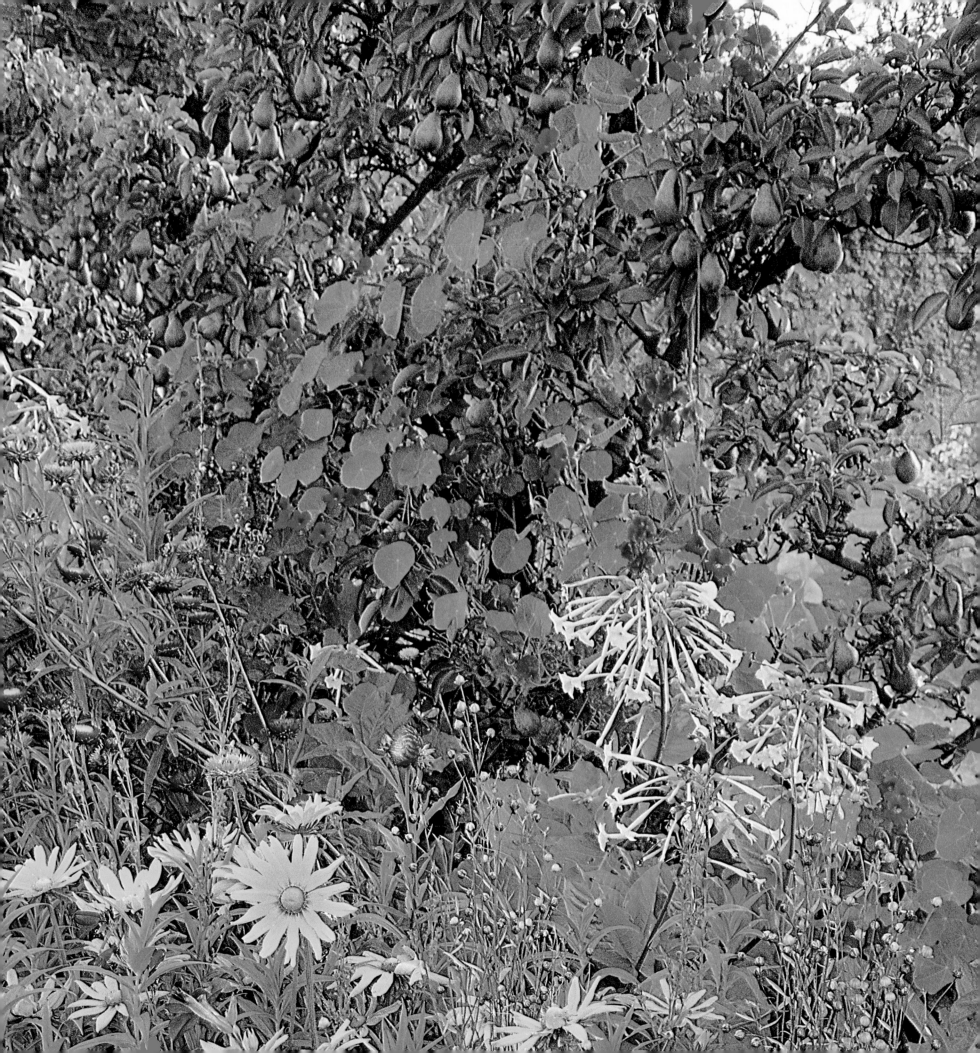

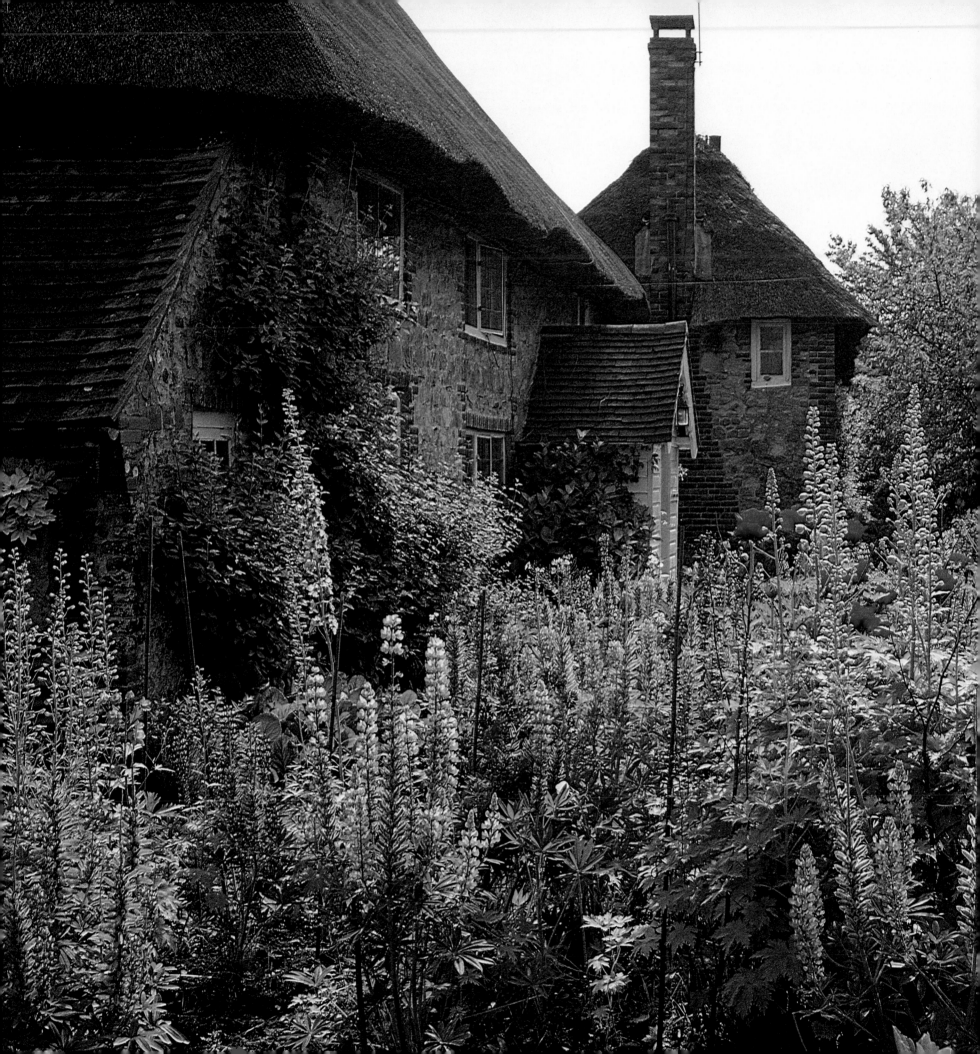

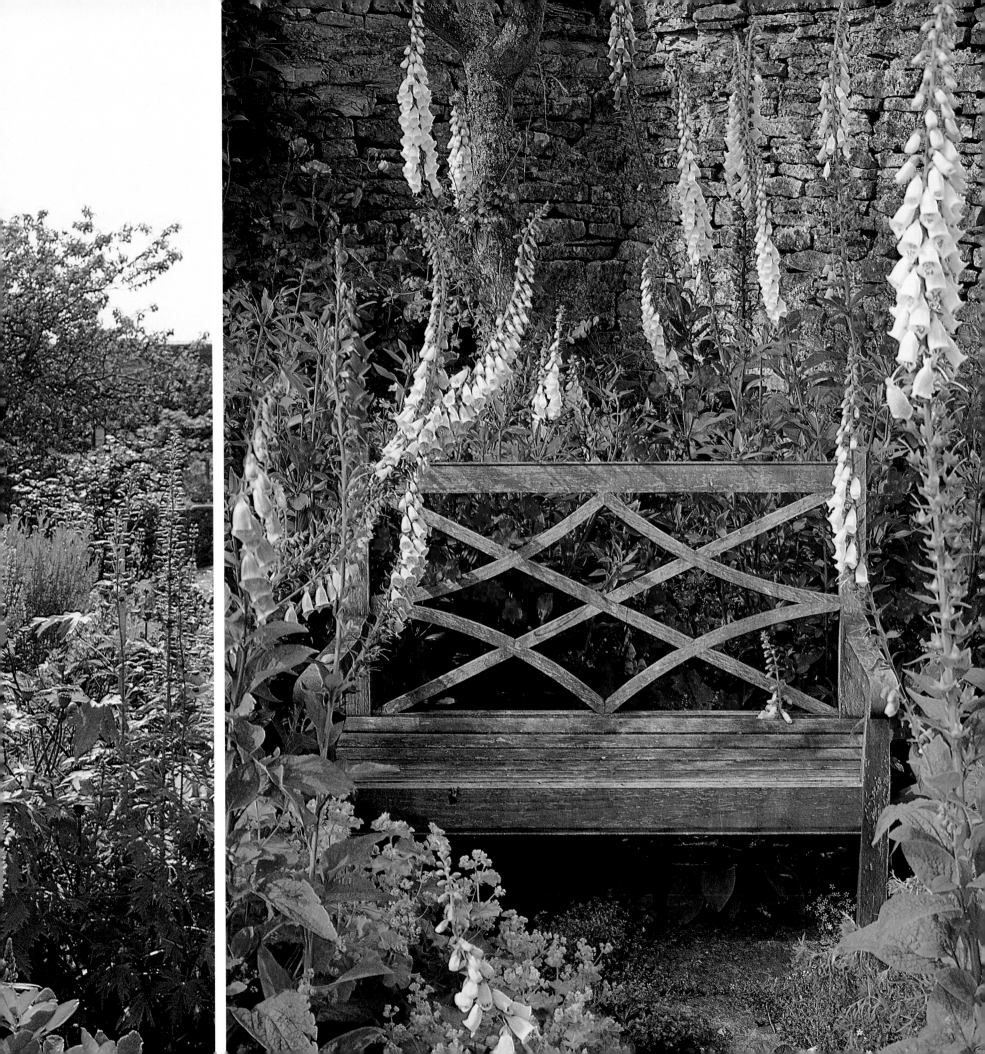

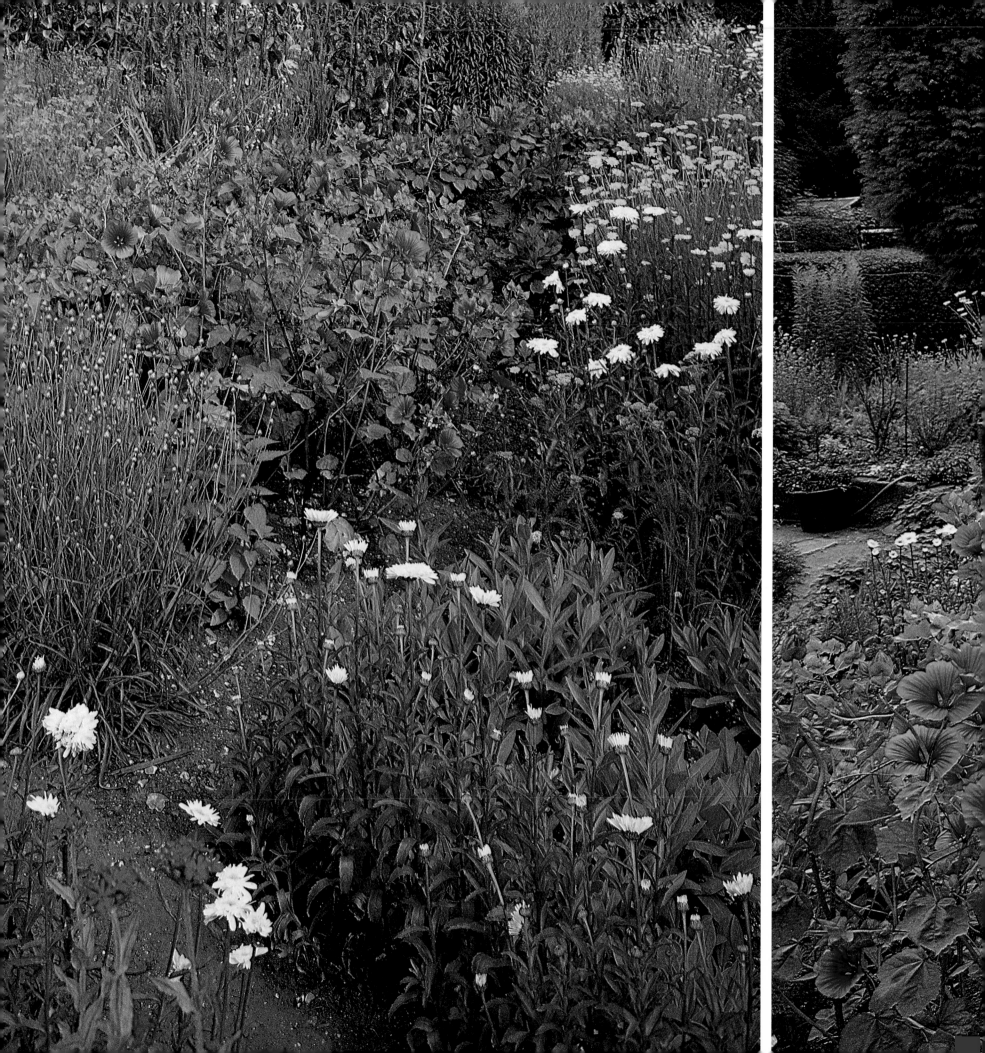

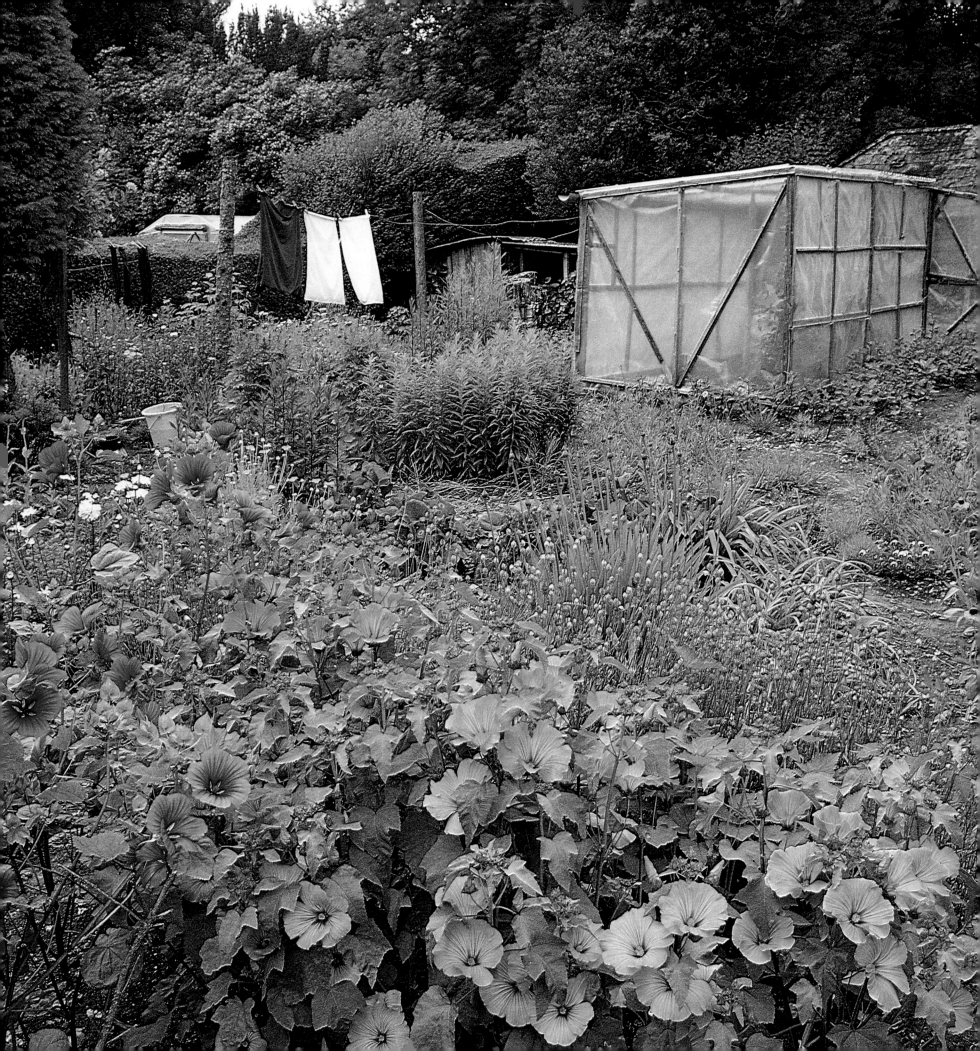

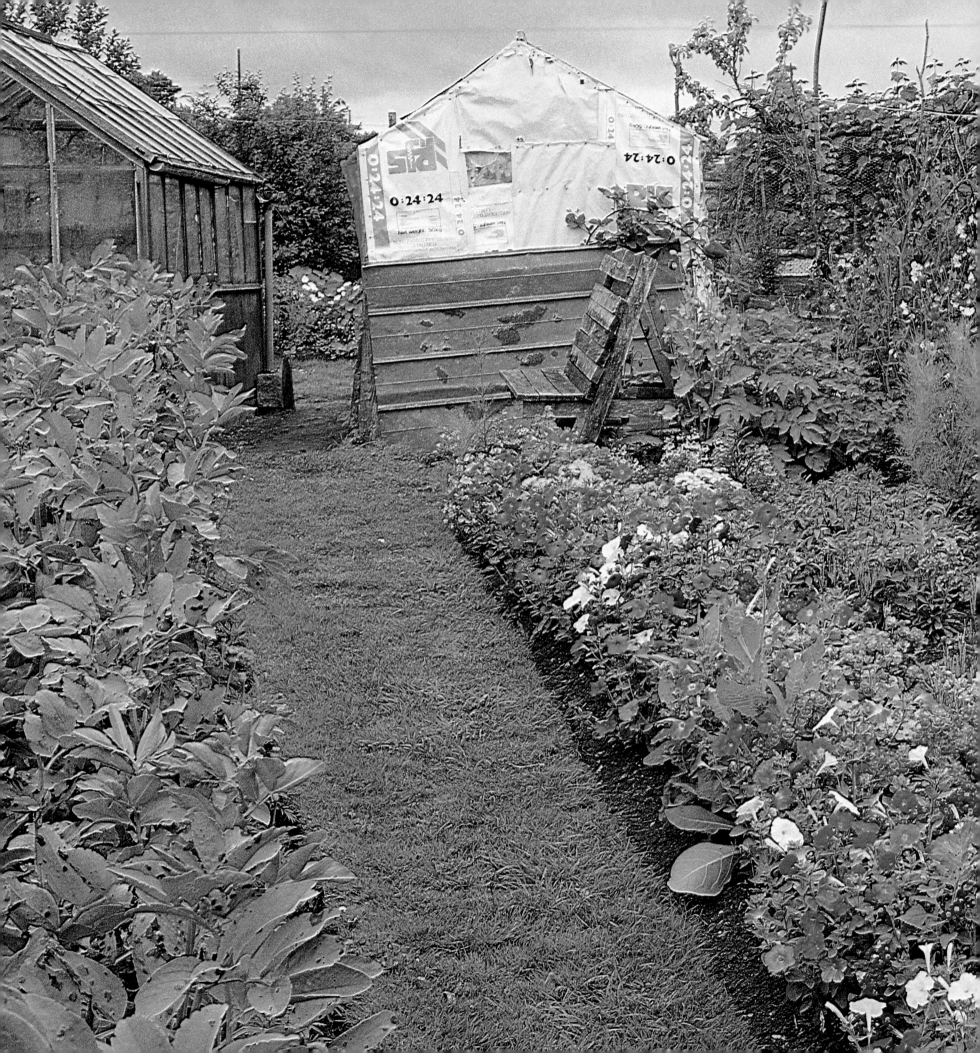

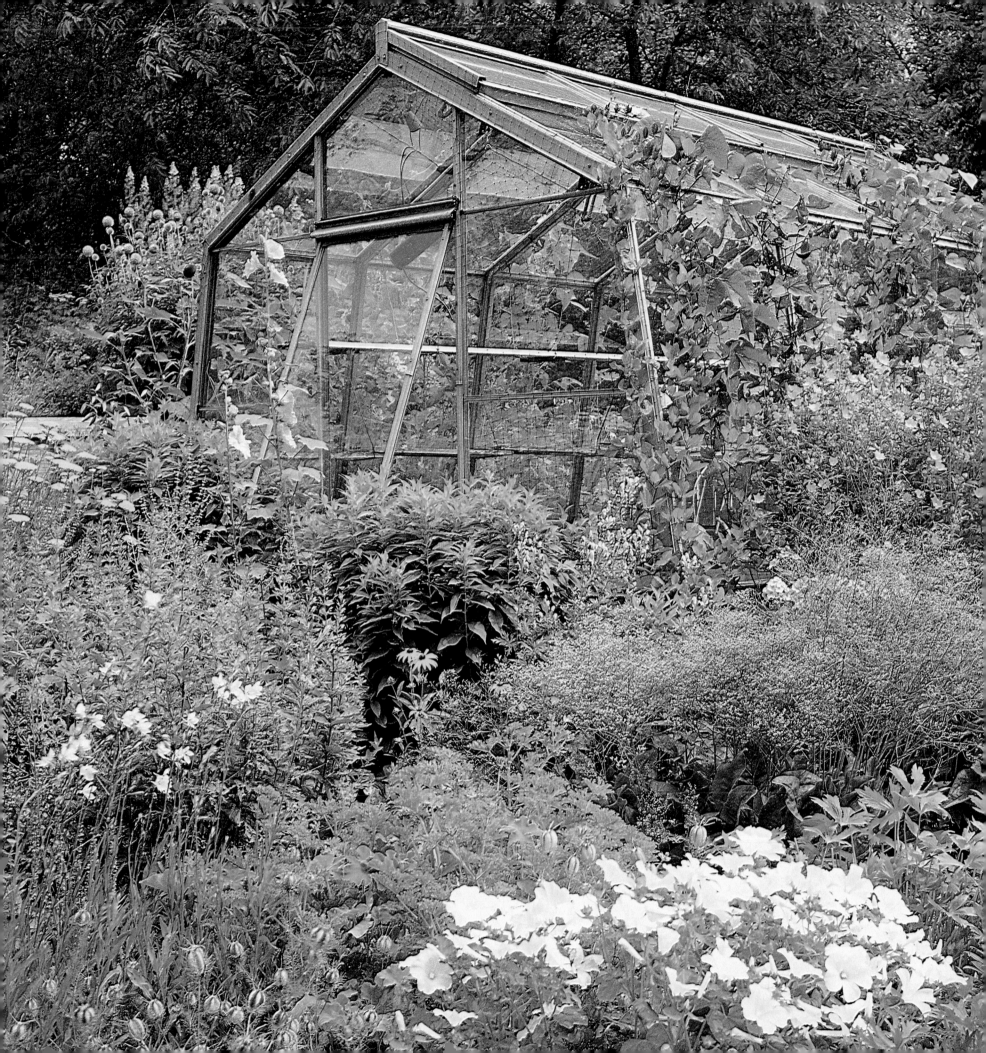

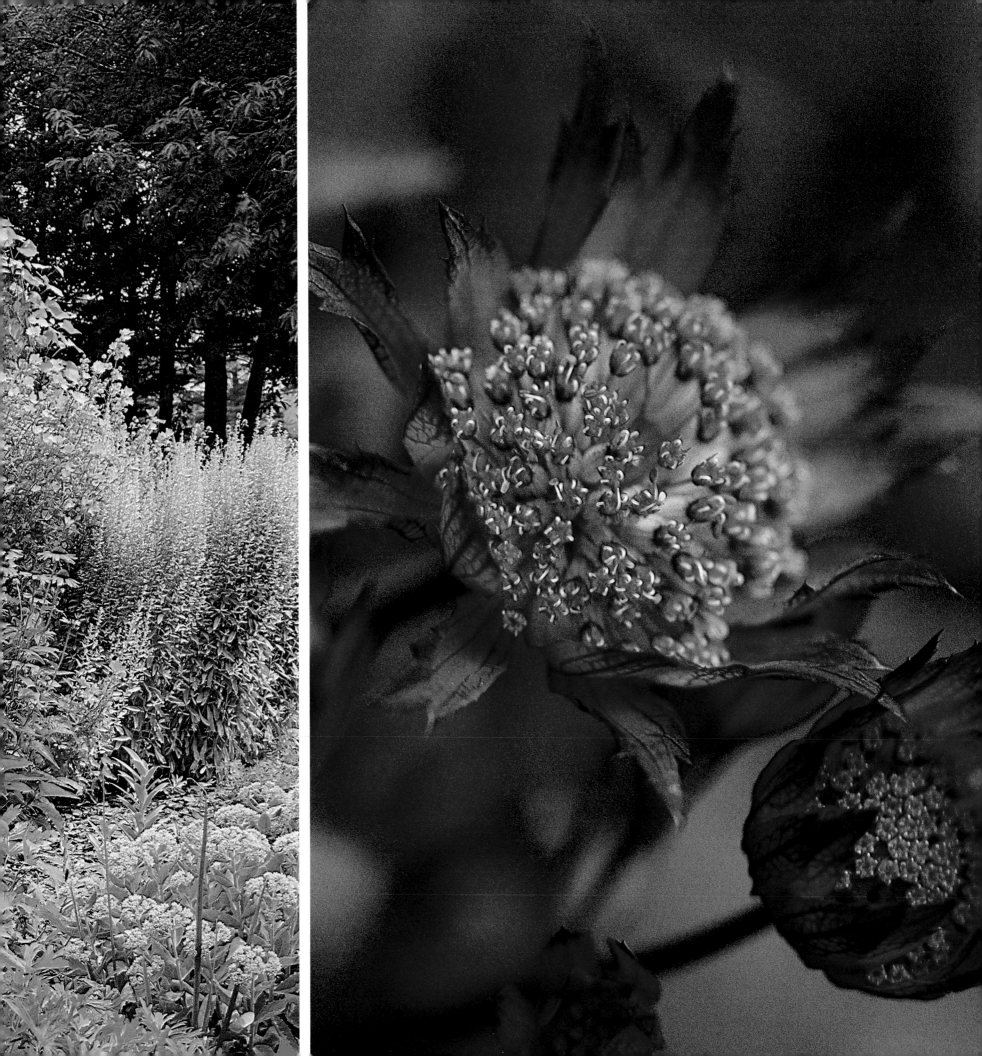

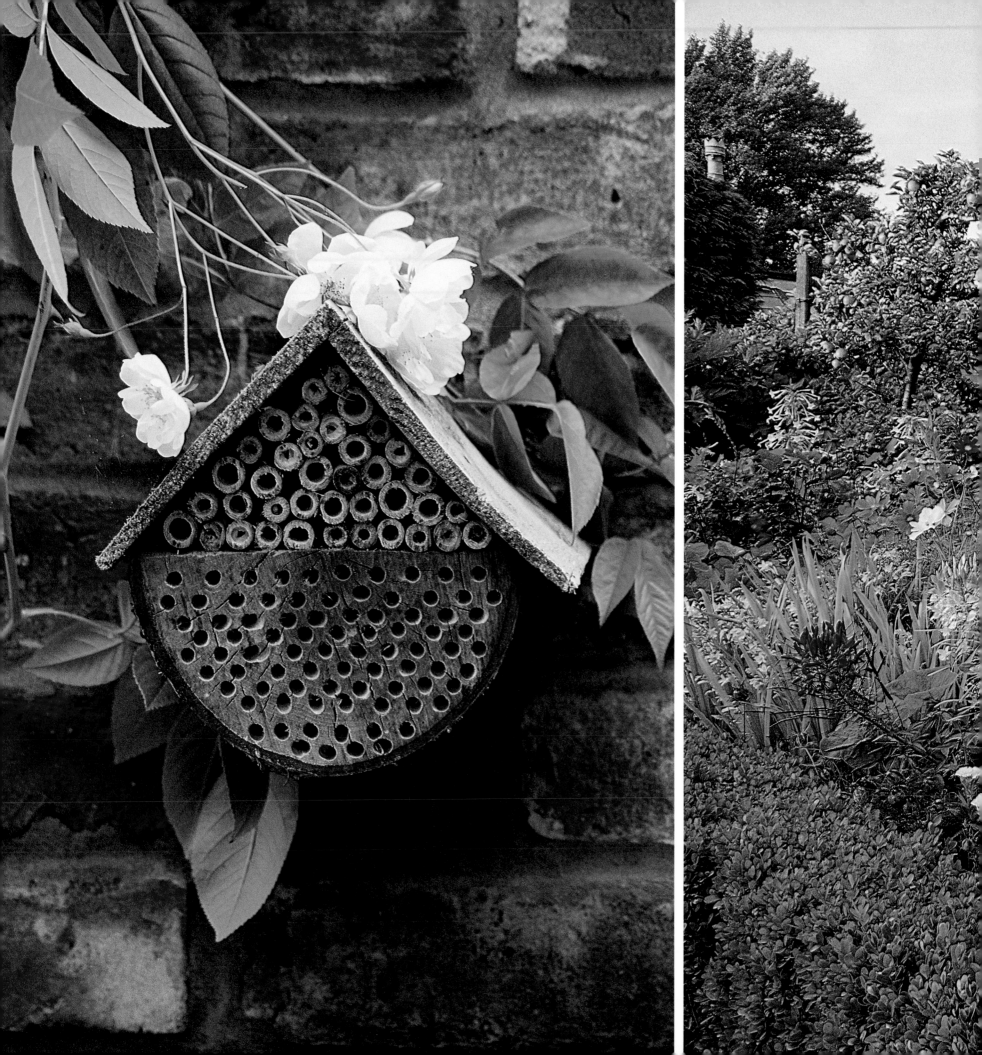

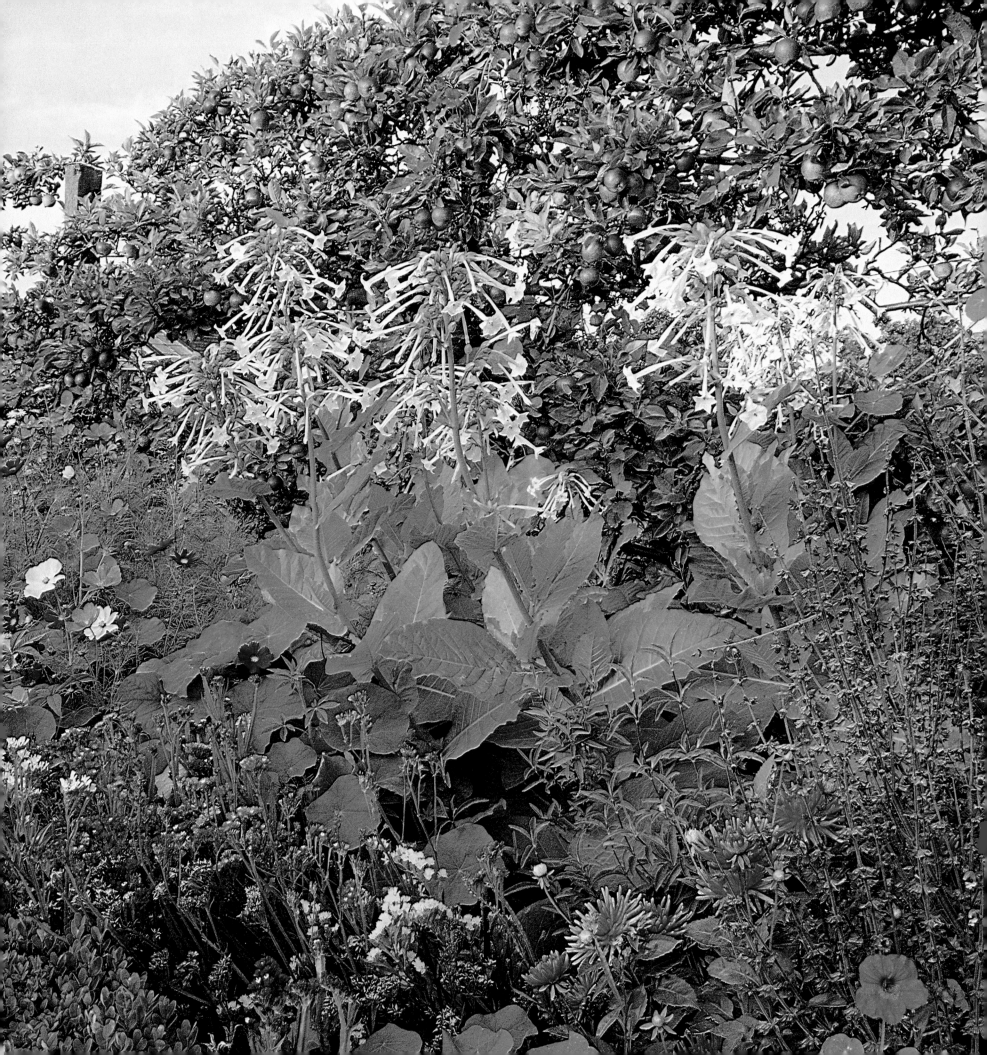

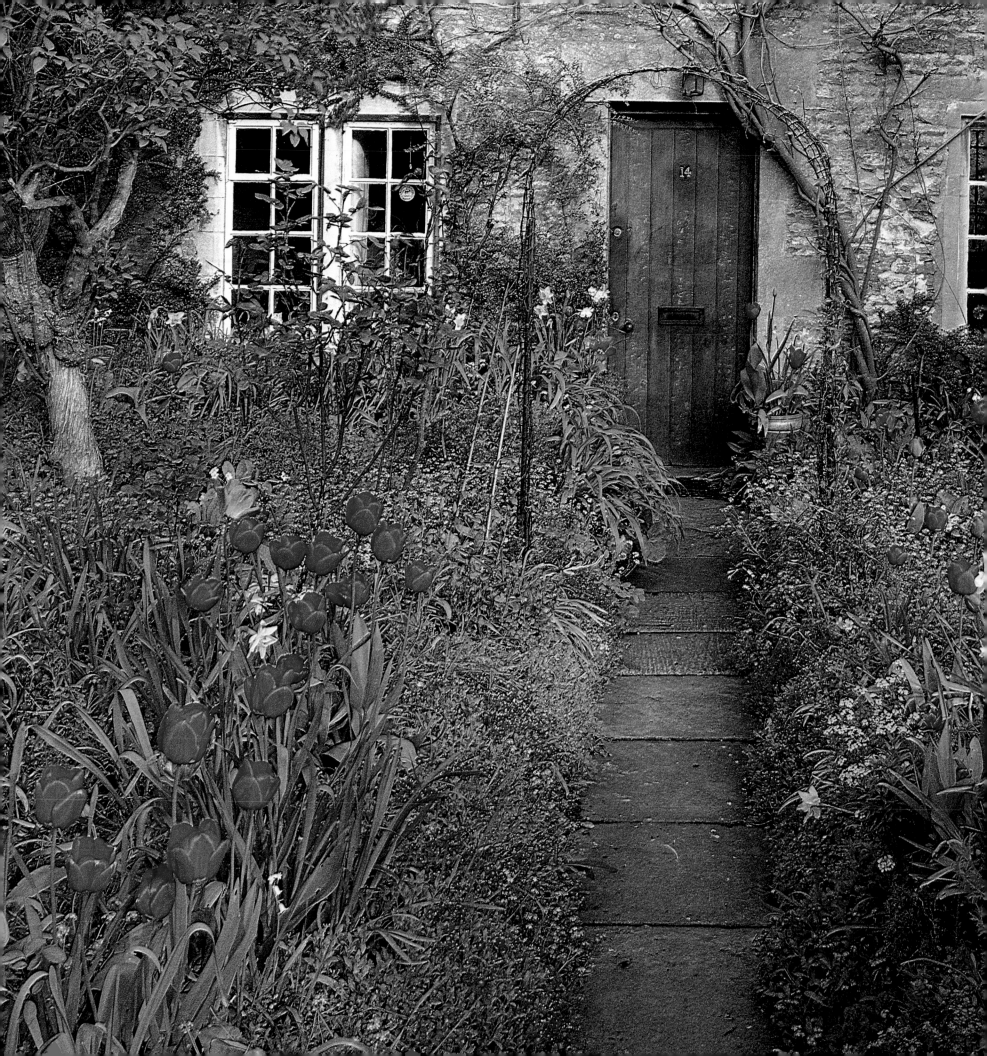

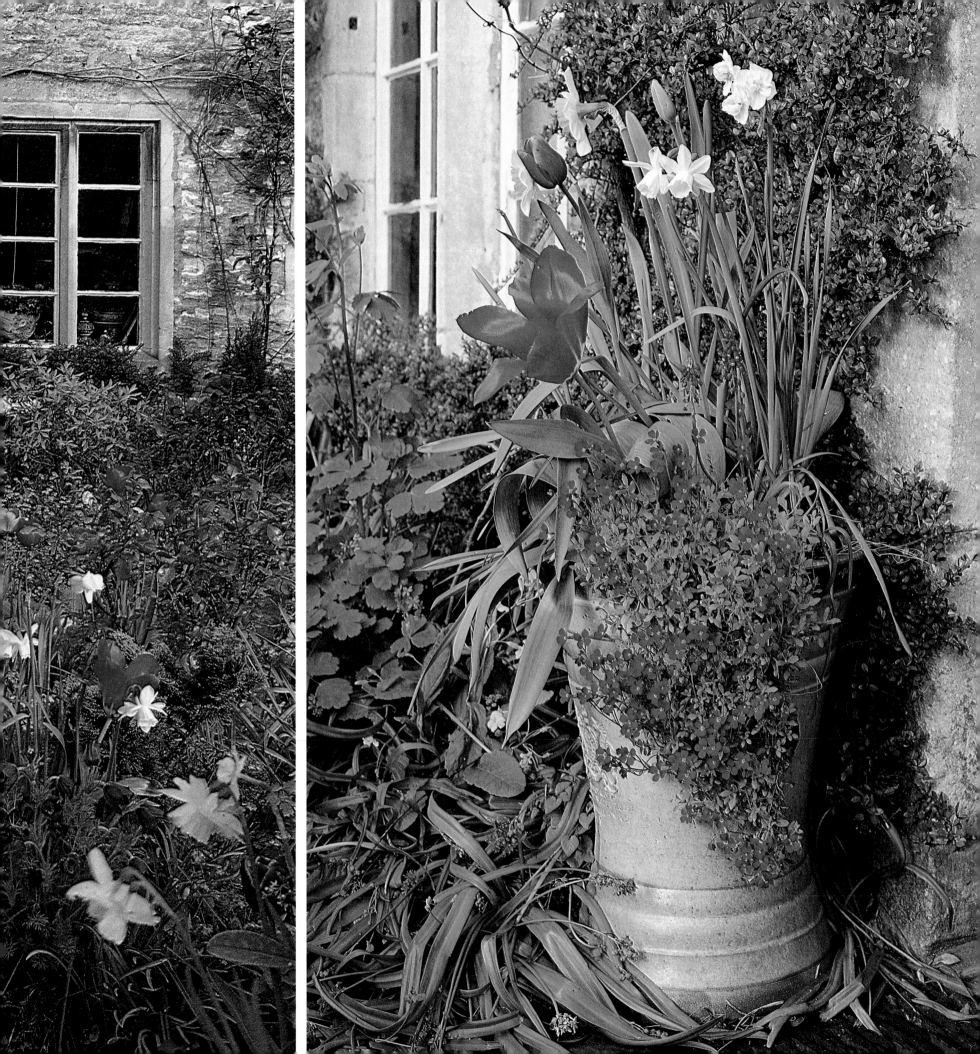

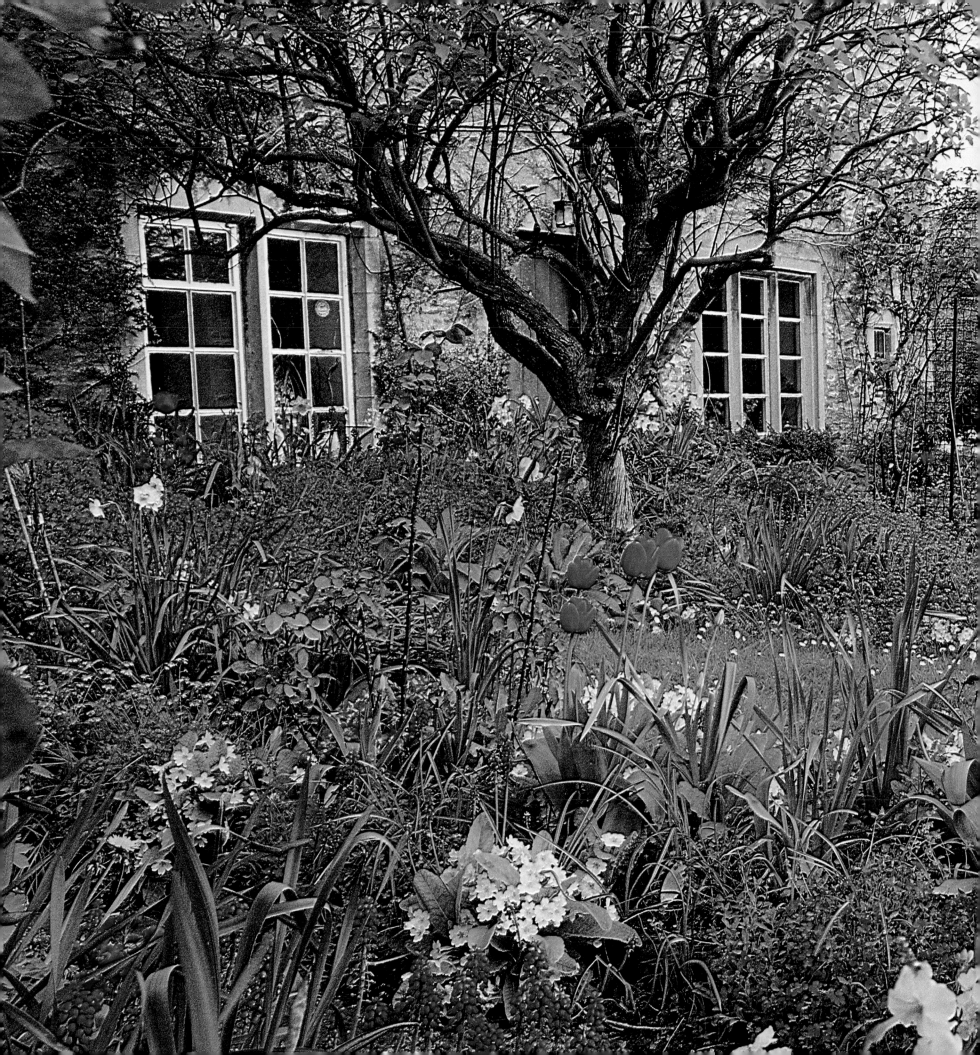

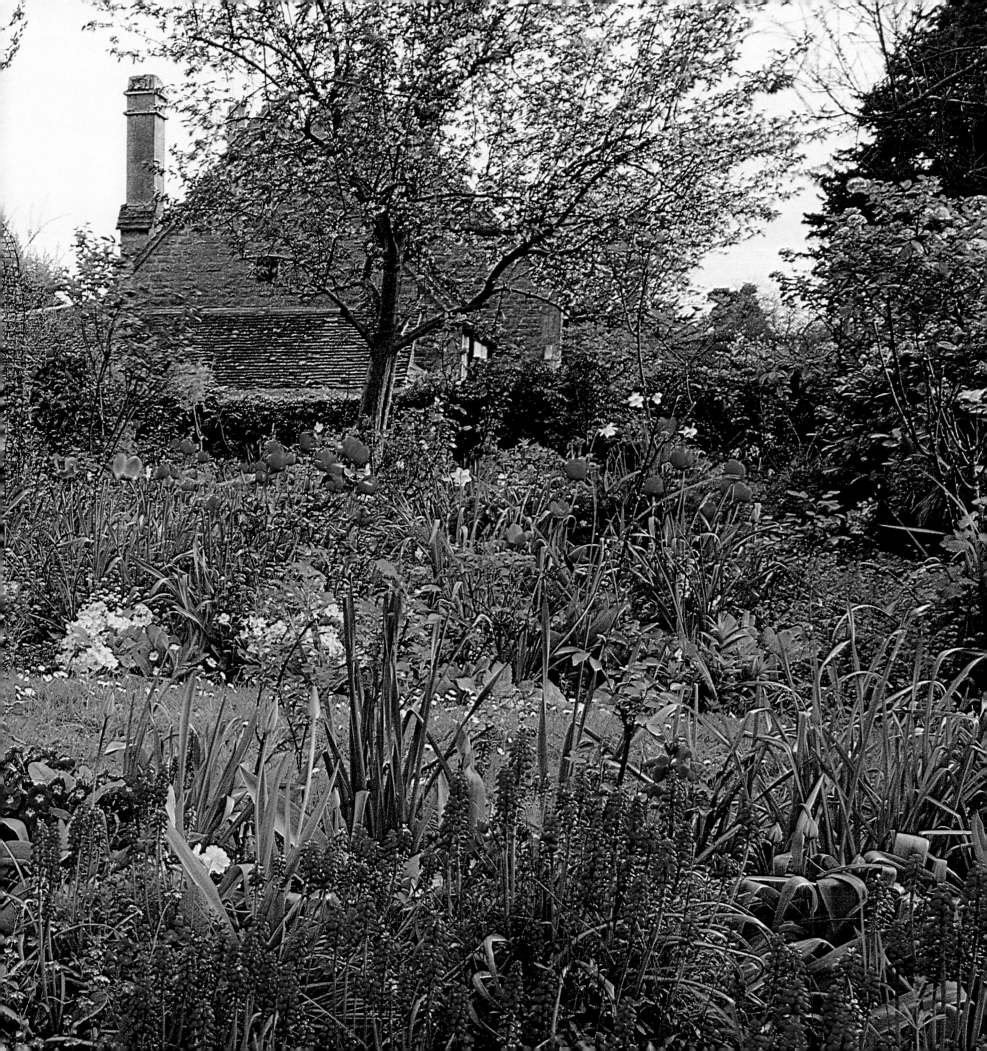

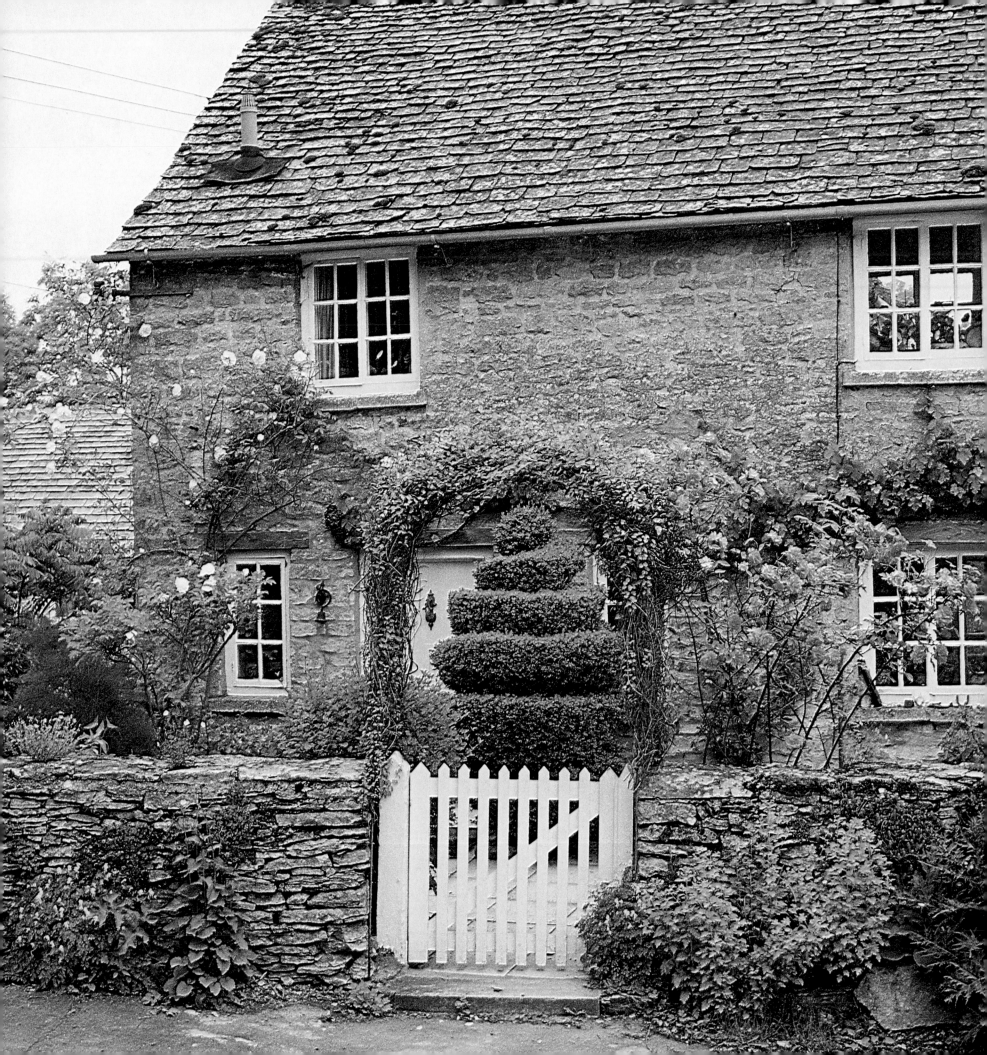

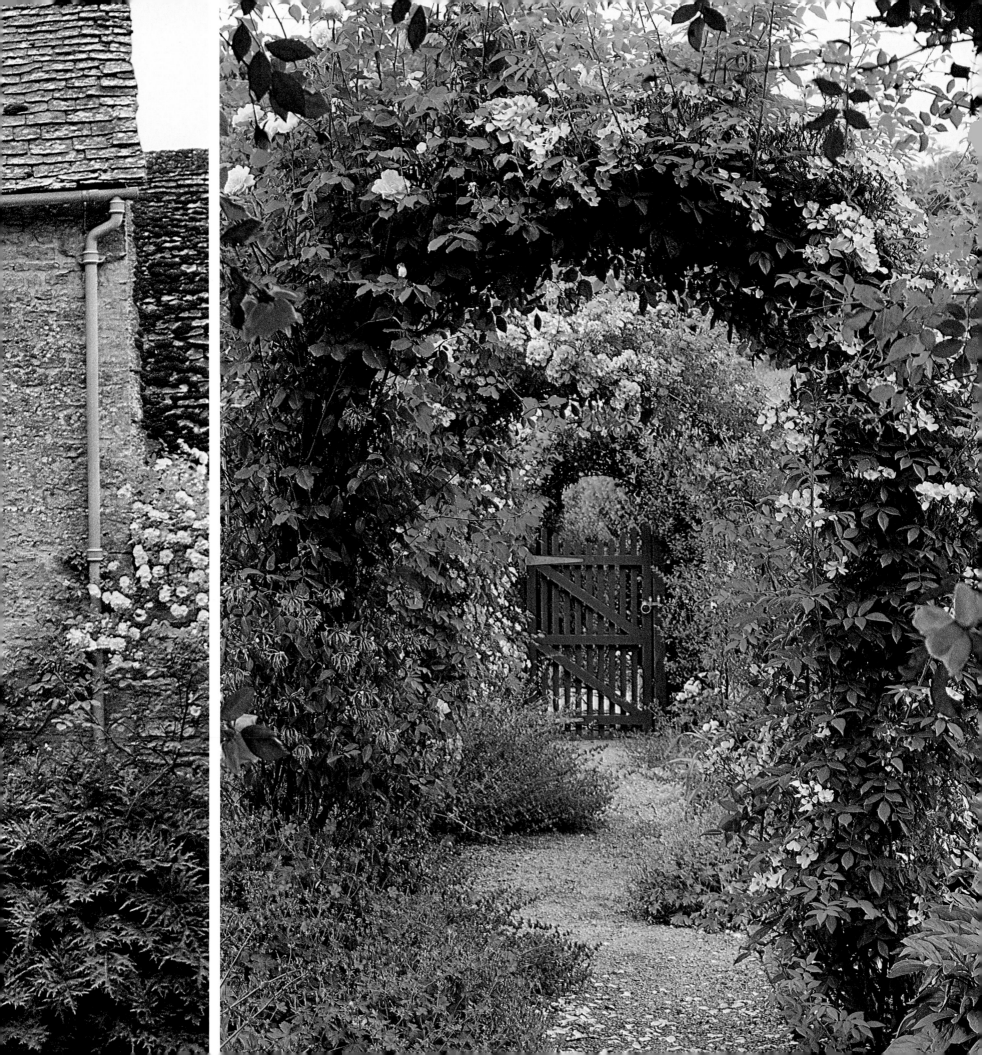

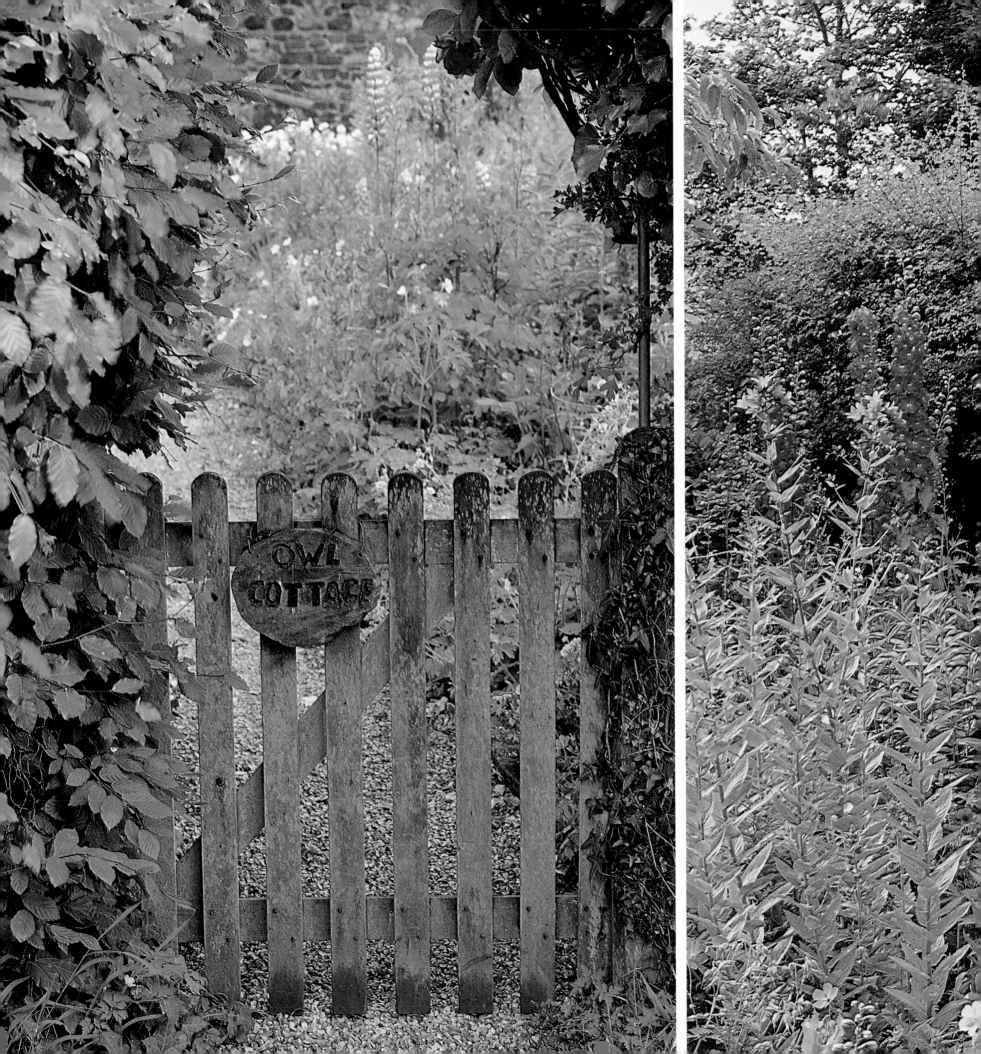

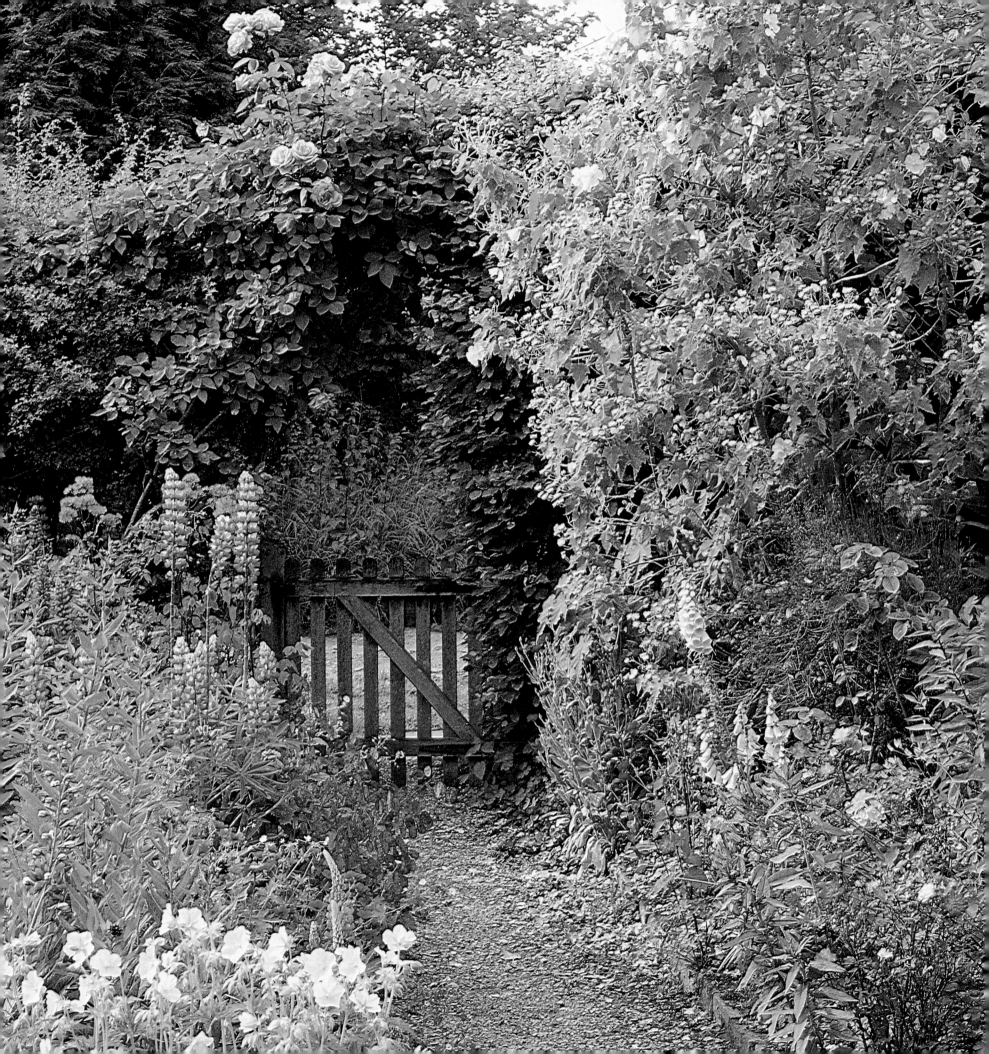

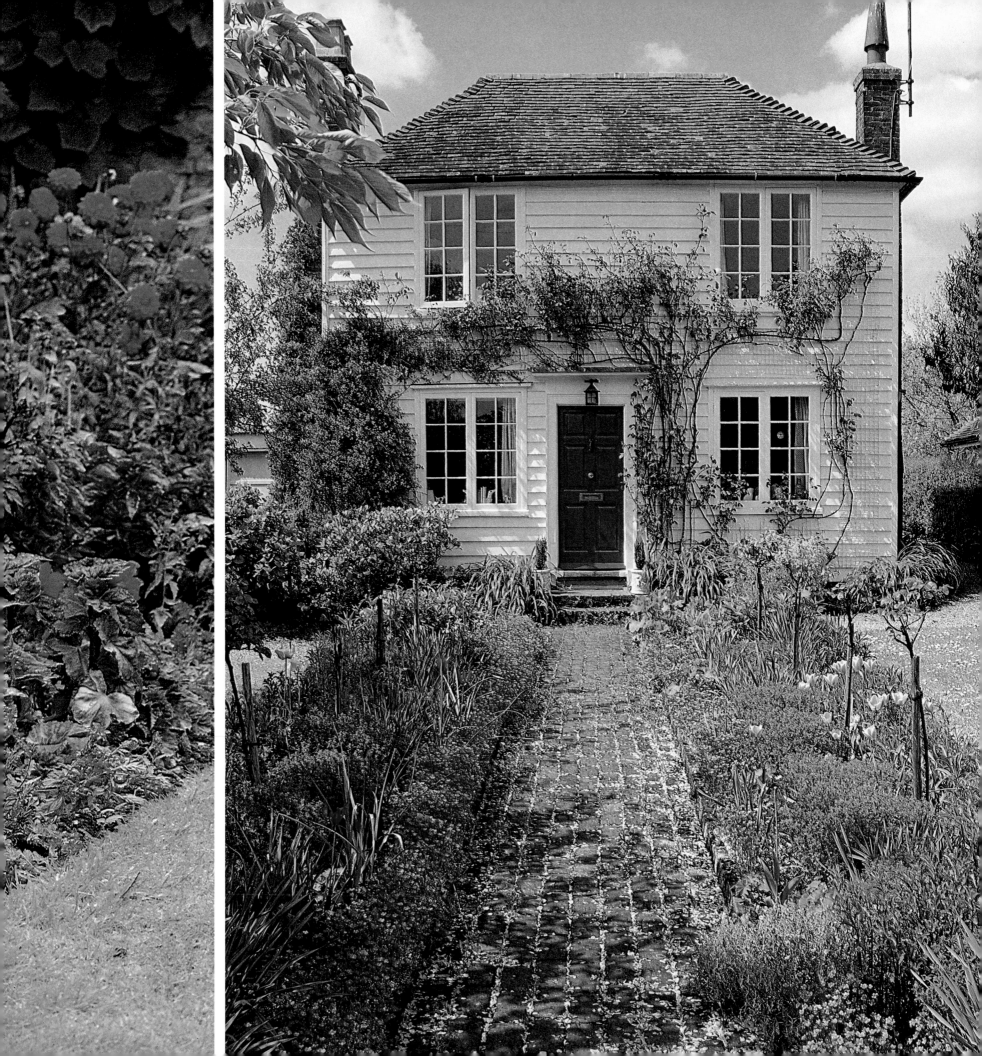

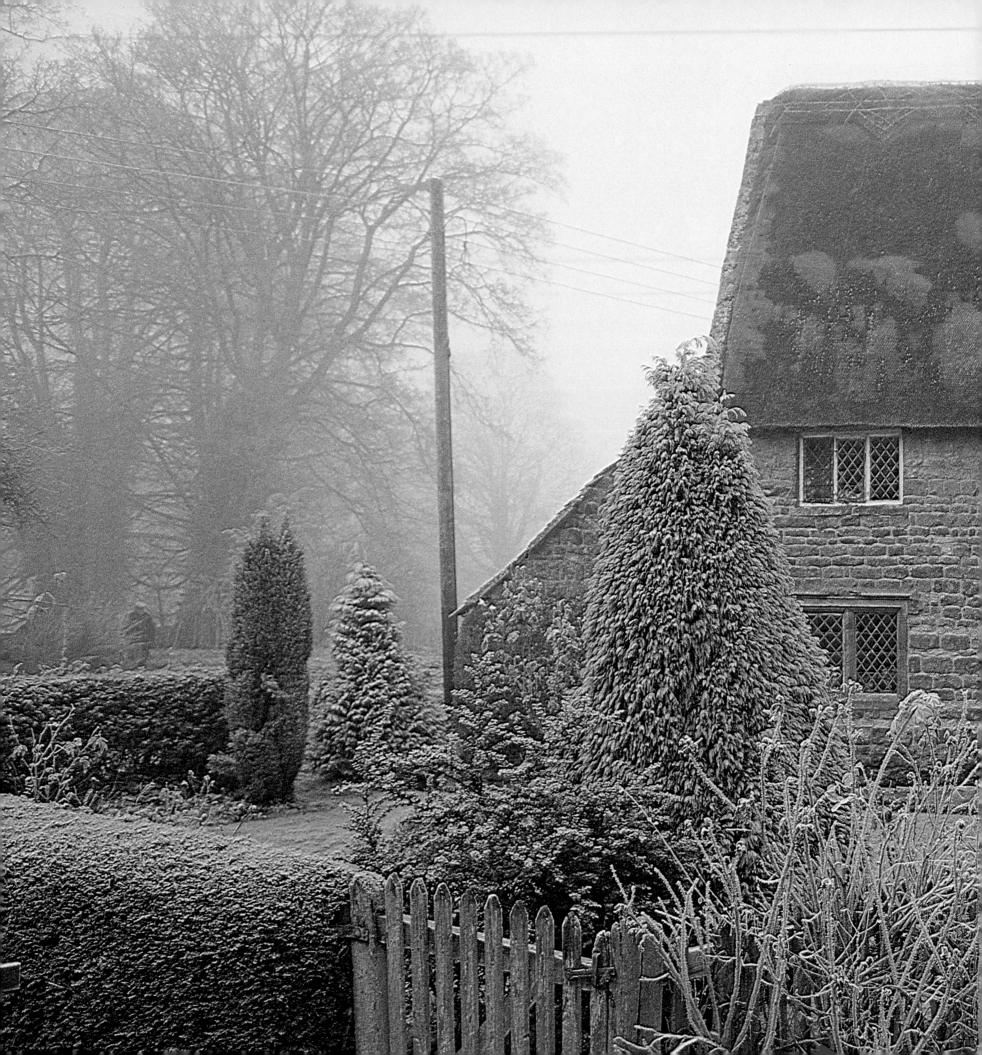

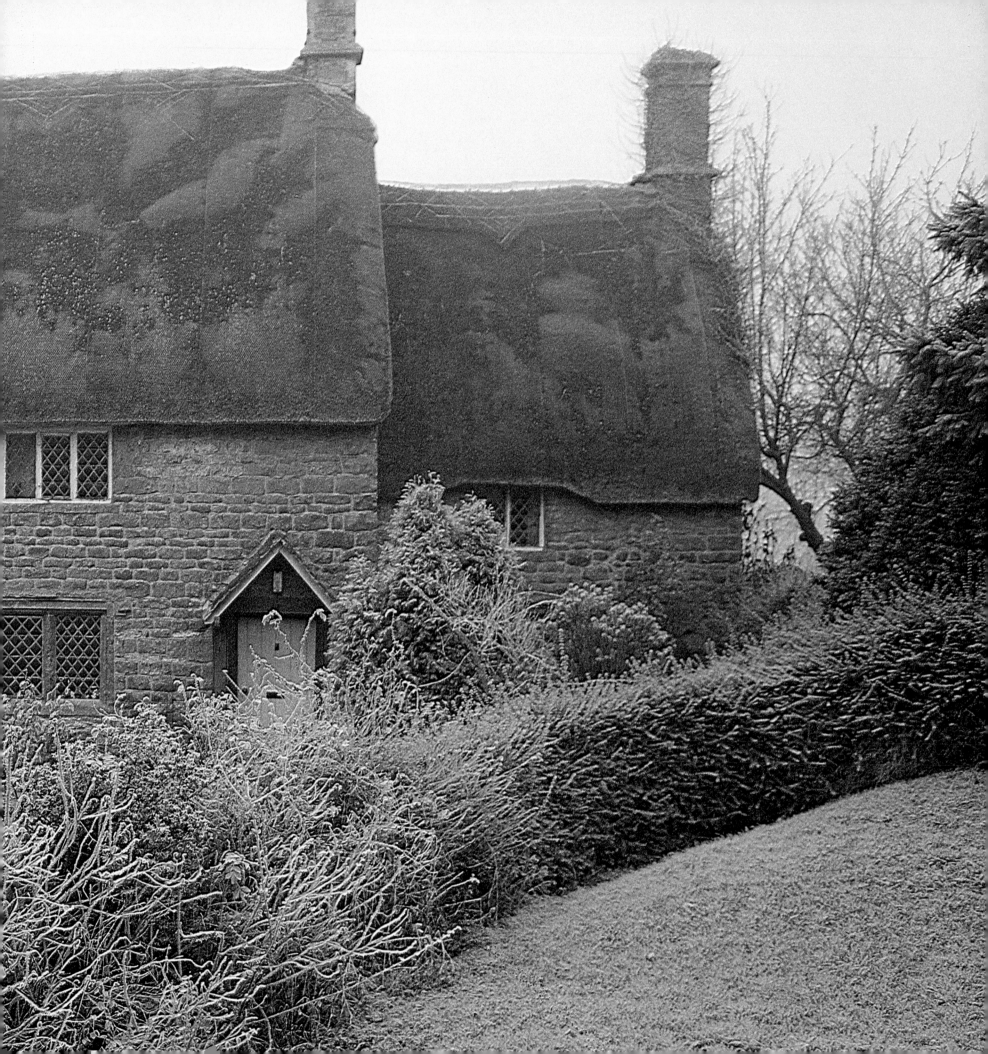

## Exquisite Consorts

William Lawes (1602-1645)
and Henry Purcell (1659-1695)

### Music, the Food of Love

William Lawes
1 Symphony
to the Lira Consort 1:48

Henry Purcell
2 »If music be the food of love« 4:01

Cormack MacDermott (†1618) / William Lawes
3 Pavan
to the King of Denmark's Harp Consort 4:50

(Samuel Pepys Ms)
4 »To be or not to be« 5:27

(Anon.)
5 The merry cuckold 1:13

### The King's Private Music

(Anon.)
6 The French King's masque
to the Consort of six 1:08

(Anon.)
7 The battle of Harlaw 1:55

William Lawes
Fantasy Suite
to the Organ Consort 7:20
8 Fantasy 3:49
9 Almain 1:37
10 Galliard / Close 1:54

### The Masque of Love

William Lawes
11 Masque 1:59

(Anon.)
12 Cupid's dance 1:26

(Anon.)
13 The scolding wife 0:31

(Anon.)
14 The pleasant widow 1:35

(Anon.)
15 The mock widow 1:30

William Lawes
16 Antic 0:45

### The Night Piece

William Lawes
17 »In envy of the night«
to the Consort of Wire Strings 1:45

John Coprario (1575-1626) / William Lawes
18 Pavan
to the Harp Consort 10:10

### The Mad Scene

(Anon.)
19 Old Tom O'Bedlam 1:04

(Anon.)
20 Mad Tom of Bedlam 2:50

Henry Purcell
21 »Bess of Bedlam« 4:47

William Lawes
22 »Hence ye profane«
to the Consort of Masquers 2:34

### The Country Dancers

(Anon.)
23 The night peece (Shaking the sheets) 3:00

(Anon.)
24 The Spanish jeepsies
to the consort of Rude Musick

### The Harp Consort

Ellen Hargis, soprano

Douglas Nasrawi, tenor

Rodrigo del Pozo, tenor

Harry van der Kamp, bass

David Douglass, renaissance violin

Nancy Hadden, renaissance flute, recorder

Hille Perl, bass viol, lyra viol

Jane Achtman, bass viol

Paul O'Dette, lute, theorbo, cittern, orpharion

Lee Santana, lute, cittern

Pat O'Brien, bandora, guitar

Steve Player, guitar, castanets

Thomas Ihlenfeldt, lute, guitar, theorbo

Directed by:

**Andrew Lawrence-King**
harps, organ, harpsichord, percussion

CD 2

**Music for a While**
English lute songs of the 17th century

Henry Purcell (1659-1695)
1  Music for a while  3:23
2  Now that the sun hath veil'd his light
   (An Evening hymn on a ground)  3:15
3  If music be the food of love  3:42

Thomas Morley (1575-1602)
4  Thyris and Milla  1:44
5  She straight her light green silken coats  1:25
6  With my love my live was nestled  1:43
7  Sleep, slumbring eyes  5:05
8  O mistress mine, where are you roaming?  1:34
9  It was a lover and his lass  3:08

John Dowland (1563-1626)
10  The Right Honourable Robert, Earl of Essex,
    His Galliard for solo lute  1:58
11  Time stands still  3:45
12  Flow not so fast, ye fountains  2:31
13  Sorrow stay  3:04
14  Can she excuse my wrongs  2:57
15  Come again: sweet love doth now invite  2:21
16  In darkness let me dwell  3:41
17  Flow, my tears  4:02
18  Fine knacks for ladies  2:41

Christoph Genz, tenor
Michael Freimuth, lute / theorbo

Publishers / Sources:
Stainer & Bell (1, 3-7, 9, 11-18)
Novello (2)
Peters New York (8)
Schott (10)

℗ 2002 edel CLASSICS GmbH
A co-production with: Bayerischer Rundfunk

CD 3

**Edward Elgar** (1857-1934)
Enigma Variations, Op. 36

1   Theme  1:37
2   I. C.A.E. (Caroline Alice Elgar,
    the composer's wife)  2:12
3   II. H.D.S.-P. (Hew David Steuart-Powell)  0:50
4   III. R.B.T. (Richard Baxter Townshend)  1:17
5   IV. W.M.B. (William Meath Baker)  0:31
6   V. R.P.A. (Richard Penrose Arnold)  2:10
7   VI. Ysobel (Isabel Fitton)  1:26
8   VII. Troyte (Troyte Griffith)  0:59
9   VIII. W.N. (Winifred Norbury)  2:03
10  IX. Nimrod (August Johannes Jaeger)  3:38
11  X. Intermezzo: Dorabella (Dora Penny)  2:48
12  XI. G.R.S. (George Robertson Sinclair)  0:58
13  XII. B.G.N. (Basil G. Nevinson)  2:33
14  XIII. Romanza *** (Lady Mary Lygon)  3:04
15  XIV. Finale: E.D.U. (the composer)  5:15

Rundfunk-Sinfonie-Orchester Berlin
Rolf Kleinert

℗ 1971 VEB Deutsche Schallplatten Berlin

**Charles Villiers Stanford** (1852-1924)
Piano Concerto No. 2, Op. 126

16  I. Allegro moderato - Molto tranquillo -
    Animato  15:41
17  II. Adagio molto - Più mosso (quasi andante) -
    Adagio - Più moto ma molto tranquillo  12:32
18  III. Allegro molto - Largamente e sostenuto  10:54

Andreas Jetter, piano
Rostov Philharmonic Orchestra
Dmitri Vassiliev

℗ 2003 Bella Musica Edition Jürgen Rinschler
With kind permission of
Bella Musica Edition Jürgen Rinschler

CD 4

**Ralph Vaughan Williams** (1872-1958)

1  Fantasia on »Greensleeves« (1934)  3:59

Edward Beckett, flute
Richard Blake, flute
John Marson, harp

2  The Lark Ascending (1914, rev. 1935)  14:16

Richard Friedman, violin
London Festival Orchestra
Ross Pople

**Frederick Delius** (1862-1934)

3  In a Summer Garden (1908, rev. 1912)  16:48

Philharmonia Orchestra
Owain Arwel Hughes

℗ 1991 (1, 2) 1988 (3) Sanctuary Records Group
Licensed Courtesy of
Sanctuary Records Group Ltd.

**Benjamin Britten** (1913-1976)
Simple Symphony Op. 4

4  I. Boisterous Bourrée: Allegro ritmico  3:18
5  II. Playful Pizzicato:
   Presto possibile pizzicato sempre  3:42
6  III. Sentimental Saraband:
   Poco lento e pesante  6:29
7  IV. Frolicsome Finale: Prestissimo con fuoco  3:18

Rundfunk-Musikschul-Orchester Berlin
Jörg-Peter Weigle

℗ 1990 Deutsche Schallplatten Berlin GmbH

Publishers: OUP (1, 2)
Oxford University Press /
Boosey-Hawkes GmbH (4-7)